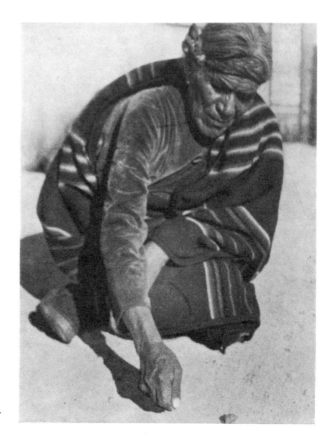

Fig. 1. *Sandpainter strewing sand toward himself*

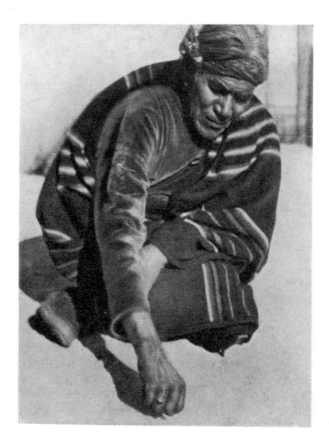

Fig. 2. *Sandpainter strewing sand away from himself*

Sandpaintings
of the Navajo Shooting Chant

by

FRANC J. NEWCOMB

with text by

GLADYS A. REICHARD

DOVER PUBLICATIONS, INC., NEW YORK

To Professor Wendell T. Bush

Table of Contents

International Standard Book Number: 0-486-23141-0
Library of Congress Catalog Card Number: 74-15004

Manufactured in the United States of America
Dover Publications, Inc.
180 Varick Street
New York, N.Y. 10014

List of Illustrations[1]

[1] Unless otherwise noted the paintings belong to the Male Shooting Chant.
[2] The names are those of the Chanters who are authority for the picture.

Text Figures

Preface

Work among the Navajo cannot be successful without a great deal of cooperation. To begin with, it is expensive. The actual collection of the sandpaintings from which those of this book are selected is the inspiration of Professor Wendell T. Bush, who furnished not only inspiration but also financial aid. Supplementing his accomplishment, the Council for Research in the Humanities, Columbia University, rendered further help. As early as 1924 the Southwest Society made it possible for Father Berard Haile to record the Shooting Chant in Navajo, and from time to time since then has made it possible for the writer of the text to study Navajo ceremony. Since a great deal of time was necessary for the entire work, the Council for Research in the Social Sciences also participated in the work, for much of the material on ceremony was gathered when she was learning to weave. To these individuals and institutions we acknowledge our indebtedness.

In the Introduction some of the history of the material is given and we have noted that the myth came from Blue Eyes of Lukachuckai. Without it no satisfactory interpretation of the ceremonial details could be made. Furthermore, the study of ceremonial itself was made with Miguelito, a pupil of Blue Eyes, and his interpretations were checked with the myth. However, few of the paintings are his, and those reproduced in this book are to be accredited to the medicine-men with whom Franc Newcomb worked: Galison's Son, Dudley (also called hatá·lí ts'ósí·h and hasti·n didjólí), and Blessing Chanter, all of whom belonged to Blue Eyes' school, the last a son of Blue Eyes' sister, the acknowledged authority on the chant; Little Big Reed (lók'ayá·jí) from Lukachuckai; Shooting Chanter whose lore came from another source far east on the Navajo Reservation; and Navajo Frank from the San Juan region.

We give our sincerest thanks to those who have worked with us, individually and collectively, and to the memory of those no longer living we pay our reverent respect. And it is not only to the Singers of this particular Chant, but to all the medicine-men we have known that we acknowledge our gratitude and appreciation for helping us so patiently and tolerantly in our difficult task.

Franc J. Newcomb
Gladys A. Reichard

As the writer of the text, I wish to add a personal word of thanks to that which we both feel. To Roman Hubbell, for introducing me to Miguelito's family with whom my life was an idyll, for showing at all times the most lively interest in my work, for communicating to me many suggestions and clues about various phases of Navajo life, and above all, for his immediate and unfailing understanding of demands which to others must at times seem not only extraordinary, but even abnormal, I accord the sincerest thanks I am capable of expressing.

For reasons which differ from the above only in detail, especially for understanding my needs and placing at my disposal every facility within her power, for her uncomplaining, even uplifting companionship in uncomfortable as well as in pleasant circumstances, and for her hearty cooperation in making the sandpainting collection and this book possible, I take this opportunity to express my gratitude to my collaborator and friend, Franc J. Newcomb.

I pause for a word of appreciation also to Professor Franz Boas, Dr. Elsie Clews Parsons, and Miss Elizabeth S. Sergeant for suggestions and help in the organization of the text.

Gladys A. Reichard

I

Introduction

In 1887 Washington Matthews, medical officer in the United States Army, published the first account of a Navajo chant.[1] His observations date from 1880, and in 1902 a much fuller description of the Night Chant was published.[2] This account is supplemented by an earlier, but less complete one by James Stevenson.[3]

It is surprising that these accounts, suggestive in the extreme, did not until fifteen or twenty years ago, spur on investigators to exert greater efforts in obtaining more complete information on Navajo ritual. The Navajo were and are the largest of our Indian populations; they have maintained an unbelievable amount of their ancient beliefs and practise. In spite of all conditions being most conducive to ethnological research among them, no significant contribution has been published regarding these matters since those of Matthews.

During the past fifteen or twenty years, however, various efforts, until lately largely unsystematic, have been made to collect Navajo material, but this material remains uncoordinated. In this time, too, the methods of ethnology have become more thoroughly crystallized and descriptions like those of Matthews and Stevenson, while of the utmost value as far as they go, are felt not to go far enough. That is to say, the ethnologist is now interested in the psychological background of a religion as complicated and compelling as this. Descriptions can only partially satisfy his desire for interpretation in a field where such interpretation is readily available.

It was with the intention of discovering the manner in which the Navajo regard their most engrossing activity, religion, that the writer began in 1930 the attempt to master some of the more intricate and less apparent phases of Navajo culture. To this end she learned the language for she has always felt, and experience has only emphasized the conviction, that no culture can be understood outside of the language in which that culture is framed. In this respect the method does not differ from that of Matthews for he too spoke Navajo. In fact, it is not contended that there is a great difference of approach.

In these years there has been, however, emphasis upon training in acquiring linguistic and cultural material, more especially, time has become available for assembling and organizing such material systematically, and above all, interests, though related, have been broadened. Now Navajo sandpaintings are known, not only as something important in themselves but also as a spectacular and appealing part of a large and complicated unit called the Chant. But the relationship in which we are interested does not end there. The Chant itself with its attendant beliefs and practises is visualized as an elaborate complex which ramifies into every phase of Navajo culture and in so doing affects the behavior of every individual in the tribe.

Even here the interest finds no limitations, for Navajo religion is largely composed of elements which are distinctive of the Southwest, closely related to those of the Pueblo peoples, which in turn show close affiliations with the religions of Mexico. The fact that the Navajo are expert at adaptation

[1] The Mountain Chant, Report Bureau of American Ethnology 5 (1883–84).
[2] Memoirs American Museum of Natural History VI.
[3] Ceremonial of Hasjelti Dailjis, Report Bureau of American Ethnology 8 (1886—87).

and reinterpretation has caused them to furnish us with the richest sort of material for studies of assimilation and acculturation.

Further, as if these problems were not sufficient, their linguistic relationship to the Athapascans of Canada and of Northern California issues a challenge which involves anthropological questions in every conceivable field: linguistic, cultural, and historical.

With some conception of the scope of the work necessary to solve the "Navajo problem", and with that conception enlarging constantly the longer she worked at it, the writer was convinced that valid generalizations could not be made on the basis of our present knowledge, that we must, so to speak, start again, secure the most minute details of the various phases of Navajo culture, and by studying and interpreting these details in their entirety, formulate new conclusions and generalizations more far-reaching. In her seven years of putting this conviction into practise upon every possible occasion she has become ever more firmly convinced that the procedure is fruitful and the results gratifying.

The method was simple, merely to live with a Chanter's family, to try to live as nearly as they do as possible, and through accumulating experience and often fortuitous moments of comprehension, to attempt to regard matters in a Navajo spirit. The Chanter with whose family I imbibed as much understanding as I have, was Miguelito, or Red Point, whose range lies six miles south of Ganado, Arizona. Chance seems to have played a large part in the circumstances which made the results of this book and of my additional work on the Shooting Chant unified.

In 1924 through the interest of the late Dr. P. E. Goddard of the American Museum of Natural History, the Southwest Society made it possible for Father Berard Haile, O. F. S., to record a long text of the Male Shooting Chant as told by Blue Eyes of Lukachukai. When Dr. Goddard died in 1928 he was preparing this myth for publication, and since I was interested in the Navajo, it fell into my hands. This myth is the description which gives the Chanter the key to the order of his rites and explains to him the why and wherefore of his action. Every Navajo Chant has such a myth which the Chanter learns as he proceeds with his instruction.

I could not help feeling that this myth was just so many words which could not become the living thing those words indicated unless through experience, comprehension could be put into them. Four points of view seemed to be indicated: that of the audience, of those who witness the ceremony and participate indirectly in its good and who understand little of its significance but firmly believe in it; that of the "one-sung-over" for whom the ceremony is given and who, according to his position in the tribe as a medicine-man or layman, may or may not understand the reasons for the ceremonial procedure; that of the Chanter's assistant who, like the patient, knows or does not know according to his interests; and finally and most importantly, that of the Chanter in whose mind and hands inheres the final and almost overwhelming responsibility for bringing and keeping all things in accord for the individual and tribal welfare.

With all this in mind, perhaps not quite as clear and comprehensive as I now feel it, I appealed to Roman Hubbell to find me a family in which I could work out these notions. His first suggestion was Miguelito, and I consider it a favorable chance that he happened to be a singer of the Shooting Chant. During the five summers I lived with his family I saw him perform the Shooting Chant three times, and each time I was able to follow the ceremonial from beginning to end in the greatest detail.

The first was a nine-day performance of the Sunhouse Branch given for Miguelito's daughter, Marie, in which, by every means known to him, he endeavored to drive out the evil accruing to her because she had, seventeen years before, been in a house struck by lightning. Generally the amount

paid a Chanter for his work determines the length and elaboration of the chant, but this motive was absent on this occasion since the father determined to do his best for his daughter.

Later he sang the Prayerstick Branch of the same chant over me, once for five days, once for two nights and one day. The reason for these was to "make it safe" for me to handle such powerful material and for blessings in traveling. Had our plan gone to its ultimate conclusion, these two performances would have been repeated at intervals, and the four would make me eligible to learn even the most powerful and detailed elements of the chant. However, Miguelito died in the fall of 1936 and these two repetitions have not taken place. The chants sung for me differed from Marie's only in that they were sung to bring me blessings, whereas hers was given to drive out evil. This fact gives us a basis of comparison for fine detail. When the three versions are compared with one another and with the myth, it is astounding, almost incredible, to note the way in which the details correspond. One reason for this is that Miguelito was a student of Blue Eyes, but the well-known individualism of the Navajo, as well as the differences in the human mind, make it remarkable nevertheless.

Some two years after I began my work on ritual I learned that Franc Johnson Newcomb, a trader's wife living at Newcomb, fifty-eight miles north of Gallup, had become so interested in Navajo sandpaintings that she was making a collection of them and developing a technique for recording. Her interest, I now know, grew out of an appreciation of art, a natural ability to get along with Indians, and a sense of almost appalling futility at the realization that here was a field untouched by, practically unknown to, artist or scientist. At first with only her personal urge she started her vast collection which now numbers almost three hundred sandpaintings.

As my own knowledge of the field grew, I learned that in 1920 Miguelito had reproduced in water color forty-seven paintings of his chant for the late Mr. J. F. Huckel of Kansas City. Interest in the decoration of El Navajo Hotel at Gallup had inspired this collection but the imagery of Navajo art and literature exerted an influence on Mr. Huckel much in excess of that needed for strictly utilitarian purposes. Besides the paintings there is a large amount of literary and interpretative material. Mr. Huckel's death before he was able to use it has caused an inestimable loss but it is to be hoped that some means will be found to make this rich material available to the public before too much time has elapsed.

At the time I met Miguelito in 1930 he was well along in making a set for Roman Hubbell, a number of which Mr. Hubbell has had permanently preserved in Navajo tapestry weaving.[1] At the present time Mr. Hubbell has about twenty of these water colors which the writer has gratefully used for interesting comparisons with those here published. It is certain that comparison between the Huckel paintings and the Hubbell ones will prove of tremendous interest since they were made by the same Chanter at different intervals, and it is more than obvious that comparison with these here presented will be tempting since these were secured in different parts of the Navajo Reservation from different informants.

As I became better acquainted with Franc Newcomb, I learned that she had more paintings belonging to the Shooting Chant than to any other. By this time I had put the myth into a form which could be read by Whites, and armed with this which has many descriptions of sandpaintings, and with her constantly increasing information, Mrs. Newcomb has been able to round out a collection of fifty-six paintings belonging to various branches of the Chant of which forty-four have been selected for reproduction here, thirty-seven in color, and seven in black and white.

A word must be said about her method which is not only unique, but also as exacting as is humanly

[1] See Reichard, *Navajo Shepherd and Weaver*, Chap. XVII, p. 153 ff. (Reprinted by Dover Publications as *Weaving a Navajo Blanket*.)

possible. In spite of the fact that some of the Navajo paint or weave the sandpainting designs, there is a feeling that they should not be made permanent. Naturally this feeling was stronger when she began to work than it is now that more medicine-men have become accustomed to the idea. Even now, however, they dislike the use of pencil and paper in the presence of the painting. Conforming to their feeling in this matter, Mrs. Newcomb has learned to memorize the painting while it is being made. She often assists in making it and is consequently criticised, and in turn criticises errors, or asks reasons for change of detail in those she knows. If there is a new and intricate painting she scans it attentively, and when it is nearly finished leaves the hogan in which it lies, retires to a spot where she can concentrate, closes her eyes, and builds up a memory image of every detail of color, direction and composition. Naturally after many years of practise she spots the essential points at once as she does the gaps in her memory. She then returns to the hogan and fills in these gaps.

As soon as possible after the painting has been made she makes a sketch of it so that the important details will stand out. She then calls in the Chanter to criticise it, for he has no objection to doing this once the actual occasion for the painting is past. Generally the Navajo inform her when a painting is to be made in her vicinity. They have an ulterior motive even now in that, being a generous contributor, she "helps them out lots", that is, with tobacco and other gifts, but their confidence in her is great too after all these years. Once, however, when they had a singer from "the other side of the mountain", they seemed unusually eager for her to come. She attended the laying of all the paintings which were new to her and very complicated. After the Chant was over, the Chanter, accompanied by one from her region, came of his own accord to see her. He looked over her sketches most critically, had her change a few minor lines, then broke into a burst of Navajo laughter as he told "her" Chanter, "You win!" Whereupon she learned that he had bet she could not learn, just by watching one morning, each of his paintings. Naturally her Chanter bet she could, and the stranger, typically Navajo, was a cheerful loser.

Not only has Mrs. Newcomb availed herself of every opportunity to see sandpaintings in her own vicinity, but, like a Navajo, she has traveled extensively over the Reservation securing paintings unknown where she lives as well as different versions of those painted there.

Besides the paintings in this collection, now the property of Columbia University and Professor Wendell T. Bush, there are other collections which may eventually become available at least for exhibition. Columbia University has eight of the Hail, a chant so closely related to the Shooting Chant as to be almost a part of it, and seventeen of various branches of the Wind Chant.

Miss Mary Cabot Wheelwright of Boston has a collection of nearly a hundred paintings made by Franc Newcomb which differs from those mentioned in that it is representative; it includes some paintings from almost every Chant we know of. Mrs. Newcomb's own collection of nearly three hundred of course includes those she has made for other collectors, but among them are a number of rare paintings used for the Night Chant in numerous "branches" and for the Male Branch of the Mountain Chant. Matthews' account is of the more common Female Branch of the Mountain Chant and of the most commonly sung form of the Night Chant. Our discussion of Chant and Chanter (Chapter II) will show why witnessing the Chant, even a number of times, does not give the full import of the number and kinds of paintings belonging to it.

In the Huckel collection at Kansas City there is a full set of Miguelito's paintings belonging to the Bead Chant, and miscellaneous pictures and parts of pictures which are called the Day Collection. Miss Wheelwright has also some paintings collected by Mrs. Laura Armer and Mrs. Louisa Wetherill. I have heard of small collections made by other individuals but I am not familiar with them and at best they are scattered.

Although Miguelito died before I had a chance to work with him intensively of a winter, in January 1937 I had long and illuminating discussions of ceremonial material in Navajo with hataĺí tłˊăh of Newcomb. tłˊăh devoted a lifetime to the mastery of ceremony and since he was conscientious in his record and interested in ceremonial above all things, an immense amount of understanding which can come only with comparison, has become available. The Shooting Chant is the large complex from which the Hail, Wind, Water, and Feather Chants branch off and there is consequently much overlapping. tłˊăh was said to have been the last Navajo knowing the Hail Chant but he had not sung it for many years, for his greatest interest was the practise of various forms of the Night Chant. We have not found anyone who knows the Water Chant, which with the Hail is the most closely allied to the Shooting. Of this group the Wind and the Feather remain to be done, although some of the paintings are available.

It seems hardly necessary to apologize for the fact that we have lifted the paintings from their ritualistic setting and the portions explaining them from the myth. If a word is required, I may say that we have done it to make their artistic and religious form intelligible. We try to explain the place of the paintings in the Chant. We feel that they, as well as certain other parts of the Chant, can be understood better at first, if they are treated as a subject apart. Navajo order is exceedingly confusing in its complications, and although we advocate at first an understanding of the separate parts, we nevertheless never lose sight of the whole to which each part belongs. Furthermore, although we realize how imaginative, unusual and even exciting these visual portrayals of Navajo symbolism are, we try not to exaggerate their relative importance in the Chant according to the Navajo mind, remembering that they constitute only "one of a great number of things".

Naturally after presenting, from time to time, the units which go to make up the chant – herbal medicine, its collection, use and classification; the prayersticks and their functions; the poetry and song; the myth which includes the drama and the literature, as well as description of rites – we hope to publish a technical account of the Shooting Chant in much the same form as the Navajo conceive it. We hope by that time also to be able to present comparisons with other chants and with more than one or two parts of the Reservation.

II

Chant and Chanter

Sandpaintings, the subject which this volume illustrates and explains, are not something of and for themselves, but they are a part of a performance which continues for a period varying from one to nine days which is commonly referred to as a "Chant" or a "Sing". These words simply mean a combination of many ritualistic acts carried out in a fixed order. They include preparation, purification, performance with and disposal of, materials, all carried out with the greatest of care. Herbal medicine is gathered, used and disposed of. Prayersticks, made of reed, decorated with paints, accompanied by their prescribed feathers, are prayed over and carefully deposited at places where the gods they invite to the ceremony will not fail to see them. Seeing them and noticing that all is in order, deity may not then refuse to accept the invitation proffered.

Each act is accompanied with song, for without it the order of procedure is incomplete and unacceptable. Many of the rites must be performed with the objects which were decreed in mythological times and given to a hero who was enabled to perform miraculous exploits with the aid of the supernatural beings who attended him. All the knowledge necessary to the successful performance of one of these elaborate ceremonies and to an understanding of the belief is included in the word "Chant".

There are perhaps twenty or twenty-five major Navajo chants of which the Night Chant stands above all others. The Mountain Chant, even more spectacular than the Night Chant in some respects, is also outstanding. Chant lore and understanding is by no means complete with these which are given only in the wintertime, nor can it be said that any one is of greater or less importance in the Navajo mind. Each has its function and each is equally powerful in performing it. It is difficult, almost impossible, to give the exact number of Navajo chants, even as it is difficult to count clans or to measure dye products, the enumeration depending upon the interpretation one chooses.

For example, almost all chants have a male and a female branch and these may be counted as two for their emphasis and procedure differ and they are prescribed for different diseases. Thus there is a Male and a Female Shooting Chant. At present, however, the Female seems to have been absorbed by the Male. That part of the Chant denoting sex has nothing to do with the sex of the person for whom it is sung or with any obvious sex category. Female and male chants deal with diseases brought on in different ways, with as much differentiation as say, Shooting and Hail Chants.

Within the Male Shooting Chant, to which our information especially applies, there are numerous "branches" and it is a question as to whether each of these should be counted separately or whether all should be included as one. The Chant sung for Marie was the "Sunhouse Branch of the Male Shooting Chant". It was chosen because seventeen years before Marie had been in a building which was struck by lightning and, although she was not injured, it was believed that her severe headaches were caused by her exposure to the evil effects of lightning at that time.

I was not ill, but desired to experience a chant as a preliminary to learning it. Consequently, the "Prayerstick Branch of the Male Shooting Chant" was sung over me to bring me blessings in

traveling. Both of these branches were conducted along the same lines and followed the same drama as related in the myth, so I should not be inclined to list them as separate chants. The main difference was that the emphasis in one was the driving out of evil, in the other, the bringing of good. The same paintings may be used for both.

On the other hand, myth and paintings of the Female Shooting Chant differ somewhat (Pls. XV, XXIV and Fig. 4) from those of the Male, as they do in the so-called Corral Dance Branch which is a Shooting Chant with the "Fire Dance" performances of the last night (Pls. XII, XIV, XX, XXI). We include some paintings from each of these branches, and perhaps they should be listed as separate chants. So it goes with all the chants, and the differences are as marked for those described by Matthews as for these. His description is of the Female Mountain Chant and the Male is vastly different, now at least much more rarely performed.

Chants with varying names may be more closely related than those with the same name. I have said that Hail, Water, Wind and Feather are closely related to Shooting. Their relationship is of another kind. Myth and paintings are peculiar to each with slight overlapping, but symbols and ceremonial procedure differ only slightly. For these reasons then, the question of the number of chants and paintings may be left at an estimate of say, twenty to twenty-five major chants with a total of from four to five hundred paintings of which more than three hundred are known.

Each chant is considered a cure for, or a charm against, certain diseases, although the disease categories do not remain rigid or consistent. Marie was cured of an illness caused by lightning and will henceforth be immune also to the powers of arrows and snakes. No illness of mine was due to any of the three, but I shall remain safe from their onslaughts indefinitely for not only do they fear my olivella shell, but they have communicated their power to me. However, there is a close relationship between Wind and Snakes too, and a Wind Chant may cure one of a disease incurred by Wind and make him immune to snakebite as well.

The belief, briefly stated, is that certain elements, animals or persons, through imitation, cause disease which is equivalent to discord. They are able to do this because they have made contact with the person out of order. If then, they can be induced to be present where they can be honored in the proper fashion, which means order of procedure, they will not only no longer be harmful, but they may even bring good, which means accord.

Influence for harmony or discord has no spacial or temporal limitations. Marie's headaches were caused seventeen years before the cure was tried. Her sister at one time had an indefinable illness. She lacked ambition, had dizzy spells, felt fearful and ill at ease. When the diagnosticians[1] were consulted they found that she had camped at a spot on the mountain where, in days long past, deer had been driven into an impound. Consequently she had the same feelings they had and a one-night "sing" properly carried out was sufficient to free her spirit and she became well.

This is the reasoning behind the War Dance[2] belief also, for when it is held to be necessary, it is because a parent saw or came in contact with some part of an enemy while the person now ill was being carried by his mother. With such a belief no one can be solely responsible for himself but must combat discord brought on by other individuals who are in their turn unconscious of coming into contact with it, or at other times, perhaps a generation or even many decades before, the Navajo concerned was born. But, by the same token, he may, by submitting to the Chant, gain power which will terrify the powers of evil and keep them away or which will force them to bring him nothing but blessing.

[1] See L. C. Wyman. Navaho Diagnosticians, American Anthropologist, 38 (1936): 236—246.
[2] Gladys A. Reichard, Social Life of the Navajo Indians, 112—133, and Spider Woman, 233—259.

The individuals in whose hands the safety of the tribe lies are the Chanters. There is nothing in their appearance to distinguish them from the rest of the population, nor are they organized into societies, guilds or priesthoods. They are however, the repository of all the religious, mythical and practical lore of the tribe.

A man, usually more than thirty years of age, or even middle-aged, "old enough to have settled down", will indicate through an intermediary his desire to learn a particular chant. His choice is free, but is often influenced by some Chanter in the family or by some special experience with a particular chant. He who puts himself up as an apprentice for the Night Chant has particular courage and ambition: courage, because it is believed that false knowledge or errors in the use of information will cause paralysis; ambition, because the Night Chant makes greater demands on the Chanter than other chants and all demand much.

It is not likely that a man arranges to learn a chant on impulse. He has doubtless shown aptitude in assisting at chants. He may even be urged or coaxed by the orthodox in his family. He realizes even as a doctor does, that he is assuming a tremendous responsibility, for upon him and his fellows, once he practises the Chant, rests the entire burden for the good of his whole tribe. Perhaps the first to suffer by a misuse of power, whether intentional or accidental, may be himself.

The main test of his adequacy is his intelligence. He need not learn fast, but he must be accurate and painstaking. These are not his final tests however. He must be willing to make financial and personal sacrifices to get this training and the prestige which goes with it. When his intermediary makes the agreement with his teacher, he gives a gift to bind it. At intervals during the many years of apprenticeship there are payments, and ceremonies requiring great resources must be held for acquiring special property. Miguelito, for instance, had a Night Chant sung over him when he secured the "wide boards" which are an important part of his bundle. After the novice has become a full-fledged Chanter, his ability approved by his teacher, he pays him a royalty, that is a portion of every fee he receives for singing this particular chant, for the rest of his life. This fee, like everything else Navajo, is an indefinite one, but is more efficacious the larger it is. His training has, of course, furnished him with a means of livelihood, for, if he is successful, he will be called upon often to sing and he may expect a generous fee every time he does so.

Not only does he sacrifice wealth in the form of gifts which are voluntary and indefinite, but during the years of his apprenticeship which may, in a sense last the rest of his life, he must be ready to concentrate deeply, to apply himself to routine matters which must be rehearsed again and again. There is no doubt that he has at some time herded sheep and has learned much about the habits of birds and animals. He will have to add to this knowledge and he may have to go far afield to secure the animal skins for his bundle. He will learn how to catch them without wounding, how to smother them in pollen, a ritualistic necessity for blood must not be spilt.

Similarly he will have to know plants, their uses, where they grow. He may sometimes make pilgrimages to collect rare plants and cut them with pollen sprinkling and prayer. His need for sacred water may lead him on many a journey and he learns to find efficacy in strange and distant things. In all of this he naturally finds great pleasure as well as some inconvenience.

Besides wealth, time and application, he must contribute to his calling much endurance. This does not seem to him as overwhelming as to us. From childhood he has seen his people, even those in the best of circumstances, spend days without much food or even with none. He has for years learned to exist for a long time on scanty ration, so that fasting is mainly a state of mind with him rather than a period of physical suffering. Similarly he is inured to being alone and a long vigil, even at night, with prayer among the Holy Ones whom he invokes does not terrify him completely,

but may even comfort him. Physical endurance which he must have is a matter of good health. A Chanter sings almost continuously for the nine nights of a major chant with only brief intervals for sleep between the periods of song. It is not unusual to hear him rehearsing during these intermissions.

Miguelito at sixty-nine sang a five-day Bead Chant, came home and after one night began a nine-day ceremony during which he never faltered in voice or memory. The day after the "sing" was over he slept for less than four hours in the morning and spent the afternoon vigorously hoeing in the cornpatch. During another chant he coughed a great deal and by the time it was over his cold alarmed me. I told him to rest all of the day after and he did sleep for some hours. But when I went down to his house about four in the afternoon Marie said with a smile, "My father just ran in when he saw you coming! He was fixing the roof."

If the Chanter's profession makes exorbitant demands, it also furnishes great satisfaction. The first we should consider perhaps is the wealth he may accumulate. With many Navajo that is a primary consideration. There are others however who, although they believe that payment for curing should be made, no matter how difficult it is, nevertheless use that wealth, distribute it among their relatives or give it away entirely, so that they have "gained all and given up all things." These are, I admit, not numerous, but there are enough to show that self-sacrifice is one ideal.

Of greater significance in the mind of the Chanter is the satisfaction his profession affords him. There is no doubt that he believes in his power explicitly. My acquaintance with numerous medicine-men, the light in their faces, the conviction with which they speak of their belief, all suffice to convince me that their devotion is genuine. These are perhaps intangible evidences and nothing more than impressions. A fact that is incontrovertible is that, when discord or disease overtakes one of them, no matter how much power he has in his own right, he submits himself to the ministrations of his fellow Chanters with complete faith in their ability to relieve him. Miguelito died while his family were making preparations for a chant to be held over him. They undertook these preparations at his bidding.

I have heard that there are Navajo singers who try to cheat white people about medicine lore. I have never met any. They are persons who have had experience with Whites and whose knowledge of their own faith is weak.

The question as to whether they would try to deceive their own people is a different one. I have never heard of a charlatan. One reason perhaps is, that there is always a check on ceremonial procedure in the general population. Knowledge is correct only if it can be proved by others who should have it. A sandpainting or prayerstick may have certain individualities, but the test of its genuineness is that it can be read and understood by others who are qualified to know. A serious chanter therefore confesses the weaknesses in his knowledge if he is aware of them. He does not pretend to know that about which he is not sure, and he may refuse to perform even that part which he seems to know because it is not complete. Criticism is free and the smallest detail carelessly performed is likely not only to be detected but even to be criticised in public.

Difficult as satisfaction in virtuosity is to define, even more so is the power which a Chanter believes himself to possess and wield. A woman is very ill, let us say. The first thought is to find out the cause of her sickness. This may in some cases be apparent. When Maria Antonia had cutting pains in her lungs, it was not necessary to consult a diagnostician to learn that the Knife Chant was prescribed. Did her pains not cut like a knife? Her illness was too sudden and severe to allow of an elaborate public form of the chant. Miguelito, her husband, sought the Knife Chanter who dropped everything he was doing and came at once to sing. The rite was short and intense, there

were no guests, the complete five-day performance would be delayed to some future time when the patient was well and the family had time to prepare for it. At the emergency performance as well as at the formal one she would be referred to as the "One-sung-over". For the sake of convenience I refer to the incumbent as the "patient", whether or not he is actually ill when the chant is performed.

Just as the doctor gets satisfaction from the power to cure which he believes he possesses, so does the Chanter. It matters not that all his premises are different, faith and numerous successes give him confidence in either case, for the Chanter can point to many cures. Even though we may often feel that the patient must die of the cure if not of the disease, he never feels this way and he often recovers. Like a faith-curer, the Chanter counts to himself only his successes, he never mentions the failures. If a patient dies or fails of cure and he is asked the reason, the Chanter can always point to some mistake made by the One-sung-over; he has made an error in the order of things, or he has broken a taboo.

It is not difficult to realize how great is this power which the Chanter wields. That he generally does not abuse it is evidenced by his perpetual willingness to learn more, his constant endeavor to achieve correctness, and the complete absence of insignia or exhibitionism. Because of the power that lies within him, because of the demonstrations of ability which he has given on numerous occasions, the Chanter is consulted on all matters, whether social, economic, or moral, for his judgment and wisdom are respected. Nevertheless in any gathering he may appear the lowliest among those present. He has a new shirt but he prefers to wear his old one. His granchildren will not fail to wear their best silver and turquoise, he may have his or it may be in pawn. They will wear their newest blankets, he prefers the one he has worn for many years. He makes no show of shabbiness, he simply does not consider it.

We have said that the sandpaintings are only one form in which this great power of the Chanter is expressed. What are the others? Above all things a Chanter must be able to sing and his memory for song and music must be accurate. Every rite is accompanied with song, in fact, many rites *are* songs. "The day" which is the last night of most ceremonies, refers to the entire night of song during which other rites become only insignificant. Hundreds of songs belong to the Shooting Chant. The Hail, though a major chant, is one of the shortest, and has 447 songs. Not only is song a major part of rite, and not only is it curative in itself, being like a "wide board" or bull-roarer, a gift from the Holy Ones, but it also furnishes the major aid to the Chanter's memory, and instructs him in the order of events.

Performing the same function and including all the acts and explanations of the Chant, is the myth, but the Chanter learns this incidentally, and only rarely when he is teaching, relates it in its entirety. The songs, on the other hand, he uses whenever he performs, and he may use groups of them secularly. When he tells the myth for record, the Chanter often stops the narrative and breaks into song, reinforcing his memory with the words of the songs which seem to be suggested to him by the music. Again he gives the verbal text, and repeats the episode in song, to explain and emphasize the narrative.

Facing the novice then is the vast gamut of songs, but although he may realize the enormity of his task in a general way, he does not think of it in terms of four or five hundred songs. He probably knows some already, he picks up others as he specializes on other parts of the chant.

One necessity in the practise of his art is his bundle. In this he keeps the paraphernalia of his craft. He may begin gathering it as soon as he starts to learn the Chant and gets it by devious ways. In some cases he inherits it, but even then, it is likely that certain items are lacking. The bundle

should be made of a wrapping of buckskin or some other hide available in early days from an animal ritualistically killed. In it are many objects, among them the "bundle prayersticks". These are specific for each chant, the Shooting Chant has twenty-two. Four are sticks curved like canes, elaborately wrapped with string with feathers attached, others are straight but also complicated in composition, four others are called "wide boards". They are about six inches long by four wide and have a handle. One has a cloud symbol cut out from the center and all have crude paintings and down feathers.

Collars made of Beaver and of Otter fur have whistles attached and belong to the bundle, as does a bull-roarer. The rattles used by Chanter and chorus are kept in the bundle also. They are made of buffalo hide for the Shooting Chant and have rainbows painted on them. Another item is the medicine-sprinkler. It is a short stick on which a bunch of long feathers is wrapped with involved windings and fastenings. From the flattened end of this which he dips into the sacred cups, the Chanter tastes the herbal decoctions, with its feathered end he sprinkles them.

A firedrill, both pieces made of sacred woods, is another article kept in the bundle, for the purificatory fire of the first day is kindled with this. Besides these large objects all of which are quite obvious at some time during the ceremony, there are numerous sacks of skin, some large, others tiny. One very small one contains infinitesimal particles of turquoise, whiteshell, redstone, abalone and jet (cannel coal) which are used as sacrifices when prayersticks are made. Other sacks contain pollen of various sorts, rare herbs dried, ground rock, for example, rock containing mica or specular iron ore, and feathers. One contains a straight pipe, one a hollow bone which is, in its turn, a case for the hairs of turkey's beard. In many of the sacks containing dried or ground substances there is some hard substance, a rock crystal, or a piece of turquoise.

The only way to know what all of these and other articles in the bundle are used for and mean is to know the chant as the Chanter knows it, that is, well enough to sing it without error. Parts of the bundle such as the elaborate prayersticks, collars, bull-roarer and medicine-sprinkler, compose the altar. They are placed outside the sacred hogan while the sandpainting is being laid to warn the profane against entering, and when it is finished each has its own position near the painting with it making the altar. This priest not only conducts his rite, he also procures his own altar and sets it up each time he chants.

I have mentioned the permanent prayersticks, which, when the painting is destroyed, are returned to the bundle. There are other prayersticks made each time the chant is given. The Chanter must know all about these too. All are made and used with song. There are four sets of circular prayersticks, each set for one day of the purification rites. On each of four days other prayersticks are made and offered to the gods. These are considered invitations to the deities, which if properly made, may not be refused.

If the Chant is to continue for nine days certain ones are made and planted on each of the first four days and these acts, with the purification rites which include sweating around a fire and emesis, constitute the main order of the day. In this form of the Chant, the longest, more and larger prayersticks are made. If the five-day form is used all three rites, purification, prayerstick planting, and sandpainting with treatment are performed each day. The significance of the prayersticks gives some comprehension of the responsibility resting on the shoulders of the Chanter, for to what purpose does he sing if the gods do not attend? How shall they notice their prayersticks if they are not properly planted? How are they to be induced to come if the invitations are not properly made?

The Chanter does not make the prayersticks, the assistants who make them need not know their

requirements. The Chanter tells them what materials to use, the size to cut them, the patterns to paint on them, the feathers to lay with them, and as they do all this he sings the appropriate songs. These prayersticks differ from those of the Pueblos in that the feathers are laid on them, not tied to them, and the day's set is deposited as a whole wrapped in a cloth. Along with the feathers, a hair from turkey's beard, three tiny offerings of Navajo precious stones, and a small tuft of cotton yarn are laid. In the highest mystical sense the inch of cotton yarn is as important in the Chanter's mind as the entire sandpainting. Without one the other could have no efficacy.

The Chanter knows when to have the patient called in, and he sings as the patient lights the prayerstick ceremonially with a crystal held to the Sun, often for this reason called a cigarette. The assistants then seal the prayersticks at the direction of the Chanter and when all are finished the whole is placed in the hand of the One-sung-over.

Now comes the moment when the Chanter demonstrates his greatest power of concentration and the quality of his memory. Litanically he and the patient recite the prayer and it, although very long, must be recited without error, repetition, or hesitation. Naturally, since the patient does not know it, and since the Chanter intones it quite rapidly, it is to be expected that the patient does not always respond correctly. If he gets the last syllables of the lines wrong, he may throw the Chanter off the track entirely.

Even if the patient is ideal, there are other points at which the Chanter must watch himself. The prayer has many lines repeated often with only one word changed. They must be said the exact number of times, no more, no less, and of course the word must be changed at exactly the right place. Furthermore there may be long lists of names, of place or of deity and the order and number of these is also fixed so that the Chanter cannot skip one for there is no opportunity to insert it later. The same principle was involved when he learned these prayers and he did so only after his teacher took the utmost precaution to guard them both from harm. The teacher recited the prayer *in toto* and only in this form could the novice repeat it, never could he repeat, even to himself, parts on which his memory was weak.

Of course the teacher has a safeguard against chance mistakes of his pupil and the Chanter against those of his patient. The Navajo, even in his most visionary moments, never loses sight of human frailty. The Chanter has a prayer to erase the danger of error from himself and all concerned if an honest effort has been made to avoid it. Miguelito evidenced his attempt at concentration by closing his eyes. He always did this when praying over the altar at dawn and when intoning the prayers for the deific invitations.

He performed the Shooting Chant so often and was so confident of his knowledge that this extreme form of concentration was never noticeable elsewhere, and he carried out all other rites surely and swiftly, at times almost casually. Indeed there was never the slightest hesitancy apparent even in the long prayers. Once I heard him sing the Bead Chant. Gone was his air of nonchalance. He closed his eyes as he sang the songs, never did he interrupt himself with a smoke, a joke or one of his habitual bantering asides. When the painting was disposed of, he threw himself exhausted on a pile of skins in the cooking shade, and lighting a cigarette, said to me, "When I sing the Shooting Chant I do not have to think, I know it so well. But I sing this one so rarely that I have to concentrate on every word and it makes me very tired."

In recalling the songs, the Chanter has the aid of word and music, in making prayersticks he has visual help in the form of properties although they seem to be related only in the most remote way, and it would be easy to omit some part inadvertently. In repeating the prayers not only does the Chanter not have anything at all to aid his memory, but he has in addition to overcome

obstacles in the form of the patient's ignorance, stupidity, or lack of cooperation. None of these difficulties is present in the sandpaintings for each is a complete unit illustrating some incident in the adventures of a hero with supernatural power and they are represented visually as well as aurally.

Every Chanter knows many more paintings than he can use at a single performance of his chant, nor are all of these known by the general public. Some major chants like the Knife Chant and the War Dance have no paintings. Ordinarily only four large paintings are strewn for even the most elaborate form of the most complicated sing. Among other things, the Chanter knows the more simple paintings, called "prayer paintings" and used on each morning of the purification, when the immense fire burns for the sweating and emesis. The Shooting Chant does not use the sweathouse but other chants do, in which case prayer paintings are strewn each day on the surface of the sweathouse. The Chanter decrees which of all the paintings should be used upon any of these occasions as he does when a person is desperately ill and the chant becomes an emergency measure.

Of all the paintings he knows, he usually chooses the four large paintings he will use. The patient or some member of his family is entitled to a choice for it seems that all paintings are equally effective. Commonly, however, neither the patient nor his relatives know the pictures and they leave the choice to the Chanter. He is likely to have favorites which he will use time and again. Especially is this true of those with which he has had conspicuous success, and the others may become dim in his mind, or be dragged out only on special occasions. Certain rare paintings are used for cause, for instance, that of Pl. XI which is painted only after an eclipse of the Sun, and that of Pl. XXXII which is used after too much rain. Through neglect and lack of use paintings have become extinct even as have entire chants, such as the Water and the Red Ant Chants which can no longer be found. Still others, like that of Pl. XIII, have become lost through fear. Since everyone in the Newcomb area who was treated with this painting died, the Chanters agreed to give it up, explaining that they "do not know enough to handle its power". Consequently it turns against them and does harm instead of good. It is possible that new pictures have originated through gradual change in content and interpretation, and our information on this subject is sadly lacking.

For the Male Shooting Chant Miguelito knew forty-seven paintings of which he could never use more than six for any one performance. We could count these as twelve in which case it would be necessary to raise the total number far above forty-seven. The prayer paintings of clouds, let us say, were four if we count each one used for the days of purification as a separate one. As a matter of fact they were all the same except for color, and the large painting of Pl. XIX includes them all as well as a representation of the Sun's House.

Small paintings are made around the fire on the same days, but again they are different versions of snakes and arrows, all of which may appear in a single painting.

Not only does the accomplished Chanter have a large fund of information to draw from but he is responsible for every detail depicted in each painting. He impresses upon you the fact that the original paintings were represented by a deity on some medium which could not endure, clouds perhaps, or buckskin procurable only by the gods. They instructed the Navajo hero to copy them only in sand, they particularly said they should not be made permanent. The hero had therefore to memorize each in a short time and he had to do so without error or gap.

The Chanter knows the symbols peculiar to his own chant and he sometimes remembers them by comparison with another. This knowledge gives him partial control of the second chant and it is not unusual to find a Chanter who knows and practises two or more. Miguelito was an authority on the Male Shooting and Bead Chants and often conducted the War Dance. He was learned too

in the Night Chant and had authority to sing it but never did so because he had never been able to secure the necessary masks. He knew parts of several other chants as well. tł'ăh of Newcomb knew the Hail and many, perhaps all, branches of the Night Chant, as well as parts of others.

We who work with them never cease to marvel at the knowledge and thoroughness of the medicine-men we know best, but there are others who dare more in the hope of bringing even greater good to their people. They are the ones who reverse the Chant, after all else has failed. For instance, they begin the sandpaintings after sunset, they move anti-sunwise instead of sunwise in their rites, everything is done in the opposite way from that which is customary. This means alliance with the powers of darkness and it can readily be understood why we know almost nothing about it. Franc Newcomb practically stumbled into a rite of this kind once and thus discovered its existence.

The Chanters we worked with are men, but we do not mean to imply that women are barred from religious practise. If they were we might not have been allowed to participate as we have unless some special dispensation had been made. Nowadays women Chanters are few, formerly there were more, but probably never many compared to the number of men who chanted. One who was held in the greatest respect practised the Shooting Chant and died only a few years ago. At the present time Blue Eyes Sister is considered the greatest authority on this chant although she has not sung it for many years, perhaps never did.

The Chapters V–IX, at the same time that they interpret the paintings, will point out the details which must be mastered by the Chanter without fail.

Certain attitudes of the Chanter, the sincerity of his belief and practise, for example, and his willingness to make all kinds of sacrifices for his profession, have already been noted. Others have been repeatedly observed. Of fundamental importance in dogma is the need for the spiritual accord of all things human, natural, and supernatural. Consequently if someone strange or untrusted intrudes upon a ceremony or some part of it the great Chanters may utter a word of protest for the sake of preserving order but none should enter into a heated argument if the intruder persist. That would mean the introduction of a greater disharmony.

I once saw a minor ceremony in which objects like hail were made along with the prayersticks. The chant was performed for the grandchild of a famous and authoritative Chanter who knew that certain details were wrong. Quietly but with considerable persistence, he pointed out the errors. The medicine-man in charge did not concede and finally the Chanter gave up. At intervals during the next two days he made remarks in a somewhat resentful tone about the mistakes. At the time I asked, "But isn't there something you can do adout it?" "Nothing," he answered "except I have made a prayer for correction." With the failure of the boy's cure at any time in the future, this circumstance may be cited as cause for his continued illness.

The Chanter who tried to make the corrections in this case has the gentlest temperament I have ever come in contact with. His argument was to him a statement of fact, not a sop to his own conceit. I discovered that conceit may be more apparent than real once the setting is understood. Miguelito was very active, impulsive and on occasion, even dominating. He had a good opinion of himself. I thought this attitude exaggerated, naïve, and even amusing on two occasions when he said, at a certain point in the ceremony, "I know and perform this more exactly than any other Shooting Chanter. Always when someone else sings it, I note mistakes, and I tell them and they don't like it."

Long after, in working over the myth in detail I found that this speech is ceremonial, an assertion of faith, as it were, in the power of Chanter and Chant. It may even be put into question form and

asked of the One-sung-over, "Do you believe that I know this rite completely and perform it without error?"

What seems to be conceit is, therefore, an attitude demanded by dogma and is manifest even in the Chanter who is modest of his accomplishments but who must, above all things, have faith in his professional ability and training.

A quality which is readily apparent is patience. This is exaggerated in the Chanter, although it is striking in the Navajo population in general. It sometimes happens that the painters who volunteer are not particularly expert. The Chanter does not refuse their aid, he corrects only the form of their work, i. e., design, never does he deplore poor lines or lack of skill at the time the man is working. He corrects errors with unvarying tolerance and only at the dullest stupidities does he make a remark of disgust which is at the same time touched with humor.

The same is true of his teaching. Never in my experience have I met with better teachers than the Navajo medicine-men. They have tolerance for human shortcomings, but none for error, so that they never let a mistake escape. But they make the correction, not as if it were a personal deficiency, but as a matter of objective fact. If a Chanter allows unsteady lines to stand in a particular sandpainting, it is not because he is unaware of the imperfection or because he likes it. It is rather because the painter is useful to him, he is doing his best, his mind should not be distracted at this time. After the Chant is over and when a suitable opportunity presents itself, the Chanter may give a few well-considered words of criticism but not without tangible suggestions for improvement.

In nothing that the Navajo undertake is the question of time important as it is to us. Therefore the Chanter is not annoyed at slowness. Miguelito was swift and efficient about everything he did, but never did he condemn a person because he was deliberate, no matter how long he might take at a task. Accuracy and finish are the ideals and if they can be attained in three days better than in one, by all means take three. If, as often happens in learning a chant, a man attains virtuosity in ten years, we should by no means urge him to try to do so in six or even in eight.

The Chanters are clear in speech, song and thought. Since much of their life is spent in instruction they have developed clarity. They take pride in their language and use conservative forms whereas the young people use elisions, abbreviations and even mispronunciations, often without being aware of the classical forms.

Many of the qualities I mention as outstanding for the Chanter, are characteristic of the Navajo in general but emphasized and cultivated by the Chanter because of the character of his office. Of these resourcefulness is outstanding. In singing a major chant, the Singer must have help of various kinds and he must therefore consign certain tasks to individuals who are not entirely dependable, or who meet obstacles they cannot overcome. For instance, Miguelito once sent a youth for a plant whose habitat he carefully described. The young man did not find the plant, and instead of reporting his failure, went off on a drunk. Miguelito waited for him longer than I should have, then sent once more for the medicine. The second man had to find his horse before he could start but eventually brought the plant. This happened several days before the "sing" started, so it was begun two days later than had first been announced.

Miguelito had intended to make the Chant for Marie absolutely complete, but on the day that the "scare act" was to be put on, he chose to use the most pretentious painting. He had only a few painters, and after much of it was finished, rain drove through the smokehole from the east and the picture had to be repaired. All this took so much time that it was impossible to have a man dressed like a bear come in and scare the patient into a fit. After this act a ceremony of restoration would have been required. Miguelito was forced to omit this part and he did so with regret.

It is considered great good luck if rain comes during a Chant because one of its functions is to bring rain, and even the inconvenience of restoring the painting scarred by the raindrops does not try the workers' patience. However, it does take time and with few workers it may transpire that only with difficulty can the painting be finished before sunset. If the rain continues, a man is sent to the roof to cover the smokehole, the workers inside are handicapped by the lack of light, but even if the Chanter himself has to help, the painting is finished and disposed of in the allotted time.

The successful Chanter may be exposed to the thorns of gossip against which there is only the most difficult defense, if any. With a religious belief like that of the Navajo, this takes the form of a whispering accusation of witchcraft. Power which manifests itself in the accumulation of wealth gives rise to jealousy which may express itself in insinuations not susceptible to proof or disproof. I heard various innuendos made about Miguelito by various Navajo. I was in a position to check them because I knew him well and could get his opinion and observe his behavior. In no case was any insinuation substantiated in the slightest degree.

Upon one occasion he got wind of certain words of gossip which hinted a suggestion that he should never sing again. I was never able to get the details of the accusations in this case but I could see that giving up singing would cause life to be not worth the living to him. He immediately undertook to confront his slanderers personally. Seething with righteous indignation, he sat silent beside me as I drove him from his home at White Sands to Ganado where he had heard the gossiper was at the time. When the latter saw my grandfather come in sight he leaped onto his horse and rode hastily away. Nothing more was heard of this, but I can well imagine that Miguelito "had it out" with his son-in-law who was partly responsible for the spread of the whispering. At any rate Miguelito went on singing even more than usual, showing that his reputation had not been injured for the Navajo may choose their Chanter and the choice is not limited, for this chant at least.

I have no way of knowing how direct other men are. I suspect they differ as greatly as Whites in this respect. I can only say that Miguelito was forthright almost to a fault, that not only did he manifest this quality amongst his own, but even toward me, a member of an alien — and often hated — race; and that although I could always expect his criticism when he found it merited, I could also always count upon his unflinching loyalty in my behalf.

No religion can exist without rationalization and that of the Navajo is no exception. It exists in the myth, the making of a prayer for error is another example, and each Chanter adds his own to the dogmatic rationalizations. In the mythical past it was decreed that the sandpaintings should not be made permanent. Today we not only have many paintings of them in water-color, but some of them were made by the Chanters themselves. Furthermore, some have been woven into tapestries, and again in cases by the Chanters. The breaking of the taboo against permanence has been rationalized. A woman, planning to weave paintings of a given Chant, may obtain immunity against the powers it invokes by becoming the "One-sung-over". A Chanter can extend his prayers against error to include this also.

Most common is a simple device to prevent harm. Believing that completeness and accuracy are the efficacious factors in the painting, many Chanters who paint outside of the decreed limitations change details. It is sufficient to change only one thing in order to maintain the "safety" of the Chanter. Such a change, in destroying the power of the painting, also means that the tapestry even in alien surroundings will not take its power "out of the tribe" and that too is important. Changes made for these reasons may be ascertained by checking with paintings made for the Navajo,

and since the paintings here presented were so made, they have none of these rationalizations. One man may interchange two colors, which in the position used would have no function for the Navajo. Miguelito always used green instead of blue in the water colors he made for Mr. Hubbell and for me. At first I thought it was because he did not have blue, but even after I gave him a good supply he continued to use green. The Navajo distinguish the two colors carefully, so his use of green was really a distinction.

Although the style and symbolism of Navajo Chant, and within it, of the sandpaintings, is fixed, nevertheless individual differences may occur. Sometimes these are regional, again they depend upon the considered opinion of the Chanter or of his teacher. Differences of this sort will be noted in the chapters on Symbolism (V–IX). Since this is the case, the medicine-men have constant discussions about the rightness of this form or that. These arguments may become heated but never are voices raised nor is there intolerance. Each practitioner knows he must give cause for the details he uses, and is prepared to do so. If his explanation is not accepted by them, he may take a long time trying to persuade them. If, at the end, they remain sufficiently unconvinced to continue in their own way, they are likely to yield to the extent of conceding that his way may be all right for him. They will carefully watch his results, however, and the number of successes, as well as the failures, will be remarked and held as evidence for or against his procedure. And even though each one continues in the way to which he is accustomed, it is more than likely that he has learned much by the discussion.

III

Painters and Painting

It is morning of a clear winter day when we come up to a large hogan from which issues an occasional low murmur of conversation. About six feet from the door at the east we note a small mound of sand in which stand sticks with down feathers attached, and other objects which have an air of guardianship. Laid on the mound in exact fashion are two fur collars, one of Beaver, one of Otter; and near them, insignificant in appearance, but mighty in potentiality, is a bullroarer, its string neatly wound about it.

Lifting with an air of caution, the double door curtain of the hogan, a thin frayed cotton blanket over which hangs a worn faded comfort, we enter and stand quietly near the door for a moment while we allow our eyes to adjust from the blinding light of outdoors to this of the interior, dimmed and shaded except for the smokehole.

We are now able to see the Chanter smiling a greeting from his corner at the southwest, and the assistants in their awkward position allowing sand to trickle through their skillful fingers. The Chanter smiles upon us because he knows and expects us. Otherwise we might have been refused admittance or ordered out once we had lifted the curtain, for it might be "dangerous" to witness the laying of a sandpainting if certain requirements had not been met. We are women who should not see the paintings being made unless we have been treated with them. I have undergone two initiatory rites and my friend has earned her privilege to be present by long years of learning and assistance.

The Chanter, who at the moment reclines against his pile of sheepskins smoking, is tall, and though lean has an air of wiriness and strength. The creases about his mouth and eyes have got their shape and depth from years of habitual smiling, and his steel-gray hair also indicates to us some years of life. Casual observers might judge his age at sixty or a little over, but we know he is sixty-nine.

This is the eighth day of the Chant, during which time he has had only brief and readily inter-rupted sleeps, and now as he smokes, he reclines, for he has instructed his painters how to work. His moccasins lie near his feet. His two pairs of trousers, the faded red gingham on top, cling creasingly to his legs bowed by many years of perching in a saddle. The sleeves of the two shirts he wears are ragged, the blue under the white, shorter and more worn than the upper one. His turquoise necklace and ear pendants are of blue incredibly pure and the whiteshell beads are small, smooth and thin, and tinged with only the slightest hint of lavender. These beads are technically in pawn but the trader has lent them to the Singer for this occasion.

Like his moccasins, his bright pink headband, new and tied in a knot, has been laid aside. Feet and head unbound indicate relaxation. He will not need it until the Chant is over, but hanging on a nail above his head is his wide-brimmed black Stetson hat with its braided band once white and its characteristic creases completely consistent with his trousers, sleeves and face.

Two of his assistants are no longer young and their sleeves are also ragged. One wears a velvet shirt, but the lower part of one sleeve hangs loosely, for it has ripped away from the upper part. The younger fellows show greater vanity. Their new overalls are held up by belts with huge conchas.

One wears a new orange-colored shirt with an Irish-green neckerchief, the other a green shirt with cerise scarf. Their four-gallon hats reserve the owner's places at the side of the hogan and defy disturbance or careless handling by their very lack of creasing and the wide beaded bands around the crown.

The hogan is perhaps twenty-five feet in diameter so it has not been necessary to take out the stove (if we may call it that), for there is plenty of room behind it even for the large painting. It is made of a large iron tank in the bottom of which iron bars have been set to serve as a grate some nine inches from the floor. Two long splintery sticks of juniper, door open or shut according to the way it has been left, it matters not, and the fire roars up the short pipe fragrantly disgorging cedar smoke on the desert air. The iron cylinder, red-hot, reflects its heat evenly in every direction. The heat, absorbed by the adobe plaster of the hogan, is more than sufficient even on this day when the temperature is below zero. The patient will appreciate this when, stripped to the skirt, she sits for two hours submitting to the body painting and ritual of the Chanter.

The group of four men, half-reclining at the rear of the hogan, attracts our attention. After removing everything from the hogan except the "stove" and waterpail, they cleared the floor by sweeping and shoveling out an inch or two of the sand which composes it. They then brought in a large quantity of natural-colored sand (tan or pinkish tan) which they spread three or four inches deep over a space at first two or three feet square, but with the possibility of widening it as they should work until the painting would cover almost all of the floorspace behind the stove. The hogan was built large for ceremonial purposes but the family uses it between times and moves out when a ceremony takes place.

This body of background sand had been carefully smoothed with a broad weaving batten and, when we enter, the part of the design already finished includes the centers and the radiating figures of the Blue Corn painting. The painters had provided themselves with sands of seven colors, specially collected and prepared for the occasion (p. 31). From the root of one of the oaks they burned charcoal. One man ground it on a metate and mixed it with white sand to give it body, and thus secured black. To some of the black he added a large quantity of white and obtained "blue". This is really gray, but in the enchanting light of a Navajo hogan appears as powder blue.

Three of the colors were made by grinding rock as it is found naturally. White is from so-called "white rock", red from red ochre, yellow from yellow ochre. These products are plentiful in the Navajo country and require nothing more than collecting and grinding. Our painters know deposits where the colors are pure and the consistency of the rock satisfactory, and they take special pride in obtaining good colors.

Pink, which represents sparkle, was made by mixing red and white. Dark brown is a combination of red and black. Small quantities of these sands in bark, cloth (calico or sacking) or cardboard receptacles stand within easy reach of the painters. Reserve supplies in larger quantities, according to the needs of the particular picture of the day, are ready and lying near the door. In the Shooting Chant pink is used extensively, brown very little, red only for outlining, and the other colors in large quantities and about equally.

When we arrive there are only four painters at work because that is all there is room for at the center of the painting. As they enlarge it by working outward, others join them and sometimes as many as twelve men may assist at a single picture.

A man working at the center assumes a position half-sitting, half-reclining, for he must be careful not to disturb the smooth background and he sometimes reaches a long distance as the painting assumes size. He takes a small amount of sand of the necessary color between his index and

second finger, and guiding it with his thumb as in Figs. 1 and 2 * he drops a narrow or wider line of it where he wishes. The technique is simple indeed, skill is the *sine qua non*. As the design widens he may sit nearly upright, and of course he changes his position somewhat from time to time so as to rest. A man may work for an hour and a half or longer without resting. Then he takes a smoke or grinds more sand in case a color seems to be inadequate.

Fascinated, I watch intently an unusually skilled painter who sometimes draws the lines toward himself, sometimes sprinkles the line away from his body. He holds his hand a few inches from the floor and has no support for his arm. His lines, even when long, are straight and sure. The man next to him, I notice, uses his left hand to steady his wrist and his lines are also good. He must always sit nearly straight for he cannot use his left hand to balance his body, as some do when they reach far.

As he works, the painter completes his portion of the design in all the colors necessary. When he wishes to change the color, for example, to use white after black, he rubs his fingers through a small portion of natural-colored sand to clean them. Thus he keeps his colors clear. He blows the fine dust from each "handful" of sand he picks up so that his lines will be sharp, not blurred by dust.

The painter I am watching, being skilled and experienced, knows the designs he is making. However, if he makes a mistake, he corrects it by covering it with the tan sand, and laying the proper line on top of that. Unless he is the head Chanter, and he does not often help with the painting, the workman need not assume any responsibility for the correctness of the design, for he is instructed by the Chanter who watches the progress of the painting carefully. He and others look it over often, and omissions are filled in and corrections made frequently. When a painter rests, he criticises from the onlooker's point of view, for distance from the work gives him perspective. The painters even accept our carefully considered criticisms.

The paintings are a combination of sand strewing and sculpture combined with some real objects. The center may represent water, in which case a bowl of water is actually sunk in the sand; or the painting may be made around a small fire. Mountains, either at the center (Pls. XII, XIII) or elsewhere (Fig. 3), may be piled up. Sky-reaching-butte at the west of the double painting (Fig. 3) is made of pottery clay, tempered and kneaded into the shape of the frustum of a cone. The medium of our painter allows him to use one color on another, even as he makes corrections, and he sometimes uses as many as six or eight layers of sand. The mythical instruction for one painting runs:

"First there is Fallen-off-mountain, its lower part sprinkled black to represent soot; over this white is sprinkled to represent dawn, over this blue for blue sky, then yellow for evening light, and finally over all this all is black to represent the mountain itself."

We see only the black. Similarly when he strews the body of a person or deity, the painter first makes the body of the proper color and lays over it the clothes and ornamentation.

The painter I am watching is now making the squash vine which divides the north from the west, and he represents the fruit with a smooth mound of sand over which he sprinkles white for the background and black for stripes and border. After finishing the plant he draws a cloud on which he aims to paint one of the Corn Gods. The body is long and straight, so his friend helps him to hold a string along the line he wants to draw. When it is in place as exactly as his eye can judge, he snaps it once and he has a perfectly straight indented line in the background sand as a guide.

He now completes his figure with attention to the requirements. Clouds, roots, body, arms, head and headdress are all drawn according to convention. The painter's imagination is given free rein in depicting the pouches of the gods. They are varied and elaborate and the Chanter does not dictate their form or color.

* For Figs. 1 and 2, see the frontispiece.

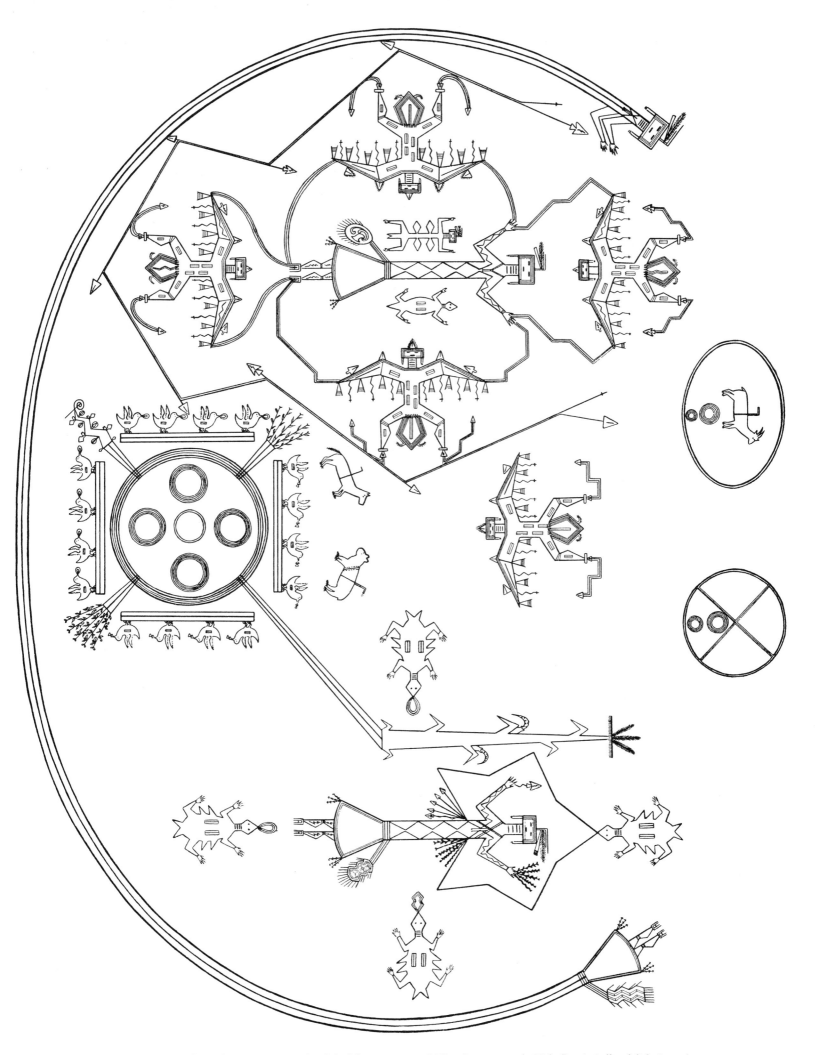

Fig. 3. Double sandpainting, at north, Holy Man in power of Thunders; at south, Holy Boy in belly of fish (p. 39)

As we watch the picture, my friend cannot resist the temptation to help with the painting and she starts making one of the coarser designs. I practise on the sidelines with natural-colored sand. The Hail Chanter who came with us smokes and converses for a time but the sand finally draws him, too, and he helps for a little while.

No one pays any attention to time and no one hurries, but it seems not more than half an hour when the woman who grinds some white rock for the painters remarks, "The sun is at the center", meaning, it is noon. By this time the picture has grown, almost imperceptibly, until it covers a space about eighteen feet wide by fifteen long. The most dexterous of the painters outlines the encircling rainbow guardian; another lays down its arms and head, and still another the legs, skirt and pouch.

Another makes two guardians for the opening at the east. These are not always made, but most of the paintings of the Shooting Chant have them. After the painting seems complete, it is carefully inspected once more by the head Chanter, now alert and fully clothed. When final approval is given, the leftover sands are set aside. For only a few seconds the painting is now complete and it has one element which we do not show in the reproductions. All spaces of the background not having pattern have been filled with wavy black lines. These have no artistic significance, in fact, they detract from the general effect, but from now on the painting is a live thing, possessed of great power and therefore dangerous, and the wavy black lines add power.

Up to now no obvious attention has been paid to time. The Chanter had enough assistants to finish the painting before sunset and they started to work early. But now that it is finished, even though it is early in the afternoon, there is a note, if not exactly of haste, nevertheless of application and bustle, not noticeable before. The painting must be used. It is powerful. The longer it lies the more likely it is that someone may make a mistake in its presence, therefore the Chanter will put all in a position to imbibe its good, he will do all he can to prevent error, which is the same as harm. He brings in the objects of the mound we saw outside the door. They were placed outside to warn spirits and humans alike that sand was being sprinkled in the form of Holy Ones. He sets them up at points about the painting which have been designated in the myth, which he learned along with song and ritual.

He places the pollen ball, a pill-like object nearly two inches in diameter, composed of many kinds of "medicines" mixed with cornmeal and covered with pollen, on the mouth of one of the deities. Hardly noticeable to the audience are the "offerings", one of a small, though handsome, turquoise bead, the other of a short string to which a similar bead and an olivella shell are tied. These, too, the Chanter places on the painting. As he does this someone goes to call the patient and others who wish to see the painting and the treatment with it. It does not take the Chanter long to fix the sacred prayersticks, collars and bull-roarer in their respective places. He then puts dried and fresh herbs into a turtleshell, a glass cup, and an abalone shell and fills them with water. He lays the medicine-sprinkler across the top of the turtleshell.

Just as the patient enters, the Chanter stands in front of the painting, i. e., at the east, and sprinkles white cornmeal over it from east to west, from south to north and around the guardian rainbow. The patient, having approached sunwise around the fire, takes the basket and, following the Chanter's instructions, sprinkles the cornmeal even as he has done.

The patient now takes her place at the north of the painting where her blanket has been neatly spread and on which numerous layers of new cotton cloth have been laid. These represent buckskin and will be taken by the Chanter when the rite is over. The woman is told to undress and she removes all of her jewelry and clothing except her skirt. She is now subjected to the treatment of the last day which takes about an hour and a half.

With the accompaniment of song, led by the Chanter and joined by the chorus of men who beat the time with rattles made of buffalo hide, the patient is painted on chest, back, arms, shoulders, legs and face. The Chanter prepares the body paints after the audience is in the hogan. They also are made of natural pigments, but are of fine texture, i. e., not sandy or granular, and are mixed and applied with water like water-color.

Once more I watch with eager interest, for this is a technique entirely different from the sand-strewing. The paint must adhere smoothly to the skin, the patient must sit very still, the Chanter sings energetically at intervals as he gives the theme of a new group of songs to his chorus. When he gets to the painting of the feet I almost shiver, but the patient sits immoveable even when the Chanter covers her big toenail with paint to represent the head of a snake and also when he carries the paint down the under part of the first joint to designate the tongue. This patient is a Stoic. I have gone through this twice myself and I know it is possible to remain quiet, but it stirs me to see someone else do so. I smile to myself as I recall a boy who could hardly keep from giggling when the Chanter put a design on the sole of his foot, and Chanter and audience laughed with and at him.

Finally the body-painting is finished. The Sun is a small blue circle at the center under the patient's breasts, the Moon round and white at the middle of her back. Lines of yellow, blue, black and white run under the arms and over the shoulders connecting them, there are lightnings on arms and legs, snakes on the feet. I can no longer recognize the features of my friend for her face is covered with broad stripes of the sunhouse colors, yellow, blue, black and white; her eyes look ferocious shining out with a humorous glint from the black paint across them.

The Chanter takes pinches of sand from the feet of the deities in the painting and this includes the "feet" of objects as well as animals and "People", for example, the butt of arrows, the end of rainbows, the base of mountains. He drops this sand into the moccasins of the patient and she puts them on, and her jewelry as well. The Chanter leads her onto the painting where he bids her sit with feet spread out straight before her, facing the east. This part of the ritual consists of many acts, which take altogether not more than fifteen to twenty minutes.

Sand from all the sacred beings of the painting is applied to the patient, part matched to part. That is, sand from feet is pressed to her feet, from arms to her arms, from heads to her head. Ceremonially the pollen ball is put in her mouth and as ceremonially she is given water four times to enable her to swallow it. This represents a boy of agate which the Sun gave to his Twins so they would be invincible and it must "stand straight within" (p. 29). Accordingly, therefore, the Chanter goes through motions with his prayersticks so as to set the ball straight.

He sings over the turquoise offerings, takes one for his own, and ties the one with the olivella shell to the scalplock of the patient. Henceforth she will wear it and it will protect her from danger by arrows, lightning, and snakes, that is, from objects which travel in a zigzag fashion. That is the reason for the "Shooting" Chant.

After all the rites have been performed, she is led outdoors where she breathes in the Sun four times and puts on her clothes which someone has brought her. During this time the assistants gather up the sacred sand into gunnysacks. Four portions are carried out, one being deposited in each cardinal direction at a place carefully stipulated by the head Chanter. Thus is a "thing of beauty made a hope forever".

. .

During this day we have had an exotic experience. We have seen sticks with soft feathers blowing in the wind, worn door curtains, Chanters with ragged clothing, perfect turquoise and whiteshell

beads. Their faces, seamed with years and a rigorous life, have an expression of mystical light and satisfaction. They operate with song, with sand, with earth pigments, with herbs, with prayer. The patient, a middle-aged woman with a firm, close-knit figure, is passive during all of this and seems to be in the pink of health. Why should we call her a "patient"? What does it all mean? Why is all this done?

The Chanter, through his learning, holds the key to our questions. The sticks which guard outside during the strewing, inside during the curing, the collars of Otter and Beaver, the bull-roarer and the medicine-sprinkler, all are part of the gifts given in the past by the Holy Ones to a hero, earthly enough to understand the needs of the Earth People, but also sufficiently holy to handle supernatural power safely and to make it available and useful to Earth People. The "wide boards" with down feathers are Sun, Moon and Lightning emblems, gifts of these deities. The collars are Otter and Beaver who helped the Sacred Twins pass a freezing test given them by the Sun, their father.

The worn blanket and the shabby comfort hanging over the door are curtains of dawn, blue sky, yellow evening light, and darkness. The Chanter, chorus and audience are not People with ragged sleeves, new Stetson hats or brilliant blankets; they represent an assemblage of the gods. In fact, the Chanter for the time being, *is* a god. Frequently he sings:

"Changing Woman's child, I am
"Changing Woman's grandchild I am."

Singing so, and saying so often *makes* him the most powerful of all the War gods, Slayer-of-alien-gods himself. The "one-sung-over" is not only a handsome Navajo woman with a smiling face but rather, as the ministrations of the Chanter progress, one and another of the Holy People. As the Chanter paints her she becomes the Sun, the Moon, and imbibes their powers. When he paints the broad stripes on her face she is with the Sacred Twins in the Sun's House and with them secures the incredible powers he gave them in mythological times.

She is Changing Woman, the Earth Mother, old, decrepit, and feeble, but as the Chanter leads her to four different stations about the painting, she, like Changing Woman, renews her spirit and her youth and finally becomes young and mystically as beautiful as the earth. When she sits on the painting of Corn God she secures its power of fertility; when sand from the back of the Rainbow is applied to her back, her backache will be cured for Rainbow has no pains. When the olivella shell which represents rain, is tied to her hair, she will have rain-giving power and the turquoise which represents her sacrifice to deity will remain hers to remind the arrow, snake and lightning powers that they have made her immune to their darts.

The Chanter gives her the pollen ball and fixes it with song and the pressure of the "wide boards" so it may stand straight within her. He communicates to her these and other powers which are guarded and bestowed by Slayer-of-alien-gods and when she walks out of the ceremonial hogan to breathe the sun, the words sung for her by the Chanter become reality:

"Changing Woman's child I have become
"With him I go
"Being restored to youth according to beauty I walk
"All is in accord again,
"All is in accord again,
"All is in accord again,
"All is in accord again."

IV

Myth of the Male Shooting Chant[1]

I am being instructed
Talking God I am.
From my breast may the pollen of dawn instruct me
From my back may the pollen of yellow evening light instruct me
From the soles of my feet may the pollen of earth's little whirlwind instruct me
From the top of my head with sky, sunray, bluebird pollen being instructed, may I walk.
Earth's little whirlwind pollen will instruct the tip of my tongue
Now restored to youth according to beauty may I be
Being instructed I walk.

I am being instructed
hactc'é'ôɣa·n I am
From my walk may the pollen of yellow evening light instruct me
From my breast may the pollen of dawn instruct me
From the soles of my feet may the pollen of earth's little whirlwind instruct me
From my head with sky, moon, rainbow, yellowbird pollen may I be instructed
With earth's little whirlwind instructing the tip of my tongue, I walk
Restored to youth according to beauty now being instructed, thus I may go

Changing Woman and Salt Woman lived at a place where it was very difficult to get a living. Rattlesnake Man and Bear Man were their doorkeepers. Changing Woman and her companion went daily to gather wild seeds for their food or grass to make sandals and clothes. Not only was food hard to procure, but everywhere there were dangers. There were many monsters so fierce that it was impossible for people to inhabit the earth.

Giant Monster lay at Hot Springs, Burrowing Monster was at the foot of Mt. Taylor; there were a monster called Throwing-off-the-rocks, a Tracking Bear, a Walking Stone, four Roving Antelope, and others, any one of which was too powerful for man. This situation of danger made Changing Woman consider seriously how she might help to rid the world of these monsters and make it habitable. She thought if she had a child he might succeed in the task, but she knew nothing about conception.

After several vain attempts she conceived of the Dripping Water and then was approached by the Sun. "So that simultaneously two were conceived within her womb, one of the Sun and one of the Dripping Water."[2]

[1] Author's Note: In presenting this abstract of the myth I have reduced it to one-seventh of its size. Consequently it has been impossible to reproduce every detail in the original version. The descriptions of sandpaintings are given where their symbolism is discussed and ceremonial details, except for those which have to do the with paintings, have been omitted. I have tried, however, to include sufficient detail to bring out the principles, literary, ritualistic, and artistic, which have been noted in the discussion. G. A. R.

[2] This explanation of the origin of twins is quite consonant with Navajo belief for they think that two men are concerned in procreation if a woman bears twins.

After four days the Sun visited her again and in four days more she was in labor. On the ninth night she woke in pain but until dawn was not delivered. At dawn the sky was dark with clouds. When it was fully light lightning struck in the east, west, south and north and then a child was born. The first was born "somewhat carelessly" and for this reason he has a very powerful name, Slayer-of-alien-gods, for he was born to kill monsters. The second, Child-of-the-water, was born easily to the accompaniment of gentle thunder. So that the children might not be discovered six coverings were made for them, darkness was the one directly over them, then blue sky; next, blue-rising-from-the-east-at-sunset; yellow evening light, mirage, and heat.

Thereafter when Changing Woman and Salt Woman went abroad to gather food, as they had to do frequently, they gave special instructions to the doorkeepers, "Be sure and watch the boys. Don't go to sleep and let danger come in to them."

One time the women were gone four days and when they returned the children were very weak. When Changing Woman asked the reason, Bear Man answered, "They did not eat the soup I made them from the field rats and rabbits you left, so I fed them my own food made of mountain pollen and mountain dew."

"And I," said Rattlesnake Man, "I fed them the pollen of vegetation of all kinds."

The reason the children were so weak was that the food of Rattlesnake and Bear was too powerful for them. Another reason was that Salt Woman used her whole hand to stir the soup and it was therefore too salty. However, the children were able to withstand their dangerous diet and it was constantly made stronger for them. After four days they walked and when they were only twelve days old Talking God visited them, gave them bows and arrows and predicted the future. The arrow which was made for them was to be the symbol of the Shooting Chant (p. 50).

The first inkling the Monster People had of the existence of the Sacred Twins was on the day they were released to the east by Changing Woman. Man-eaters, First Man, First Woman and Coyote who lived at Earth Mesa ate the chiefs of Earth People. Red Crow, Red Buzzard, Red Bluejay and Red Coyote were their messengers and the day the Twins were released to the east Red Crow returned with a warning. Successively the messengers met the Twins and reported back that there was new power abroad.

Big Monster who had got the news from Red Coyote visited Changing Woman and questioned her but she scolded him and drove him out with her poker with which she had stirred the ashes. That night the boys, cosily wrapped in their sky covers began to plot, "Let's ask our mother, 'Who is our father?'" they whispered. "Go to sleep," said their mother knowing their thoughts, "who knows anything about your father?" This continued for three days, curiosity about their father being the only thought in the minds of the children. On the fourth night, however, their mother said, "Far away your father lives. Between here and there every conceivable danger lies. Now go to sleep and think no more of it."

Then they seemed quiet but kept on talking to each other. Secondborn heard something and said, "Older brother, what a nice song our mother is singing!" "You don't hear anything. But who will give me a song?"

Again their mother told them to go to sleep and after being quieted three times, Secondborn realized it was not his mother singing but that the sound was at the doorway. Then he knew that the song was given him by the cover of darkness over them. He "prayed with song" and then both children slept.

At daylight Talking God woke them. They returned his arrow and he dressed Firstborn in white. With white moccasins, white leggings and a white shirt he was attired. Secondborn had the same

clothes of different colors. Then Talking God strung a rainbow on which he put white, black, blue, sparkling (i. e. pink), and yellow medicines and on this they traveled until it dropped to the ground, and they took up the journey on foot.

Soon they came to a dwelling where they found Spider Woman and Mocking Bird Woman living. As soon as anyone entered the house Spider Woman ran out and wove four webs, dark, white, blue and yellow, then returned and questioned them, "Where do you come from, my grandchildren?"

"Somewhere we have a father whom we seek, mother's mother," they said.

She warned them against the insurmountable obstacles they would have to encounter and they told her they were going to visit their father no matter what obstructions were put in their way. So saying they started out, ran into the web Spider Woman had spun, and were thrown back by it. Now they noticed that bones were hanging there, some completely dry, some with flesh still adhering, others so recent that the faces to which they belonged were still smiling. When they realized their danger they blew black, white, blue and yellow flints at the webs. Spider Woman, seeing power greater than hers, begged them to desist but Wind whispered to the boys, "Let them beg until they give you a life feather and a tail feather, then restore their webs."

Thus the Twins secured bows and arrows to be used in the future, mounted a rainbow and traveled on. Not long after the rainbow landed they met their next danger. It was a stream no wider than a man's finger, but when anyone tried to jump across it, it spread and thus overcame him. The Twins subdued it by pretending to jump four times and then remaining on their side, but they could not get across because their rainbow was only a short one. Old-man-measuring-worm had a long one. He took them safely across and they rewarded him with one of Rainboy's songs.

Their rainbow carried them on and landed at a place where two mountains clapped together when anyone tried to pass between them. Once more the Twins pretended to pass through four times but finally, after Wind had advised them, they got through on an arrangement of their bows and arrows which they had set up.

Always traveling the same way they came to another danger, a field of Cutting Reeds. Instead of going into them, the boys pretended to go in and the Reeds had at them with a sizzling sound but the Twins remained at the edge. Then Fire God appeared and tried to dissuade them from trying to go on, but the boys persisted, and he made a fire with his firedrill and burned the reeds making them useful for Earth People, for they now become prayersticks when properly treated.

The next obstruction was a Sliding-sand-dune which buried travelers, for it looked as if they could climb it, but when they were well on their way, it slid over and buried them. The Wind himself carried the boys over this. Now there were only mountain ranges between the children and their father's house, one red, one glittering (pink), one iridescent of abalone, one white of whiteshell and one blue of turquoise. All these were harmless. From the top of the blue mountain they could see a house of four different colors which, because of its beauty, they judged to be the Sun's house. They rested on the turquoise mountain and had a smoke. It was not far from there to the Sun's house and they arrived about noon.

When they attempted to enter they were resisted four times each by the doorkeepers, Wind, Thunder, Rattler and Bear. Their mentor told the boys the names of the guards and as soon as they spoke it, each quieted down and let them pass.

They came into the main room. In the east there was a turquoise trumpet above which twelve rattles hung in a row. In the west these objects were of whiteshell; in the south, of abalone; and in the north, of redstone (Pl. XI). A fat woman, the Sun's wife, sat in the room. As the boys looked

about, staring particularly at the rattles, they started to move, then lightning flashed and the Sun returned. This happens once in a while and if others, such as horned toads, blue lizards, or winds, enter with him, irritating things may occur.[1] Knowing the habits of her husband, the woman hid the boys for she said, "Your father has no pity."

When he entered the Sun looked about, and seeing nothing, asked his wife where the boys were for he said he had seen two objects moving toward his home. Three times he asked and three times she refused to answer. When he asked the fourth time she said angrily, "You always say you visit no one as you travel about, but now here are two who claim to be your children."

The Twins heard this argument as they lay hidden and took out the life feathers Spider Woman had given them. Then the Sun drew them forth from their hiding place and threw the turquoise trumpet at them. This had the power to fold on itself and crush its victim, but it merely touched them and flew back from the life feather. The Sun was surprised, but tried the other trumpets and each sprang out but retired quietly to its place after hitting the life feather.

Next, Sun brought out his Sphinx Worm which disgorged poison. Warned by the Wind, each boy set up his life feather and stood on it. As the Worm advanced the feathers rose and the poison fell wasted, so the Sun tried this only once.

At sunset the Sun took the boys to a white rock which stood up like a tiny island out from the shore, for his house was near the water. Pretending that they needed rest, Sun took all their clothes away and told them to sleep, but he really meant to let them freeze. Just as it was becoming un- bearably cold they heard somebody coming up out of the water. It was Beaver Man who spread his coat under them. He was followed by Otter Woman who covered them with her coat. Both animals warned them against oversleeping in the morning and told them to throw the coats back into the water at predawn. As they slept, the small rock became a mountain, which grew into the clouds but became its usual size after dawn. Beaver and Otter had to wake the boys to get back the coats, but then they slept again covered with deep frost. The Sun woke them roughly and they got up showing no effects of the freezing (p. 64).

Next he ordered them into a sweathouse he had made for them. He had used agate stones which would fly in all directions when water was poured on for steaming. Talking God entered the sweat- house, dug a hole and closed it up with four white shells. Wind warned the boys to go into the hole as soon as they entered. Sun poured water on the hot flint and when the noise ceased and the pieces all settled down, he called to them four times and they did not answer, but when he lifted the curtain they were sitting unharmed.

Now at length Sun recognized them as his own and had blankets of valuable goods spread for them to sit on. Then Sun called in his other children, and using them for models, had his wife mould the Twins in exactly the same way so that "nothing should be lacking to make them look like children of the Sun." At this time Sun decreed that no sweathouse should be used in the Shoot- ing Chant for there would be nothing to restore any harm which might be done.

From this time on Sun spared himself no pains to make his sons invincible, and his wife became jealous of them and advised him angrily to cast them off. Her youngest son had been bitten four days before by a watersnake and was all swollen up. Instead of attending to him, the Sun fed the Twins sacred mush from baskets of precious stones, and after this was over, he apologized for the "bad sense" of his wife in displaying anger, and gave the treatment of his youngest son into the hands of these, his newly-recognized children.

[1] This explains the bad luck which follows an eclipse of the Sun (see p. 56).

They met this last test by curing their brother and once more the Sun scolded his wife and averred, "Truly you are my children. Now you are holy and you will remain holy."

He then began to question them trying to guess what they had come for. He mentioned his most cherished possessions, horses, sheep, the mule which became mirage, precious stones, water of all kinds, mirage which turned into a gray-bellied burro. The Twins acknowledged that all these were desirable and that Earth People would like to have them, but then they requested obsidian armor and lightning arrows so that they could overcome the earth monsters.

At this request the Sun bowed his head in sorrow and after some time looked up with tears in his eyes. "I suppose it can't be helped," he said, "but those are my children just as you are. Nevertheless let it be done."

Then he clothed them in flint armor; moccasins, and shirt of black for Firstborn, of blue for Secondborn, he laid down, and for the older son, a zigzag lightning arrow; for the younger, one of flash lightning (Pl. XIII). Furthermore, bidding them close their eyes, he laid his hand upon the heart of each one and afterward explained, "Now I have placed a man of agate within you. With it you will conquer the most powerful enemies. The song you were fed with is the food of the agate man which I have placed standing inside of you. The mush you ate from the east side of the basket stands inside you as the legs of the man, that from the west is its head, that from the north its left hand; that from the south, its right hand; that from the center, its heart. When I said 'The pollen of Restoration-to-youth-according-to-beauty he eats' I meant his mind would be standing strong within you, and when I said, 'dark clouds, its dew, Restoration-to-youth-according-to-beauty its dew he eats,' I was making his intestines. Nothing is missing, with him invincible as I made him inside you, you too are invulnerable. Although the armor is good, that which is inside you will overcome enemies which now exist, or any future monsters, even those over which the armor has no power."

To their garment he added hats of lightning and placed the lightnings in their hands, then went with them to test them in geography and to help them through their first encounter. They got as far as the middle of the sky and Sun was just beginning to ask them to name different parts of the earth when a black cloud came up out of the south and out of it strong lightning darted. This meant a fight and in it Rain Boy, Rain Girl, Hail Boy and Hail Girl, Water Boy and Girl, and Rainbow Boy and Girl were overcome by the Sun and his helpers. Those killed were restored and the defeated side paid the "wide boards" for the restoration. It is here that the Shooting Chant and the Hail Chant come together for the People concerned agreed that their "medicines" should be the same, e. g., the wide boards, and many of the songs and rites.

After this affair had been settled the Sun quizzed his children about the places of the earth and in every case they answered correctly (see p. 69). Then Sun was satisfied and showed them where to descend and at this point each received one of his names. Firstborn was called With-zigzag-lightning-he-came-down, and his brother, Let-down-on-a-sunbeam. Sun told them to let him take charge of their first slaying for they were to attack Giant Monster first.

Accordingly the flash of lightning with which the boys reached the earth deafened Giant Monster and robbed him of his mind. Instructed by Black and Blue Winds respectively, Firstborn shot at the sole of the monster's foot and Secondborn at his pelvic joint, but Giant Monster said, "What bug is crawling over me?" Then the Winds told the boys to shoot at the shoulderblade and under the occiput, and when they had done so Giant Monster staggered to the east, and earth and sky shook for some time. When all was quiet again he was dead. Then the blood from his mouth began to flow toward the east and that from his veins to the west. There was no grade on either side so

that the two streams of blood were flowing together. Then Dark Wind warned, "Don't let them meet or he will revive." They held their flint-pointed clubs crossed between the two streams until the blood hardened and turned into lava.

The boys took the scalp of Giant Monster home, hung it up outside the house, and told their mother casually, "We have killed Giant Monster." "Hush! Who could do such a dangerous thing!" she warned. Four times they said it and she was so frightened that she ran outside and beheld the scalp. She danced around it four times and came back in and thanked her children.

Soon after, they asked their mother where Burrowing Monster lived. She hushed them up three times and the fourth time told them. In the morning they started to it, but when they saw it, it seemed to face in all directions at once. Before starting out Firstborn had given his brother a prayer-stick on which dry blue paint and specular iron ore had been sprinkled. "This will be a message to you. If ever I am in danger this sparkling prayerstick will turn red. Then you will know I need help and you will come to me."

As Firstborn planned his attack on Burrowing Monster, Gopher warned him against going near it. However when Firstborn persisted, Gopher offered his help, for he could approach easily since he customarily stole the breast fur of the Monster to make his nest. He went off and after quite a long time returned saying, "I have dug a hole right under his heart and a gallery of four tunnels one above the other at the east. Go into the far end of the lowest and shoot at him."

When the hero came to the tunnel he could hear the monster's heart beating. He shot at it with the lightning arrow and the Monster darted to the east. Then from the second burrow he shot again and successively from each. The Monster was wild with pain and began to dig up the burrows but when it got to the fourth collapsed. Gopher was rewarded with the scrotum which was to be his medicine bag. Then Kangaroo Rat came along and was given a part for her medicine bag, and Yellow Rat, a poor wretch, was given another part.

Firstborn cut out the heart for his own trophy but he became so weak from smelling its sweat and steam that he fell over from weakness. Ground Squirrel came up and restored him with herbs and then Gopher and Kangaroo Rat took a little soil from their holes, put it into the moccasins of Firstborn and again he became invincible. Yellow Rat made him able to outrun any monster. Firstborn pulled a hair from the tip of the Monster's tail, one from the middle of the back, one from the small of the back, one from the tip of the nose, and motioning with them toward San Juan Mountain, released them and they became elk. Finally, Ground Squirrel was rewarded by having Firstborn scratch its back with blood of the Monster so its coat became striped and had more style. Firstborn took the heart back home and once more his mother danced around it in gratitude.

Always asking their mother, always being put off three times and satisfied the fourth, the boys sought out and subdued terrible creatures. At one place two bluffs stood up one above the other. At the rim a Monster sat with his legs doubled up, his queue grown into the rock crevice. When people tried to go through the narrow passage he would kick them off to his children below. Fruit of long, round and yellow cacti was placed to entice people. Firstborn, prompted by Dark Wind, attracted the attention of Kicker-off-the-rocks to the cactus, then grabbed him and threw him down where his family devoured him. The whole family was overcome. From parts of the children owls were created; the queue was the trophy.

Before attempting the attack on Throwing-against-the rocks Firstborn dreamed of it and his mother's doorkeepers, Bear and Rattler, sang to counteract the effect of the dream. There was a whole family of Monsters which killed by throwing from one rock ledge to another. When the male monster threw Firstborn down to where the female lay in wait, he protected himself with his flint

club. From there he shot the male and the female and both fell down as prey to their children. Bat Woman helped him down from the ledge in her basket with a slender string and he promised her feathers as reward. After filling her basket he bade her keep it closed until she got home but at a place called Willow Grove, she opened it out of curiosity and all the feathers flew out in the form of birds. He changed the Monster boy into an eagle, and the girl became hoot-owl. As trophies he took two feathers from the exact center of the male Monster's tail, two from the same part of the female and several long down feathers as well.

Firstborn next overcame Tracking Bear. He cut off the nipples which became piñon nuts. One half of the tail parts became a bear and the other half a porcupine. As Bear walked away he said, "It will always be dangerous to eat my flesh. If you have plenty of meat, don't eat it, but if there should be famine, it may be eaten." The slayer took the gall and aorta as trophies.

Near Mt. Taylor Kills-with-the-eye lived. They would stare at people, never winking, and the monster's eye grew into the eye of their victims. When Firstborn saw the eyes growing toward him, he threw salt which Salt Woman had given him, into the fire. That made the killers interrupt their gaze, and he killed them. He threw the children out and they became two kinds of cactus. From the parents he cut the round portions off the toes and fingers, the tips of ears, nose, hair and eyebrows, in fact, everything which was a growing tip, blew them away, and they became antelope.

As Firstborn pursued the Roving Antelope, Coyote offered to help and rounded them up with a torch tied to his tail. The hero killed them, and with a hair plucked from the tip of the tail of male and female, and one from the heart, tip of ears, and nose he created deer for Earth People, and had them scatter widely over the Navajo country.

With the aid of Coyote he overcame Walking Rock which killed by cutting. With his flint club he broke it into four pieces which he again crushed into small bits. The bone of the monster became white rock; the flesh, blue ground rock; the hair and body, black ground stone; the blood, red ground rock; the intestines, yellow ground rock. (These are the sands used for sandpaintings [p. 19]). All the moisture of its body turned into natural water supplies oozing from rocks, some good, some bad.

"Now this was the end of the monsters. From the time the killing began until the last killing, it was said, 'From now on you will be useful.' That is why people use the things overcome. Nevertheless even those things ordained for good sometimes become harmful, so people fall off precipices, or hurt themselves by carrying loads too heavy for them. That is the way things are."

Even though there were no more fierce monsters there were certain annoyances which Firstborn thought he might overcome. Certain Gray Ones were gambling for Night and Day, the gambling being "fixed" by tricks of various participants, among them Bat and Owl. When it was time for Dawn which was long delayed, Firstborn had Magpie call the dawn, then appearing in his flint garb, he frightened the people so they scattered in all directions and became mountain people, badgers, prairie dogs, and the like. Bear had overslept and when he woke he was so flustered that he got his moccasins reversed, and he has worn them that way ever since. A very strong wind blowing for four days made the mountains as they are today, some jagged with gaps, some with hills between, others only small hills.

By this time Firstborn wandered about with nothing much to do. One day in his travels he found Hunger, Craving-for-meat, Poverty, Sleep, Desire and Want. He did not like their looks for they were filthy and sordid. Every time Firstborn attempted to raise his club Sleep brought his finger down over the hero's face and rendered him helpless. When he awoke he found himself as disgusting in appearance as they were. Then Sleep told him to ask his mother about them and she explained:

"My baby! Those you subdued were great ones. You killed them because your father approved, but these are not definitely bad although they are not entirely good either. They meet somewhere between that which causes satisfaction and that which causes pain."

Now she instructed him further, "There is one thing you should prepare for. I continue the same as you see me, but since you have destroyed the man-eaters, those who are to be born will survive. I cannot remain here to be tramped on." She referred to the new homes Sun was making for Changing Woman and her sons. From now on Firstborn whose name had become Slayer-of-alien-gods, obeyed his mother's instructions. He went to the house his father had made for him (see p. 48).

The next day Changing Woman said to her doorkeepers, "Follow your grandchild, take care of him," and Bear and Rattlesnake went to guard the canyon where Slayer-of-alien-gods dwelt. Changing Woman said, "I'll not be staying here either." With her Salt Woman and Child-of-the-water, her second twin, remained. When she asked him where he wanted to dwell he said, "I want to be with my brother." "Why did you not say so when your brother started off? Had you spoken you could have gone in the cloud with him and your father. Then it would not have been necessary to start something else."

Then she suggested the lowest of the covers in which the children had been wrapped. "Why not go in darkness?" she asked. Usually darkness follows sunset, but this time Darkness came when it was still daylight and to him the mother spoke, "In future take care of your grandchild, Darkness." Then although they were not present she spoke also to Moon, Dawn and Sun. Now when Child-of-the-water had gone in Darkness, her seeming petulance dissolved in tears, for she had sent the others hastily, but for her younger twin she wept, and as she cried she sang a song of protection for him. Salt Woman, frightened at her tears, sang a song also.

When Slayer-of-alien-gods met his brother he wept for joy and he bade him live with him but told him not to originate anything, simply follow the orders of his older brother. For this reason at the close of the Night Chant we may see them in the red of the sunset, meeting the darkness in which the younger traveled to his brother.

The day after they were reunited they heard noises at the upper end of San Juan Mountain, and also saw two people walking in a cloud. They went to investigate and met Holy Man, Holy Woman, Holy Boy and Holy Girl. They had a long talk during which many questions were asked and the Holy People, who had always been holy in comparison with the boys only recently become holy, undertook to instruct and guide them. The Holy People told of a council of Holy Ones to take place in the home of the Water Monsters and they all decided to go there instead of one group visiting the home of the other as had been intended when they started out.

Holy Man found out that he was the same as Slayer-of-alien-gods in name, in smoking power, and in every other way, and that Holy Boy was like Child-of-the-water. Then the Twins asked their counterparts to visit Changing Woman since she had forbidden them to return. They went and Changing Woman accepted them lovingly. They returned to Trembling Mountain, their home, and Big Fly brought news of the council meeting. All the Holy Ones, and in addition the Quadrupeds, Flying Ones, Clouds, Earth and Sky People, Nature People, Heat People of all kinds, absolutely all varieties were present, and when all had gathered, Slayer-of-alien-gods in all his splendor walked in.

Mr. Water Ox was chairman of the meeting and after chiding them for lack of ideas about bettering the world, and praising Slayer-of-alien-gods, he told them they had gathered to consider which chant should be first. Then some spoke for the Night Chant, others for many others of the

chants, but Coyote said, "Why, it was decided at Whirling Mountain that the Shooting Chant should be first," and they agreed with him. When various ones volunteered to "stand for it" their offers were refused but the Holy People were chosen. They were told that some sacrifice, even though it be small, must be made as a reward for help and that the sponsors accordingly must give aid.

To each person some function was given: songs, curing, restoration-to-youth, charge of the waters, and many others. Finally all went home satisfied.

The night after this Slayer-of-alien-gods was disturbed by small flashes of lightning and at dawn went to a place called Earth-caved-in. He cut off a piece of wood and made a bull-roarer on which he drew the figure of a man. At this time his brother noticed that the sparkling prayerstick had turned red, and he trailed his brother. He found him destroyed by lightning, with the bull-roarer lying beyond him. With the aid of Big Fly and a large group of Holy People, Slayer-of-alien-gods was restored and told to make a bullroarer without a figure. They made the cord of zigzag and straight lightnings, of sunbeam and rainbow, but they told him not to imitate this but rather to make the string of unwounded buckskin or the skin of mountain sheep.

Now Big Fly told him he had been delegated by the Council to protect the Sun's child and told him he must never go without Big Fly's permission. However, instead of getting Big Fly's consent, he insisted on going everywhere that Big Fly forbade, but the guardian went with him.

They came to the home of the Rattler People where Slayer-of-alien-gods overcame Rattler with his tobacco and restored him, receiving as reward a black bow and two tail-feathered arrows, a bow of mountain ash and two yellow-tail-feathered arrows, an abalone cup, and Rattler's skin. He gave the skin to Blue Lizard who said he would bring rheumatic diseases. Rabbit also declared he would bring pains in the back and nosebleed because he could be eaten.

Here sandpaintings were opened up for him and he learned that of Fig. 6 and the curing which goes with it (see p. 52). Then he was sent to Mountain-fallen-away and learned the painting of the same name. Then he was told to go to Striped Mountain where the Arrowsnake People lived with the Rainbow People and here again he learned a painting (Pl. VII ; p. 72). Thence he went to Coiled Mountain where he learned two paintings (Pls. XII, XIII). All these he had learned in one day and he went back and reported all he had learned to his brother.

His brother told him that word had come asking him over to Hanging Cloud. The next day both went over there to find four persons, two their own counterparts and two unknown ones, Changing Grandchild and Reared-within-the-earth. To them Slayer-of-alien-gods spoke, "Four days ago our father came to me and requested us to persuade Changing Woman to move to the new home he has made for her. Now even she decreed that all should move, yet she remains in her old sordid surroundings. I told him I might become angry at her unreasonableness if I went. So I sent First Man and First Woman but they failed too. Now you who are of gentle speech, won't you go and see what you can do?"

These four went and summing up the whole history of the case easily persuaded Salt Woman to move to the place made for her, but Changing Woman again refused. Coaxing further they described the new home:

"Look! This home in the west is fixed up much better than your home here. The east side is turquoise; the west, whiteshell; the south, abalone; and the north, redstone. The floor is of jet. No home can compare with it. The home of your life-mate (Whiteshell Woman) is its exact counterpart. In the east is a turquoise horse; in the west, one of whiteshell; in the south, one of abalone; and in the north, a horse of redstone.

"In the center of the dwelling is a perfect cornstalk with twelve ears on each side. At its root a horse of jet was placed dark for you."

Then Reared-within-the-earth spoke up, "Yes, it is true, mother. It is very nicely fixed up for you. At the east on top of this turquoise house there is a turquoise rattle which is constantly in motion; at the west is a whiteshell rattle, at the south, one of abalone; and at the north, there is one of redstone. In the center of the room grows a perfect stalk of corn and on its tip a beautiful black songbird sits. Even your food is all ready: turquoise pollen, whiteshell pollen, abalone pollen, redshell pollen, jet pollen. This is to be your food in future and it is all ready for you. You will eat with different kinds of water and with Little Water. With Old-age-restored-in-beauty you will become young again."

But, since even then, as she was determined to stay in her squalid surroundings, the counterpart of Slayer-of-alien-gods spoke to her angrily, "You certainly have little sense. What do you mean? Over there whatever you say will be done. All you need do is to speak and from the tip of your speech rain will start to fall and the tip of your speech will see beautiful flowers blooming everywhere". Thus he spoke disrespectfully to her.

No inducement which they mentioned could budge her and they returned to Hanging Cloud to report their failure. Slayer-of-alien-gods next sent Talking God and his companion, hactcé'-ôɣa·n, the Rainbow People, and the Sunray People. They too failed, and then the War God thought of a Shooting God and asked him to try. Now there was a company of five gods dressed in flint, Slayer-of-alien-gods, Child-of-the-water, Changing Grandchild, Reared-within-the-earth and this famous Shooting God, all dressed fearsomely and handsomely in flint. They attacked Changing Woman with relentless words and threats of extermination (Pls. XVI, XVII; Fig. 4, p. 35). They now succeeded, and Changing Woman was moved to a place near Canyon de Chelley. Her guards and messengers were appointed and to her final plaintive objection, "I'll be lonesome there where you are sending me," they replied, "All the Holy People will meet at your place: Sun, Darkness, Dawn, Yellow-evening-light, Blue-rising-from-the-east-at-sunset, often they will come and you will have plenty of visitors." When the appointed day arrived all moved to their new homes where they still live, and "that difficulty was removed" (p. 48).

Now Slayer-of-alien-gods in the form of Holy Man heard of a forbidden place and sought it out. He found a flat country in the center of which a large object with a wheel was whirling. As it revolved it blew water three miles in every direction. Its force was so strong that it first laid prostrate, then killed, anyone who came within its range. Holy Man walked around it, and as he considered, someone said to him, "Hello! My daughter's child, Earth People do not come here because of that Whirling-tail-feather which is too dangerous for them."

"Nevertheless I want to reach it," answered Holy Man.

Four times the person, who was Mr. Turtledove, tried to dissuade him and, when the fourth time he persisted, the stranger became his helper and said, "I sometimes go there to drink." There was a spring in the center of the wheel. Turtledove deceived the wheel, telling it that there was no one around, and it stopped whirling. Then Holy Man laid the dark bow from the east to the center, the tail-feathered arrow from the west, the bow of mountain ash from the south and the yellow tail-feathered arrow from the north. He was then able to go in and he found a person just like himself there.

The whirling object was about the size of the rear wheel of a wagon. It had a mouth and eyes; across its chin was a yellow streak and across its forehead a white one. Toward the east twelve white tail feathers spread like a fan, toward the west twelve down feathers spread blue, to the south twelve

34

Fig. 4. Flint-armored gods with brown bandoliers. Female Shooting Chant (p. 49)

black tail feathers, and at the north, twelve red tail feathers. Mr. Turtledove explained, "This is harmful for it makes the heart sink, the head spin, and the ear curtained (deaf)."

The owner of the Whirling-tail-feather then gave Holy Man the picture:

At the east, above the tail feather, lies a tail-feathered arrow; in the west, above the blue feathers, a cane arrow lies; at the south, in the same position a yellow tail-feathered arrow lies; and at the north, above the red tail feathers of the center, an arrow with feather of yellow-hammer tail lies.

Above the arrow at the east stands Holy Man with white shoes with white border. His skirt is white, he himself stands dark. At the south there is another figure just like it only younger (Holy Boy). The object between them is exactly like the wheel. In the center it is white and it has eyes and a mouth and is surrounded with tail feathers. Holy Man touches it with the dark bow held horizontally. In the other hand he holds a dark rattle. His face is brown and his ear ornaments are of turquoise, his head feather is white.

At the west stands Holy Woman with a dress of many colors. She holds a yellow whirling-tail-feather at the tip of her outstretched yellow bow which has a white border. Holy Boy stands at the

south. He is just like Holy Man except that his whirling feather is blue. At the north, Holy Girl, just like Holy Woman, but with a dark whirling-tail-feather stands.

The border of the picture is a rainbow with white skirt, white legs and black-bordered shoes. Its face is brown. Its arms are white and project from the figure to one side. Blue hawk feathers and yellow-hammer feathers (red) stand out on it. The doorkeeper is Big Fly. He is black with a white border and blue neck, brown face, and faces away from the south. At the north Cornbug guards, blue with a white border. Thus, he who was called One-who-turns-the-tail-feathers gave the wheel which was called Whirling-tail-feather to Holy Man for him to take for use by the Earth People (Pl. XXXIV, p. 87).

When he returned home his brother had another invitation to visit Hanging Cloud and the next day they went. They had been summoned for further instructions. This time they were directed to go with two women to a place called Dawn Mountain and, because they were traveling with women, to travel on a rainbow hidden in dark fog so none of the Holy People should see them.

At every place where Holy People lived, they learned the place-names and songs even as they learned the sandpaintings. They left the women at Dawn Mountain where they were to be made holy and without them went on to Sun's house. During this visit the Sun gave them the arrows of precious stones (Pls. X, XI, XXXV, p. 50) and others of reed. The Twins asked for the turquoise rattle but their father refused, giving them only its name and a description of the buffalo hide rattle used for the Shooting Chant. Furthermore, Sun gave instructions for the body painting and after he had finished, Rainboy, who was very handsome, came in to show exactly how the painting was to be done. They were told how to restore a person who faints, by stepping over him ceremonially.

Then Sun explained the sandpaintings of the Arrow People (Pl. XXXV) to the Twins in the Sun's house, and sent them back to Dawn Mountain to join the women. There they learned the Dawn (Sky) painting and that of Earth and Sky, picked up the women and returned to Trembling Mountain. There as they were reporting all they had learned and especially at the description of the Sun's House, Holy Girl had a fit, and thus fits and spells originated. Then by stepping and pressing the Twins restored her as their father had shown them. She was now strong enough to hear the description of the Earth and Sky painting (Fig. 5 p. 37) and of the Dawn (Pl. XVIII, p. 58).

Four days later they went to Hanging Cloud again and saw the Flint painting (Pls. XVI, XVII, p. 47). Changing Woman came over for this too. When all this was finished they were told to go to the west in two days.

Two days later the four (the Twins and the two women) started west in Mirage to make them invisible. Their one-day journey brought them to the edge of a body of water where they met twelve scouts of Changing Woman. Over a straight rainbow bridge they conducted the party past the guards, up through the water to the room where Changing Woman sat. Four tracks like those of a human being led to the door where a turquoise ladder stood. These were succeeded by white-shell footprints, ladder and door, four of abalone and finally four of jet. When they had gone through the black door they saw her.

This happened in the autumn when Changing Woman is old and just squats. It was dark with fog as when there is no moon. Here there is a description of two paintings in Roman Hubbell's collection (see p. 60). The Dark Sky Man, holding a turquoise cane, went to Changing Woman. Both taking hold of it, he led her through the turquoise door at the east and returned with her, a very old woman indeed. The Water Woman handed her a whiteshell cane, and after going through the whiteshell door at the west, Changing Woman returned looking middle-aged. Returning from

Fig. 5. Earth and Sky. Used in various other chants as well as in the Male Shooting Chant
(p. 55)

the south after being led by an abalone cane, she was a young woman, and when the Summer People gave her a redstone cane, she went through the redstone *(sic!)* door of the north, and returned a young girl. She was attired in perfect garments of whiteshell, and in this ceremonial attire decreed her gifts to Earth People declaring,

"Now the Sky People with the dark cloud will be your helpers, also the Water People with male rain and female rain, likewise the Sun People with vegetation pollen, and the Summer People with vegetation dew. With these your lands will thrive"

"The Earth, Sky, Female Mountain and Female Water will do for you what you ask them. I, for my part, with vari-colored stones, horses, sheep and goods will help you. This is not the only place you can get rain. There is some at the Place-of-emergence, some in the Sun's House, some at the Separating-of-the-waters, some at White Water, and at Round Lake. These also you may ask. As for me, there is no meanness left in me now because I am here. But those two who went east (First Man and First Woman), they alone are mean, who knows how mean. Therefore if ever an epidemic or colds or coughs should start from them an offering of white corn should be made in the morning, at noon pollen should be sprinkled and at evening an offering of yellow cornmeal. By doing this harm will pass. Thus it happened."

The assistants of Changing Woman gave the talking prayersticks to the Holy People and then guided them out through the water to their own element. When they started back the fog lifted. They came to the rim of a canyon, saw a round hogan, and went over to it. It was the home of the Quivers in which the skins of many kinds of animals were spread, but where no one seemed to be at home, although there were tracks of adults and children in the house.

So they just sat down and looked around. At the east and west hung panther quivers; at the south and north, quivers of otter skin. Soon a sound came from the quiver at the east, and a handsome young man stepped out of it. With a noise from the south a beautiful young woman stepped out of the otter quiver, and similarly a man from the west, and a woman from the north. Then many others, old men, old women, and children, all sizes and ages, came out of the quivers, and while this was going on nothing was said.

Then the first man who had come from the panther quiver at the west asked, "Why does no one speak?" and the first one which had appeared in the east spoke up, "Yes, explain it. That's what happens when no one is watching the place. Kill them now! Who knows who they may be?"

It turned out that these were dangerous Arrow People and the Holy Ones were saved from them by the talking prayersticks, and acquired their painting (Pl. XXXV; p. 50). Coyote helped them overcome their injuries after this encounter by means of a number of songs which he gave them.

The Twins visited a number of places in rapid succession (details doubtless omitted from this myth), at the last of which they witnessed the last night of the Corral branch of the Chant. For restoring some children they secured as a reward the board called With-it-it-stands-in-water. This board is now set up with the wide boards of the Shooting Chant, but it used to belong to the Corral Chant. Instructions were given them about the position of the twenty-two objects belonging to the bundle when a sandpainting is made (p. 11).

The heroes next started off to a place where the Hail Chant was being sung. When it was time to moisten the basket which was to be turned over for a drum, Slayer-of-alien-gods (in the form of Holy Man) took it out and when he came to the water hole he was pulled in by the Water Ox People who lived there. The people postponed the singing waiting for his return. The next morning they saw a large black lake on which ducks swam, and where formerly there had been only a water hole, the basket Holy Man had carried was twirling in a sunwise direction.

The Holy People went on without Holy Man and came to a large crowd of jolly folk attending a Night Chant. Here they told their troubles and Talking God said that as long as they had offerings they should enjoy the sing until morning when something could be done. The next day a party of masked gods and others went forth. Talking God led, then came hactc'é'ôɣa·n, Slayer-of-alien-gods, Child-of-the-water, Hunchback God and last, Holy Boy. With difficulty, overcome by the bravado of Hunchback God, they entered the water and found a room full of people.

The trouble was that Holy Man, going on a small errand, had not taken his talking prayerstick, but when it was brought in by the delegation of gods, Water Ox Man was intimidated. The result was that Slayer-of-alien-gods secured for Earth People the rite for people injured by water, including the offerings, prayer of the Popping Water, and the songs.

When they returned to the women from there, they all set out together again. They heard a song in front of them but had a hard time finding the kernel of corn which was so old its hull was cracked. It was singing because of its great thirst. With a prayer the Holy People brought rain and the place is now noted for good crops.

They had meant to go right home but were distracted by a cloud to which they went. They found Corn People living with Mirage, Talking God, Heat and hactc'é'ôɣa·n. Over them a cloud

always hung, keeping them moist with a gentle rain. Here they saw the Corn sandpainting which they took up and removed as it was, to the home of Changing Woman (p. 72).

During the next three days nothing happened and Slayer-of-alien-gods became impatient. His brother mentioned another forbidden place and they went deer-hunting in that direction. They secured a deer and made the first stalking outfit. With it they were able to kill three more deer. Now Holy Man went to a black mountain to see what had been forbidden and his brother went to Hot Springs in the opposite direction.

The Thunders had made a sandpainting which they wanted Earth People to know, so they set out Mountain Sheep to entice the older Twin and at Hot Springs they put a cornstalk so the other might be swallowed by a fish. The "double painting" (Fig. 3, p. 21) shows all of this in two scenes.

Now there were two sets of Thunders, the so-called "real Thunder People" to which belong Left, White and Spotted Thunders and Left and Spotted Winds. Those which come down among us in summer are Earth People and these are the ones who took Holy Man and the real ones did not know about it. When they found it out they made the ordinary Thunders promise to turn him over after they were finished teaching him. The ordinary Thunders showed him their homes and gave him the pictures which would restore persons injured by lightning (Pls. XXIX–XXXIII).

When Slayer-of-alien-gods (Holy Man) was returned by the Thunders he found out that his brother was missing. Then Duck, Wolf, Yellow Thunder, and Bear all searched for him in vain, but Big Fly suggested the cornstalk trap at Hot Springs and a party went into the waters by way of the cornstalk and helped Child-of-the-water (Holy Boy) to free himself from the fish. By this adventure the double painting with thirty songs and all the prayersticks was obtained.

For three days the brothers stayed together and did nothing and on the fourth night Slayer-of-alien-gods (Holy Man) dreamed that he killed four deer at San Francisco Mountain. He started out on a rainbow but for some time found nothing. At last, however, he found two men and two women, all handsome-looking people. After they had exchanged their names and told where their homes were they ate and while eating, laid aside their traveling clothes so they looked like Buffalo. When Holy Man, prompted by Big Fly, started a song, they donned their clothes and started off. They passed many places and camped one night before they reached the homes of the Buffalo. There four mountain ranges were pointed out as forbidden because they were ranges of the buffalo.

Now Holy Man took pride in going to taboo spots for he reasoned that he always came back restored and richer in lore for Earth People. He came to the summit of the white eastern mountain where white medicines in the shape of people lived. On three following days he visited the homes of Yellow Medicine People in the west, Blue Medicine People at the south, and vari-colored Medicine People at the north. Because of his trespassing the people he was staying with were attacked and many were killed. When the few survivors begged him to help them he began the slaughter and left a trail of death in each direction. As a reward for restoring the Buffalo he received an arrow "feathered with the hand," the medicines, and the sandpaintings of the Medicine People, the mountain ranges and the white Buffalo (Pls. XXIII, XXV, XXVII).

After all were restored the People who had brought Holy Man were on the way to return him when suddenly they were able to proceed no further although they were not at all tired. Holy Man being importuned, went to the home of Spotted Wind where he secured four hoops each tied with four life feathers. With these he restored their strength and they were able to travel on. When they got to the mountain range beyond San Juan they had to stop because a woman gave birth to Holy

Man's Child. It had a human head and the body of a buffalo (Pl. XXVIII). After due consideration the Buffalo decided to keep it and by stepping over it, made it all buffalo. However, it was decreed that the painting should be made the way the child was born. The Buffalo returned home and so did Holy Man.

The night after he returned Holy Man began to wonder what had happened to the Earth People who were said to have gone to the north, and he bade the people be ready with the talking prayer-sticks to start in four days. They came to the home of the Translucent Rock People who invited them to stay for the last night of the Blessing Branch of the Shooting Chant. They stayed and learned all of the songs of the most important night.

The next day two of these people accompanied Holy Man and Holy Boy on their quest and after two days' travel, they came to a large aggregration of hogans. They were asked in at night and, although no one saw their faces, the people there could smell that strangers were present. Then they had Holy Man tell about all his adventures from the very beginning and all this, together with the names of the places and all the boys had learned, took four nights to tell. During this time Crystal Boy who was one of the Translucent Rock People, committed adultery with the wife of the highest chief of the people they were visiting and he sent them away with a curse.

The first night they camped a black and white dog overtook them but did not harm them, nor did any harm come on the next night and the two Crystal People left them. Two nights more they were safe, and camped early in the afternoon of the following day. Holy Man went out from the camp on a reconnaissance trip and was attacked and torn up by two dogs and eight bears. The people camped without him but the ants worked on him all night and in the morning Sun, Moon and Wind People came to their aid and he was completely restored. (This is a part of the now extinct Ant Chant). His companions went off without him but made no progress for four days and after that, refused to let him join the camp for three nights but the fourth night he was completely well. This adventure had given him the one-day chant for restoration.

It was the custom of Holy Man to kill a deer every day but during his absence nothing had been killed and the food supply was low. He went out hunting and came to a hogan in which sat Porcupine, a little old man. "My!" he thought, "he has very small eyes." "So I have," said the old man, answering his thoughts. "His skin is rough," thought Holy Man. "My skin is very rough," answered the old man. Then he took Holy Man down a ravine where a young spruce and a piñon grew from the same root and told him not to look. The inner bark of the tree became jerky and the pitch, fat, and Holy Man had a good meal and left. He joined his people and stayed only two nights when he started off again without telling them where he was going.

He came to the home of White Weasel who, with a curse, shot him in the heart with a turquoise arrow, then from the other side with an abalone arrow, then drew each arrow through to the opposite side and drove him out. Holy Man walked a short distance, piled some earth together about the size of an anthill on which he let some of the blood flow from his mouth as he sang a song. At a real anthill not far distant he lost more blood and again at a hill of black ants, and at length he got to the water where he tried to wet his blood-dried lips.

As he sat beside the water and started a song he called the slim dragonflies by name for they were attracted by the smell of blood. Now although he had told no one where he was going, by this time his brother overtook him, but since he had not entered White Weasel's home he had not been shot. He carried his brother to some Cactus People, who in the form of Holy Man, Holy Woman, Holy Boy and Holy Girl were sitting there. They restored him so he was able to walk alone. Then those who pull out arrows, cane, flint and hoops helped as did Crystal Woman. They met the Holy

People belonging to the Female Shooting Chant and they agreed that the contents of the medicine bundles should be exactly the same for the Male and the Female Chant, but that one more thing had to be done.

From the time he was shot until his full recovery there were thirty-four songs called Songs of the Winding Journey or Trail Songs. After this Holy Man wanted to find the "one thing more" which was mentioned and went on a long journey spending a night on the summit on twelve mountains and when questioned by his brother said he "found all holy and beautiful." That is the end of the legend.

V

Symbolic Elements: People

Since the whole complex to which the sandpaintings belong is symbolic, it is impossible to discuss any part of the design without its attendant symbolism. In fact, the very names of the design elements indicate their meaning and they will be used as they are found in those parts of the text which describe the paintings. There is symbolism of elements, symbolism of the color in which they are depicted, of number, and also symbolism of the whole composition. Certain general characteristics of the elements may be pointed out before taking them up in particular.

Although effects differ greatly as one views different pictures, it is nevertheless at once obvious that they are made up of a limited number of elements which are repeated again and again, often with slight and subtle changes of composition which secure unusual effects through combination and recombination. There are two common methods of arrangements, although these are not the only ones. One uses a row of long figures side by side from south to north with an encircling element around the three sides, open at the east where generally two elements (animals or objects) "guard the opening". The opening is to the east or northeast if the picture is encircled. A second arrangement has a center which represents the geographical setting (mountain, lake, water, home) of the picture, for location is as important an element of Chant, picture, prayer, and myth as are the prayersticks, songs or bundle. Around the center which has numerous possibilities for variation, figures may be arranged in the form of a Greek cross, and if the picture is more elaborate, other elements may be placed in the form of a St. Andrew's cross. Both of these types may have the encircling element and the two guardians at the east. In describing the elements I shall refer to their position in the picture in this way. All plates except II, XII, XV, and XX are arranged like maps with the east at the right.

There are elements which look like human beings, although these figures are rigidly stylized. There are also animals — snakes, birds, buffalo, beaver, otter, bat, insects, fish — as well as plants — corn, bean, squash, tobacco and various "medicines", by which term herbs are meant. And further, there are objects — bow, arrow, cane, pouch, rattle, mask, basket, pottery, feather, knife, quiver — and there are natural phenomena — sun, moon, sky, earth, stars, dawn, evening light, winds, clouds, thunder, zigzag, forked, and flash lightning; rainbow, sundog, sunbeam, sunray. Some of the objects, and especially the representations of natural phenomena, are so highly conventionalized that they could not be recognized by anyone who had no guide from the Navajo. Regardless of our own classifications for these elements, they must all be considered as animate at least potentially, even though we unconsciously classify as animate or inanimate when we say "humans" and "objects".

All of these things may be depicted as the Navajo conception of what it is, and again as the "such-and-such-People". There are Arrows and Arrow People, Snakes and Snake People, Buffalo and Buffalo People. Each object, plant or animal has characteristic features so it can be identified at once by anyone knowing the symbolism, but these features may be embodied in the "People", i. e., figures with legs, clothes, arms, faces, often streaked, and holding some object or other in their hands. This can be done for snakes and buffalo, for sky and clouds just as well as for the Sacred Twins or the Holy People.

The encircling border may be rainbow or mirage garland, in which case it does not have feet, arms, or head, but it may be Rainbow Woman or Mirage God, in which case the emblems of personification are present.

Usually insects or objects and not "people" are used as guardians of the east, but Cornbug Girl and Pollen Boy seem anthropomorphic. The former may, however, be considered as an insect. This is an example which shows that there is considerable overlapping since the Navajo classification is not as rigid as ours. I shall have to differentiate the patterns for the sake of discussion but we must not forget that this is a mere convenience for white people, never the way the Navajo consider the matter. With these preliminary general remarks we shall now consider the design elements in detail.

Whenever reference is made to the "People" of a group of animals or objects, any one of them is thought of as possessing all the attributes of the animal or object it represents and at the same time as enjoying human and superhuman powers. Certain symbols depict "People". We shall describe them here and later, when explaining the characterizing features of a particular kind of People, we shall need only to point out those details.

"People" have long, often rectangular bodies which may be marked specially to designate the kind of garments, which means also the powers of those people. There is a skirt which has certain variations; feet and legs are represented by a few straight lines, as are arms, neck and face. Although strictly stylized, the resulting figure is nevertheless realistic. Navajo ceremonial regulations demand a working from foot to head or from butt to tip, and in accordance with this order I shall proceed with the description from feet to head.

Feet are described in only two ways, white bordered with black, and black bordered with white. Actually all are black bordered with white and all have a small red mark in the center.

Legs are of the same color as the body of the figure; the calf is indicated by an obtuse angle at one side, the knee-joint is of red-blue stripes. The angle serves to indicate the back of the figure, and it is complemented by the position of the pouch and the head feather, these being on the same side as the calf of the leg, all three indicating that the figure faces or moves in the direction opposite the side on which they are placed. The head parts are in full face position.

Skirts are always white but they may have different borders; red and blue[1] is a common combination but more colors may be used. They have two curved patterns, most often of red and blue from bottom to top. These dotted patterns represent vegetation of all kinds.

Sometimes the skirts have triangular patterns in black, or cloud designs in blue. The black are said by some to be decorations such as the Hopi embroider on their kilts, by others, they are said to indicate that the patient has been in danger. A cross of blue or yellow is sometimes used on the skirt. This indicates pollen sprinkling and therefore, prayer.

The skirt tassels are of three kinds. Red and white tassels represent twisted fringe and are purely decorative, as are the white ones with black spots and bordered with red fringe. A third type is significant of hunting and of fighting. They are the fawnhoof tassels of black and white with a tiny dot of red in the center of each fawnhoof. The red mark represents flesh. These may be worn only by those who carry arrowpoints and refer to hunting, hence should never be put on Rainbow.

Pouches which hang at the side allow scope for the painter's imagination. Generally, they represent the embroidered or beaded long pouch of the Plains Indians which the Navajo value highly in trade. Pl. I, B shows only a small sample of the variation and elaboration of which the painters are capable. Only in exceptional cases is the pouch described.

[1] All descriptions of borders or outlines except those of centers are read from the outside in, unless otherwise noted.

Bodies, as I have indicated, are elongated, length signifying power, and on the long surface which forms the body "clothes" which distinguish the characters are laid. They must be described specifically for the various "People".

Arms, like legs, are angular, always raised, and in most cases, like the face, shown *en face*. Two white lines may indicate the shoulder; the angle forms the elbow; and the red-blue lines show the wrist-line even as they indicate the knee and other joints. The forearm, like the foreleg, may carry the symbol of power of the figure, such as flint weapons, or lightning.

The hand has five fingers and the objects lying beside it, though they may be some inches away from the figure, are nevertheless thought to be held in the hand. Sometimes a line runs from the hand to the object held, but often there is a space between.

From each arm of most People (exceptions are Arrow People and Flint People) strings of yellow and brown streaks hang. At the bottom of each of these is an object made of red and black oblongs with white fringes. Sometimes the strings are joined directly to elbow and wrist but often there is a pair of white feathers where they are attached. These strings are specific for the chant, yellow and brown for the Shooting Chant represent otter strings. The pairs of feathers at the wrists and elbows, as well as those on the strings, represent generosity on the part of the painter. The more the figure has, the better is it accoutered. Miguelito customarily gave his figures a great many of these. The red and black object fringed with white is a medicine bundle and the black represents herbal medicine in the bundle, the red, a ball of feathers.

Across the chest double blue lines, tipped at both ends with red, cross, and from the point where they meet blue lines tipped with red, drop. This whole arrangement represents the turquoise necklace with redstone pendants, the Navajo symbol of wealth in life, as in myth and ceremonial. On some figures the body paintings of the last day of the ceremony are depicted.

Necks are always blue with four horizontal red stripes and white outlines.

Face and head with headdress indicate characters or circumstances. The face alone may be indicated, or it may be drawn with face paintings: Masks are not actually used in this chant as they are in the Night and the Mountain Chants, even though one or two of the deities are described as wearing them. Faces are laid brown, and some remain that color, others have colors applied over the entire surface so that the brown is not visible.

We can derive no rule as to what round or square heads mean in this chant, but it is certain that they do not indicate sex as they do in the Night Chant. Both kinds are used, and in the myth they are often specifically designated but without explanation. Brown faces rarely exist with no painting whatsoever. The simplest is a yellow streak across the chin and a white one across the forehead, red stripes on the cheeks, that is, bordering the face. Above the white on the forehead is a narrow red line, above it a narrow black outline representing hair, and still another red line representing hair from the elk's or antelope's chin, a ceremonial requirement.

Two small white lines, or tiny blue and white circles on the forehead may indicate the permanent token of the chant, the olivella shell with a small piece of good turquoise which the patient wears after a sing has been performed over him to indicate that snakes, lightning and arrows should be afraid of him. With these the sacred figures of the paintings are furnished (Pl. II, C, p. 23).

In some of the paintings there are two white lines at the two sides of the forehead, in others two at each side of the chin, and still others have them in the four positions. These represent the strings with which the headdress is tied on, and are used by some Chanters, omitted by others.

Earstrings of blue tipped with red, like the necklace, indicate the highly treasured ornaments of turquoise and redstone.

More elaborate and very common in this chant is the face painting of four broad stripes, yellow across mouth, blue across nose, black over eyes, and white over forehead, the symbols of the Sun's House. The color combination yellow-blue-black-white will be called "sunhouse colors" from now on. The cheek paintings and stripes of the forehead, the olivella token and ear ornaments are used with this as well as with the simpler face painting.

Almost every figure has a head feather, referred to in Navajo speech as "its soft (down) feather", which is thought of as a protective device. Usually the soft feather is accompanied by another on the top of the head. One commonly found is the emblem of Pls. XIV and XVI, a black triangular figure with red and blue stripes at the end, all bordered in white. This represents the medicine bundle which is tied to the scalplock on the last day of the chant:

This turkey-tail feather bundle is a rain symbol.

"Above this (the olivella shell) a white cord is tied and behind it a black turkey tail feather lies, next above it is a red string. This is to serve as a soft feather which, with a white line, falls back crosswise. The end of the turkey soft feather is blue, then red, then yellow, making three colors with white on top."

Other soft feathers are similarly specific in color and kind for those who wear them and the circumstances under which they appear. Generally those belonging to a particular chant are few.

Headdresses likewise are varied but only a few are used in one chant, the most common being the flint cap worn by the Twins and others when armored with flint (Pls. XV, XVI, Fig. 4), and the headdress of the chant. Among the many characterizing symbols of each chant, is one which is used by the Chanter at the so-called Fire Dance, the elaborate night of performance which displays the combined talent of the Navajo medicine-men. The headdress of the Shooting Chanter, worn only on this occasion, is a pointed affair of feather mosaic, made of red woodpecker scalps. It does not appear in the chant when sung, but is often furnished to People, such as Snakes or Buffalo, in the paintings. Other headgear may be peculiar to the beings which wear it or it may be characteristic of the episode which the painting depicts.

With this general picture of "People" we may now proceed to a consideration of distinguishing features.

Supernaturals in the form of People

Some figures are always depicted as supernaturals, consequently they appear in human form and never take on other shapes, although their clothes, i. e., their powers, may be represented in different ways. Of these representations, the Holy Twins, Slayer-of-alien-gods and Child-of-the-water, and the Holy People, Holy Man, Holy Woman, Holy Boy, and Holy Girl, are used in the Shooting Chant.

The Twins are drawn in various ways according to the position the picture occupies in the story. Many times during their adventures they change character and substitute themselves or are substituted for others of the Holy Ones. Consequently, it is often difficult to ascertain whether the actor is Slayer-of-alien-gods or Holy Man. Holy Man is teaching Slayer-of-alien-gods the various acts of the chant, but at times it seems as if the rôles were reversed. This question of exactness of subject does not disturb the Navajo for they consider that the efficacy of the chant depends upon identity between the two. The Chanter represents the one taught, and therefore the deities he importunes:

"Changing Woman's son I am, I say it
"Changing Woman's grandchild I am, I say it ..."

If he is successful, he so ably and exactly duplicates the Holy Hero that he can assume the power of the one he imitates; and if he and all concerned handle that power properly (carefully and in an orderly manner), it will be successfully communicated to the One-sung-over. For this reason there is no inconsistency in the Navajo mind when the Holy Twins take on the form of Holy Man and Holy Boy.

The Holy People

The Holy People, a family consisting of Holy Man, Holy Woman, Holy Boy and Holy Girl, are frequently represented in their various dealings with other characters. Slight differences occur due to the situation depicted but a number of characteristics remain fixed.

The Holy People generally have the following features in common: their white skirts often have black triangular decorations and fawnhoof tassels, armstrings are joined to the arm with a pair of white feathers, they have sunhouse face paintings, and turkey tail feather bundle as soft feather. The reason for the face painting is given:

"The Sun is always thus himself because his eye denotes darkness, the white on his forehead the dawn, the yellow on his chin evening light, the blue across his nose the sky. With these streaks he made his sons holy."

Although the myth says that Holy Man and Holy Boy are exactly alike, as are Holy Woman and Holy Girl, certain detailed differences exist in the paintings:

Holy Man is distinguished in Pl. XIV by: black and white flash lightning protection for feet, and zigzag lightnings on legs and arms, black body with forked lightning (white diamonds) covering it, a tail-feathered arrow in his right hand, a dark bow in his left.

Holy Boy has yellow-white sunbeams as foot protection, and a yellow tail-feathered arrow in his right hand, otherwise he is the same as Holy Man.

Holy Woman has straight lightning (red-blue) protection with female ends at her feet, straight lightnings on legs and arms, a body of different colors, each represented by an elongated arrow-point, and carries a female arrow in her right hand and a white-yellow bow in her left.

Holy Girl differs from her only in having rainbows with female ends at her feet, and the central detail of her cane in different colors. A diamond-shaped element composed of two triangles connects the two main portions of the female arrow. The triangles which represent medicine bundles are black and red on that of Holy Girl, black and white on that of Holy Woman.

In another painting only slightly different, the Holy People stand on arrows, their skirts have the black triangles but the curves are of blue and yellow dots, white and red black-tipped tassels. From their arms the strings depend, joined with white feathers, in its right hand each holds a rattle, and in its left, a bow from which hangs a basket on a sunray. Their faces are like those of Pl. XIV and their headdresses are symbols of the Chant like those of Pls. IV and VI. The faces have the sunhouse streaks because the Holy People have brought down the Sun, Moon, Black Wind, and Yellow Wind with their bows, and the baskets represent the containers of these four supernatural elements. The variegated bodies of the females are represented here by diagonal stripes of different colors instead of by the elongated triangles, and there seems to be no definite order in the placing of colors, although balance in lights and darks is maintained.

In the picture of the Whirling-tail-feather (Pl. XXXIV) the Holy People have many of their usual characteristics; they stand on arrows, in their right hands they carry rattles, those of the males, with lightning marks; of the females, with sundog marks; in the left, each holds a bow horizontally,

and from its end hangs a Whirling-tail-feather of the color corresponding to the direction in which the figure stands. The faces are round and unmasked and the turkey-tail bundle is the head feather. The skirts have quite elaborate blue cloud designs.

Pl. XXVII, shows an encounter with the Buffalo and in this all the Holy People have ordinary skirts with white-red black-tipped tassels. In their right hands they carry buffalo rattles, the males, black with white borders, the females, white ones, black-bordered. All these rattles have a sunbeam in the middle and a sundog on each half and resemble closely the buffalo hide rattle used in the Chant. The white feathers dropping at each side represent down feathers taken from live eagles. The males carry black bows, the females, white-yellow ones, their faces have sunhouse streaks and the headdress is symbolic of the Chant.

In a similar painting all the Holy People have the blue triangle-bordered skirts with the fawnhoof tassels already mentioned and the general characteristics, but each skirt has in addition a yellow cross of pollen in the center. Each carries a rattle in its right hand, Holy Man at the east, a blue one with black border, Holy Boy at the south, a variegated one with white border, Holy Woman at the west, a white one with black border, and Holy Girl at the north, a pink one with white border. These rattles match the buffalo horns. The men carry dark bows in the left hand, the women white-yellow ones. The faces and headdress are exactly like those of Pl. XXVII.

The Twins, in the guise of Holy Man and Holy Boy, were taken in by the Thunders and the Fish and this adventure is depicted in the elaborate double sandpainting (Fig. 3). They have all the characteristics of the Holy Ones, but as usual, their protectors differ. In the Thunder painting at the north, zizag lightnings run from the hands of Slayer-of-alien-gods (Holy Man) to the wing-tips of the Black Thunder at the east, sunbeams from his left limbs to the wing-tips of Yellow Thunder at the south, flash lightning from the soles of his feet to the wing-tips of Blue Thunder at the west, and stretched rainbows from his right limbs to the Pink Thunder of the north. Thus he was made invincible.

His brother, Child-of-the-water, depicted in the stomach of the fish at the south, faces him. He has the trappings of Holy Boy, but neither he nor his brother have the strings from the arms. Instead, five points on a sunray shaft are wound about his neck — they show under his right arm — and five medicines protect his left side. In his right hand he holds the flint knife with which he cuts the fish open and in his left, the five medicines which restore the fish after he gets out of it. The face paintings are yellow and white and the soft feather is turkey-tail bundle.

The Sacred Twins

The Female Shooting Chant differs from the Male in emphasizing the birth and rearing of the Twins as against their dangerous exploits. Such paintings as we have of this branch show the Twins in their Flint armor.

Pl. XV and its companion not illustrated, show the Sacred Twins in the sky with the armor supplied them by their father, the Sun. I will describe the painting here pictured. The blue circle represents the Sun and it is outlined with black, white, yellow and red. The colors blue, black, white and yellow are the sunhouse colors and red signifies danger, destruction or evil and, therefore, protection against all three. The figure is that of Slayer-of-alien-gods, covered from feet to head with black flint from the joints of which lightning flashes. At his feet are lightnings and a pair of zigzag lightnings crossing his body represent weapons which he can handle with impunity. The triangular divisions on the body represent the points of the flint. The points on each side represent

his flint armor at front and back. In his right hand he carries a club containing five stone knives which has the power of causing earthquake. In his left hand are five lightning arrows.

The hero has a brown face with the lightning symbol (five zigzags) on the right cheek indicating that he belongs to the Earth People. Flint knives and five zigzag lightnings protect his head and he has two feathers, one red with black tip and one white or down (soft) feather.

The companion picture shows Child-of-the-water on the Moon, a white circle, outlined by black, yellow, blue and red. The youth is armored with blue flint throughout and has lightning weapons at feet, across body, in left hand and on head. The weapon in his right hand is of blue flint. The white over the face with a blue cloud symbol (triangle) is said to be a mask.

The pictures of the Twins show how fierce they were with their armor and they differ somewhat from the ordinary representations of People in that they are not clothed. These two paintings, as well as Fig. 4, depict the Twins in their basic aspect, so to speak, not as People but as armed powers. They compare to the Flint paintings, perhaps, as the Snake pictures compare to those of the Snake People.

Be that as it may, the myth as well as the paintings indicate clearly the significance the Navajo assign to flint as a tangible power.

"Firstborn came up to the entrance (of the place where the people were gambling for Day or Night). He was a terrible sight to behold wearing his flint clothes and carrying his flint club."

". . . . They (Hunger, Craving-for-meat, Poverty, Sleep, Desire, and Want) stared at him (Firstborn) for his armor always inspired fear."

After Firstborn had subdued the monsters and made the earth safe and useful for humans, thereby earning his name, Slayer-of-alien-gods, his mother, Changing Woman, notified him that she would have to move.

"I am the same as you see me. Since you have destroyed all the man-eaters, now those who are to be born will be born. There will be people, so I cannot remain here to be tramped on."[1]

She then went on to tell him that his father was preparing a beautiful house for him made of flint. After some time she sent him away saying, "From now on we shall not see each other again." And for once he obeyed her, whereupon he was transported by clouds which arose from each direction into the presence of the Sun who invited him into the new house of flint which was henceforth to be his dwelling.

"Inside everything was beautifully made for him. In the east, dark flint jutted; in the west, blue flint; in the south, yellow flint; in the north, serrated flint. Then they sat down and the Sun spoke, 'From now on because your mother sent you away, you will not see her again. I have made this house for you. Flint will make you feared.'

"The house lacked nothing, even food was there. There was a fine sleeping place with a pillow made of four white lightnings. 'If ever you should have a bad dream, this pillow alone will help you. Speak to it saying, "This bad dream, shall not come about," and even as you say, so it will be"'.

Pl. XVI and Fig. 4 have to do with the secondary theme of the plot, the removal of Changing Woman to the new home the Sun had made for her. They represent the concerted attack of the five flint-armored gods in which they threatened to annihilate her with the flint (p. 34).

Five of them started out. In Pl. XVI four of them are shown accoutered in their most powerful weapons.

"Slayer-of-alien-gods dressed himself in black flint, flint jutted from his breast, back, and both sides, and he carried a black flint club."

The points downward at the south of the black figure indicate "flint jutting from his front", those pointing up on the opposite side (the side on which the calves of the legs are drawn) are

[1] Here she refers to her function as the Earth Mother (see p. 36).

those "jutting from the back" and those above and below the arms are the flints "jutting from both sides", and flint juts out even from the legs. Exactly like his were the blue flint costume of Child-of-the-water, the yellow of Changing Grandchild, the serrated (pink) of Reared-within-the earth.

"The raiment of Shooting God was mixed kinds of flint and he carried a mountain lion quiver full of arrows and a dark bow and two tail-feathered arrows."

Shooting God is not shown on this picture — we have none in which five beings occupy a major position in the field. It may be that the variegated figure of Fig. 4 represents him, but since I do not have the text of the Female branch of the chant I cannot even be sure that this painting records the same scene. There are differences which seem to indicate that it does not although all the figures have brown quivers.

The gods organized a concerted attack. All at once Slayer-of-alien-gods and Shooting God rushed at Changing Woman from the east, Child-of-the-water from the west, Changing Grandchild from the south and Reared-within-the-earth from the north, and as they did so they shouted and threatened her. As Slayer-of-alien-gods spoke they all stamped the earth and the flints rattled so loudly that Changing Woman ran out to see what was the matter.

"She saw these terrible figures start toward her changed by the sun. They were painted yellow across the chin, blue across the nose, black over the eyes, and white across the forehead. The four were painted thus but Shooting God wore a mask."

They finally overcame her prejudices; she was removed to her beautiful home in the west and "that difficulty was removed" (p. 34).

The figures shown in Pl. XVI are exactly as described here except that they do not have the sunhouse streaks on their faces. Their head feathers, like those of the Holy People of Pl. XIV, represent the turkey-tail bundle. It is possible that since the gods were emissaries of Slayer-of-alien-gods and really had no need for the sunhouse protection, the dawn and evening yellow streaks were sufficient protection. One other feature is noticeable and that is the glorified skirts with elaborate decorations worn by these beings, each different and fanciful.

Closely related to the paintings of the Twins and of the Holy People in style is Pl. XVII. This was among the major paintings which were given to Holy Man and belongs to the Corral Dance branch of the Shooting Chant. There are no new details in the figures of the Holy People but the combination is somewhat different from any we have had and each feature is highly elaborated. Slayer-of-alien-gods, dark at the east, has as protection four zigzag lightnings which cross at the point where he stands. He is fitted with flints jutting out exactly as in Pl. XVI, but there are no lightnings on his legs or arms. His skirt has black triangles as well as the fawnhoof tassels.

The weapon in his right hand is again an emphatic version of that of Pl. XVI, for from all four sides of it five male zigzag lightnings extend. He holds the usual five zigzag lightnings in his left hand, and five, instead of the more common three, writhe from his head.

To the first the other figures correspond, but their weapons are somewhat distinctive as they are in Pl. XVI, to the figures of which they correspond, though in the simpler symbolism. Child-of-the-water stands blue-flinted in the west on a bundle of lightnings, red and blue, with blue female points, and with these his club is bursting; five are held in his right hand, and the same number are sprinkled from his head.

Changing Grandchild is represented yellow at the south and his protectors are yellow-white sunbeams with male barbs. At the north Reared-within-the-earth stands pink on a bundle of crossed rainbows with male barbs which protect him as the lightnings and sunbeams protect his campanions.

VI

Symbolic Elements: Arrows, Lightnings, Snakes

Bow and Arrow

Having described the symbolism of the Wonderful Adventurers, I shall next describe the arrows because the myth specifically says the arrow was made to be the symbol of the Male Shooting Chant. "A bow of hardwood and two reed arrows were made for the Sacred Twins by Talking God when they were twelve days old," that is to say, about adolescent (p. 26).

"The arrow was pointed and had a foreshaft of hard wood."

In the paintings various kinds of bows and arrows are used. The bow is often described in the myth as "dark" and this refers to the black bow with a red line inside and a white bowstring (Pls. IV, V, VII, XXXV). This, the male bow, represents the war bow of the Navajo which was wound with black gut and red sinew to give it elasticity. It was a bow with two arches and at the ends, at the center of the bow, and at the center of each arch, medicine bundles were bound with feathers and olivella shells. The bow of the picture is a much simplified form, but the three shells on a string represent the medicine bundles. Another form of it is blue with yellow border and white string, carried by female figures. One painting, shows how the Sun and Moon were brought down by the black bows. The Holy People hold them hanging on a sunray string at the end of their horizontally placed bows.

In Pl. XV which belongs to the Female Branch of the chant, there are dark bows with red border at east and west, and at south and north the inner line is yellow instead of red. The yellow bow with white border and string represents the ordinary bow of mountain ash.

Arrows are differentiated by color to fit the description given in the myth: arrow all white, that is, white shaft with white feathers, is "tail-feathered" arrow. A white-shafted arrow with one white and one yellow feather is referred to as a "yellow tail-feathered arrow."

In the myth arrows were made of precious stones as well as of the more utilitarian materials and the description of Pl. XXXV illustrates the imagery.

"In the east over the turquoise mountain lies a turquoise arrow with white border and four joints of white shell with point to south. Above the western mountain lies a whiteshell arrow with blue border and four turquoise joints. It points north. Over abalone mountain at the south lies an abalone arrow red-bordered with four redstone joints, pointing west; and a redstone arrow with abalone border and joints lies at the north above the redstone mountain, its point to the east."

The myth goes on to explain the Arrow People and illustrates perfectly the way in which objects become personified:

"On the eastern arrow facing south stands a man with black-bordered shoes, his skirt white, surrounded by two lines, the inner blue the outer red. His legs are blue with a white border. From each corner of the skirt three white tassels extend. On the tips there are fawnhoofs, forked white, closing with black lines and a red spot inside representing deer flesh. Even with the upper portion of the skirt a white belt is drawn of four lines. At the tips of the diagonal lines of the belt fawnhoofs are again drawn. The body of the figure is blue with white border, the arms form a black bow, the front of which (i. e., inner part) next to the mouth is red. It has five fingers. On each wrist are two dots, one toward the head being blue, the other red.

"At the end of the body which resembles the nock of an arrow is a blue neck and above this a square brown face. But the brown of the face cannot be seen for there is a yellow streak across the chin, above this a blue one, then a dark, and finally a white one. Thus four lines run across the face. On either side of the face a red line, representing the red paint used for face painting is drawn. Starting from this line there is a black line running around the head and representing the hair, and over this a red line representing horsehair. The earrings are of turquoise tipped with redstone. On the head is a soft feather all white. In his left hand he holds a dark bow, in his right, a turquoise arrow."

.

"The doorkeepers are arrows, from the south, turquoise, from the north, white shell, with points facing each other."

This describes all the arrows of the picture, that of the west being a whiteshell woman with mountain ash bow in the left hand, and whiteshell arrow in the right; at the south, an abalone man with a dark bow and abalone arrow; and at the north, a redstone woman with mountain ash bow and redstone arrow.

The description gives a clue to a great number of details of the painting, some of which may be applied generally. Often some protective design lies between the center and serves as a base for the figures. In this case it is an arrow of the color and material of the mountain and the arrow figure which stands on it. It happens that the theme of the whole picture is unified and the People, as well as the doorkeepers, are arrows. The instructions for depicting the People are characteristic, although much more detailed than for some which are perhaps better known. The skirt is not described but our version has the dark triangles which indicate Hopi patterns. The tassels at each corner are the same as on the belt, fawnhoofs with a red dot representing deer flesh. Belts are not usually described, for usually they are provided with pouches of varied pattern and colors. In this case the painter is not free in decorating these Arrow People for their pouches must match the skirt tassels.

Whereas the bow and arrow were gifts of Talking God to the Twins at the very beginning of their career, the arrows made of precious stones were gifts of their father, the Sun. When they visited him in his house he laid before him a turquoise, a whiteshell, an abalone, and a redstone arrow. Then he said, "If I should give you these now and you should take them home and use them in the future, and, being earth-dwellers, you should not keep them sufficiently holy so that by chance something should happen to them, what could be done? Therefore now I'll just tell you their names."

He then revealed the names of the arrows and with the names, the control over them was established. The name of the turquoise arrow is Joints-of-transparent-turquoise-with-blue-veins; of the whiteshell, Joints-of-transparent-whiteshell-with-white-veins; of the abalone, Joints-of-transparent-abalone-with-abalone-veins; and of the redstone one, Joints-of-transparent-redstone-with-pink-veins. Whiteshell Boy and Whiteshell Girl are the names of the down-feathered arrows (p. 36).

"Since the Sun gave only two of these names we mention only two today. The first arrow we have is made from reed from Taos, the second from reed from Oraibi."

These last remarks may refer back to the arrows which were the gifts of Talking God.

Lightning Arrows

The Sacred Twins often carry lightning arrows which are different from the arrows described. These were part of the gift the Sun gave his children when he armed them. Moccasins, clothes, and hat of flint, zigzag lightning and flash lightning he gave them at the time they first requested

his aid in destroying the monsters which infested the earth. The zigzag lightning of black flint was laid down for Firstborn, the flash lightning of blue flint for Secondborn. The zigzag lightnings are shown in Pl. XV across the body of Firstborn, they also protect his feet.

The black zigzag lightning with barbed points is the male, the white lightning with smooth points is female (in Pl. XVII the female is outside, male inside; Pl. XVI male is outside, female inside). The lightnings which protect the feet of the dark figure of Pl. XIV (Holy Man) are female because they are crossed rather than barbed at the ends.

These are the usual meanings of these symbols, but like all the others, a somewhat different interpretation may be assigned to them in other contexts.

Snakes

Although the Shooting Chant includes a number of groups of related paintings, none is as extensive as that of the Snakes. This is to be expected since the Chant is a charm with and against arrows, lightning, and snakes and these symbols are prevalent throughout. Consequently, even

Fig. 6. Snakes of all kinds on each side of Black Corn (p. 53)

though it may seem inconsistent not to class them with the animals, I am going to describe them here, for it is already apparent that, try as we will, we cannot make Navajo classifications correspond with ours. Three kinds of Snakes are depicted, all of them represented in Fig. 6. The four at bottom and top are Arrow Snakes, the next toward the center are "Crooked Snakes" and those at each side of the cornstalk are "Big Snakes". All crooked snakes are specifically described as having four angles, that is, two angles on each side. When these are used as guardians they are generally shorter than those in the body of the painting and are sometimes identified with "sidewinders". It seems that all of these are thought of as rattlesnakes as the four marks on the tail indicate.

Interpretations of them in biological terms are impossible. The Big Snake is often said to be short and thick "like a stovepipe" and sometimes is said to have a head at both ends. No one has ever seen this snake but almost everyone has a relative who has!

Big Snakes occupy a prominent position in one rather simple painting, but their marks are the same as those of all the snakes of Fig. 6, simply a deer track, which is the one mark common to all the snakes used in this chant. The sidewinder guardians of the east, however, show greater, but common elaborations in the markings on each joint as well as in the colored lines which separate the joints. The combinations of marks are as in Fig. 7 and they recur frequently. The white marks

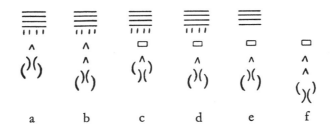

a	b	c	d	e	f

Fig. 7. Snake markings

dropping from the colored stripes at the joints represent olivella shells which in their turn symbolize rain. The rectangular designs represent the snakes' home. The curved marks indicate changes of the moon and have specialized positions in different chants. The position of the curves in *c* and *f* is used if the chant is the "driving-out-evil" branch; if it is the "blessing-bringing" branch the arrangement of *a*, *b*, *d* and *e* is used.

The colors at the joints present some difficulty, only a few rules remain valid: the colors read from bottom to top, begin with red and end with the outline color of the figure. For example, if the figure is white, the lowest color will be red and the upper one black; if the figure is blue, red will be at the bottom, but yellow at the top and so on. Between these the other colors are arranged sometimes with the male of the pair (i. e., black or blue) next to red, sometimes with the female (i. e., white or yellow) occupying that position. I am unable to explain the reason for the choice of one arrangement or another.

Often but not always, one of the guardians will have joint-colors and curved marks just the opposite from those which predominate in the body of the picture and on the other guardian. If all have the marking *c*, one guardian will have that of *d*; if the female color of the pair opposite that of the figure-color is next to red, the guardian will have the male color of that pair next to it. These suggestions do not hold in every case, however.

The descriptions apply to Coiled and Whirling Snakes (Pls. X, XII, XIII) as well, although these are always smooth. The differences in these pictures are due to composition rather than to variations in the elemental details.

Just as arrows become Arrow People so Snakes become Snake People. It seems that there is a choice as to which kind may be personified in most cases, although here again there may be some ceremonial reason for the choice. I suppose that straight snakes, like straight lightning, would refer to more gentle circumstances. For instance, we have two versions of Pl. VII, one exactly like the other except that here Arrowsnake People are represented and in the other Big Snake People.

Sometimes the rattle tip of the tail is drawn between the legs (Pl. VI, VII) but it may also be omitted (Pls. III, IV, V, VIII). Its inclusion or omission seems to depend upon the Chanter; Miguelito put tails on Snake and Buffalo People; the chanters at Newcomb did not. Most of the Snake People have the ordinary skirt but those of the Crooked Snakes of Pl. V have the dark triangles commonly seen on the skirts of the Holy People, and those of the Big Snakes of one painting have an extra border of zigzags formed of yellow-blue-red lines.

All kinds of tassels are depicted on Snakes. The most common is the white tassel with red diagonal marks and black tips (Pls. III, VII, VIII, IX), but the "fawn hoofs with the red dot representing deer flesh" is also common (Pls. IV, V, VI). One has white tassels with black spots bordered with red fringe.

I have said that great freedom is allowed in depicting the pouches of the People, and the Snake People amply illustrate the fertility of Navajo imagination when it is given free range. Those figures which have fawn hoof tassels have feathers beside their pouches (Pls. IV, V, VI), usually outside. The pouches of the figures in Pls. III, VII, VIII, IX have no accompanying feathers. When present they furnish power because they are prayer feathers, but they may be omitted and their position inside or outside is not significant.

In describing the essential elements of the bodies of the Snakes we have pointed out also those which are used for Snake People, "straight", "crooked" (i. e., with four angles), bulging in curves (Pl. III) or with angles at the sides (Pls. VI, VIII) characteristic of the Big Snakes. It seems that the curvature or angularity of the Big Snake People depends upon the taste of the painter who often lays out a pattern in angles and fills in the spaces to make the arcs or curves.

The arm strings are always present on Snake People. They are attached directly to the arms of the figures of Pl. V; with a pair of white strings in Pls. III, VI, VII, VIII, IX. Some paintings (Pl. IV) have a series of numerous pairs of feathers, blue, white, red, yellow, white (from bottom to top) on each string. These may be for additional ornamentation once again showing Navajo generosity to their gods.

The faces of the Big Snake People of Pl. VI are realistic according to Navajo imagery, the heads being angular and the yellow fangs bent down over the forehead so as to give place for the symbolic headdress. None of the snakes has the sunhouse streaks because none of the scenes had to do with the Sun or his house. The Chant headdress is used in most of the paitings of the Snake People.

VII

Symbolic Elements: Natural Phenomena

The Great Ones

The Shooting Chant includes a host of celestial beings. Sky and Earth (Fig. 5) are represented in one of the most famous of the paintings which is used in a number of chants including this one. Sun, Moon, Black Wind and Yellow Wind are of the greatest importance. They are the four "Great Ones" which were made at one time. Changing Woman is the Earth. Her name comes from the fact that she changes with the seasons. In spring she is young and beautiful; in summer, mature and beautiful; in fall she begins to fade but is beautiful with harvest, and in winter she weakens and fades becoming gray and decrepit. Her restoration to youth is depicted in the ceremony of the last day of the chant (p. 36).

The Sun, powerful in a different way, the creator of good and evil, interested in the children he made for the Earth even though some were monstrous, is the lover of Earth Mother, and although it grieves him, he helps her to rid her home of the monsters he begot so it might become habitable for Earth People. It is no wonder then that he is one of the main protagonists of the drama.

In Navajo literature and art all things go in pairs, male and female sometimes, but often two of the same sex, one strong, the other weaker. In other myths Whiteshell Woman is the companion of Changing Woman, weaker than she and not often mentioned, but always a foil. In this myth her companion is Salt Woman who helps raise the children and is a companion in need, but who sometimes allies herself with evil. One of the Twins is a weaker aid of the other, although Child-of-the-water is sometimes strong enough to save the life of his more powerful brother who usually takes the initiative (p. 33).

The powers of Earth and Sky are so different that one can hardly be said to be less important than the other, but they are nevertheless paired. Moon is the weaker of the Sun-Moon pair and Yellow Wind goes with Black Wind as the milder.

In Fig. 5 Earth and Sky are depicted. The figure at the north is Night Sky and that at the south is Earth.

"The Sky lies on the north side with four streaks over its face, neck blue with four red stripes across, and white border. It has yellow fingers just like those of a man. Across the chest, even with the elbows, the Milky Way is drawn, under it one of the Big Stars is indicated by a cross, under this the constellation called Rabbit Track, then Orion and then Old-man-straddling. Next is his soft feather and below, the Pleiades just rising. Facing upwards stands the Male Big Dipper and downward the Female Little Dipper with the North Star marked between them.

"At the widest part exactly in the center is the Sun, behind it the Moon, one following the other. From between the legs of Earth and Sky a blue cloud projects into it, the cloud has a rainbow border and yellow feet like those of a man.

"On the south side is the Earth all blue and bordered with yellow. Its face has four streaks, its neck like that of Sky. At the widest part in the center is a black vessel of water with four rainbows. Up over the heart is a cornstalk whose three roots run into the water; the tassel under the neck. It has five leaves and one white ear on each side. Below this is a squash with three roots running into the water. It has three leaves, three squashes and three blossoms. Its stem is black.

"On the south side three bean roots extend into the water. Five stalks run out from it, each with five leaves. Numerous pods hang on it and the beans in the pods are of different colors. On the north side three tobacco roots extend

into the water. The plant has five blue stems each with five leaves and white flowers. Under it a black cloud with rainbow border looms up. The feet of the rainbow are yellow and like a man's. It has five yellow fingers. From the mouth of the Sky to the mouth of Earth blue pollen is sprinkled, and from the mouth of Earth to that of Sky red pollen is dropped. Then 'real pollen' (i. e., yellow) is sprinkled into the mouths making three different kinds.

"The arms of Earth and Sky cross above and their legs cross below."

Just as Arrows and Snakes are sometimes shown in simple forms and again in figures more complex, so too are Sun, Moon and others of the heavenly bodies. The name of Sun is really He-who-carries-the-day, or Day Bearer, and that of the Moon is Bearer-of-the-night. They may be represented in many forms, from a circle colored for the character, through the elaborate forms like those of Pls. X, XIX. The blue circle of Pl. II, B, XV and that on the Sun's tobacco pouch (Pl. I) represent the Sun. The white circle of similar paintings, not including the pouch, is the Moon, the black is the Black Wind, and the yellow is the Yellow Wind.

Four circles of the same colors, each with twelve feathers represent the baskets in which these elements were carried (Pl. II, C). These are used as "prayer paintings". The crude circular symbols with fringe dangling from the bows of the Holy Ones in Bringing-down-the-sun painting represent the same thing. The Sun's basket is blue and has red feathers tipped with black, the Moon's basket is white and has white feathers tipped with black. The feathers of Dark Wind's basket are all black and those of Yellow Wind's are red with black tips, but narrower than those used for the Sun's and with smaller tips. Each basket is protected from destruction by a red line.

The Sun and Black Wind are male and the Moon and Yellow Wind female (or at least, mild and weak). In the prayer paintings of Pl. II, A female snakes (white and yellow) cross over the Yellow Wind circle and there are four bent rainbows for protection. Female snakes cross similarly over the white circle of the Moon and male snakes (blue and black) over the blue and black circles of Sun and Black Wind. All these circles are outlined in white and all have bent rainbows as protective devices.

The prayer painting, Pl. II, D which is one of a pair shows greater elaborations of the Moon. It has mouth, eyes, and the Dawn streak on the forehead and the Evening Light on the chin (the Dawn streak is not discernible on the white face of the Moon but it is always thought to be there). Blue Cornbug Girl lies on the face of the Moon and Yellow Pollen Boy on that of the Sun. Each wears the turkey-tail medicine bundle as a soft feather. The painting illustrates the use of the Chant symbolism now come to be familiar to us. If the patient is a man the Sun picture is used, if a woman, the Moon.

The circles of the pair like Pl. II, D, only one of which is illustrated, are surrounded by the sun-house colors not within it, i. e., Sun which is blue has black, white, and yellow; Moon which is white has black, yellow and blue, and both have red. Furthermore, rays of the Day colors run from the circle to stretched rainbows in each direction: white, east as Dawn; yellow, west as Evening Light; blue, south as Blue Sky; black, north as Darkness.

In the painting of Pl. II, D, male arrows symbols which are the same as those guarding the Flint People jut in each direction to bent rainbows; black-white zigzag lightning to the east, yellow-white sunbeam arrows south, blue arrows on straight lightning shafts to the west, and to the north, pink serrated points on rainbow shafts.

In the paintings of Pl. XI and its companion which are used only after an eclipse, the Sun, as in Pl. II, B, takes up the central space but in addition it has two of the red and black feathers extending from each quarter and indicating the basket in which Sun is carried.

Sun, Moon, Black and Yellow Winds in schematized form, but with all elements, present are used twice on the Sun's House. Pl. XIX illustrates this important accessory of the Sun's House branch

of the Chant. In the Chant I saw the Sun's House was made of reeds and was really a stage setting but it is also possible to lay it in sand and the designs are identical. In Pl. XIX, Sun, Moon, Black and Yellow Winds are shown as openings of the Snake houses at the bottom, and they rise once more at the top of the house surmounted with cloud symbols.

Different aspects of the Sun, Moon and Winds appear in Pls. XVIII and XIX for these are Sun, Moon and Wind People. The faces are the same but there are horns on both sides. Horns give additional power to a figure and may be used only on Sun, Moon, Winds, Earth and Sky, as they are in this Chant, and on certain figures of the Emergence Chant. The whole head is protected by a red line. In Pl. XVIII, rain lines extend to a sundog at the top and bottom of each; the Sun (blue) and Black Wind, being male, have male rains (i. e. zigzag) and the Moon (white) and Yellow Wind, being female, have straight ones, and in addition, the Winds have whirls on their heads. Sun and Moon on the night sky at the north are depicted in the same way. The whirlwinds of Black Wind and Yellow Wind may be coiled clockwise or counter-clockwise, according to the season of the year, but both are the same in the Shooting Chant.

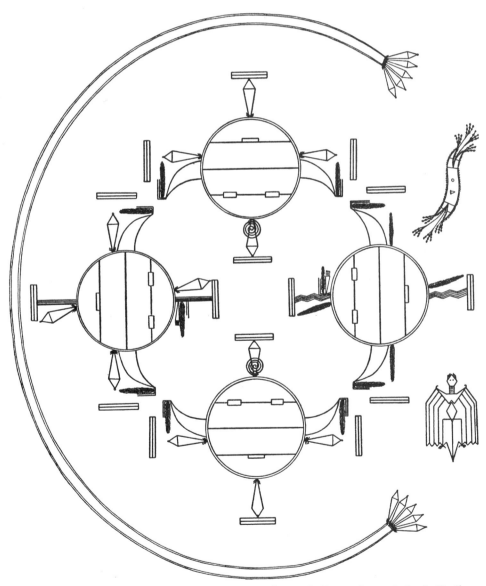

Fig. 8. Sun, Moon, Black and Yellow Winds, horned (p. 58). Drawn from painting by Dudley.

In Fig. 8 the faces are all covered with sunhouse streaks but the horns show by their color which being is designated. These have the feathers also and the Winds have whirlwinds.

The Skies

In describing the face painting and other elements used in the paintings we have seen that great emphasis is laid on the four colors, yellow, blue, black, white, and I have explained that this combination of colors belongs to the Sun's House. This is quite obvious in Pl. XIX. We have noted, too, that white represents the Dawn; blue, Blue Sky or Day; yellow, Yellow Evening Light or Sunset, and black, Night Sky or Darkness. In the simplest painting (Fig. 9) each has a trapezoidal shape. For Pl. XVIII, the description runs:

"In the east the dawn is spread all white with white border. In the center of the dawn, similar to a cloud figure, a dawn tail feather rises. On its tip twelve tail feathers with blackened tip stand in a row. On the southern corner of the tip rests a big blackbird. Its neck from the shoulder up is yellow and the top of its head is red. On the space toward the north sits a nighthawk. It is also dark, its wings speckled white. These birds sit facing each other. Exactly in the center between the birds a mountain sheep lies with head toward the south and blue breast to the west.

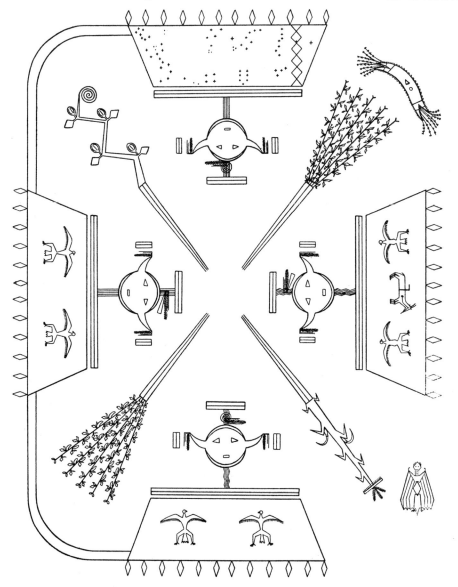

Fig. 9. The Skies, simplest version (p. 58). From a painting by Miguelito

"Exactly in the middle of this tail-feather Dawn Boy in the figure of a man stands, with body all white, bordered with yellow. His shoes are black-bordered and his skirt is white, neck blue, face with four streaks. He has ear ornaments; his head is black, on it is red elk hair. He has no headfeather but a simple down feather is tied on. In his left hand he holds a turquoise basket, in his right, a white ear of corn."

The description accords with that of Wrapped-over-dawn where the Twins stopped one time. The main mountain lay white, as did Dawn Mountain. They entered this Dawn Mountain and there found Dawn Boy and Dawn Girl (p. 36).

The description of Yellow Evening Light at the west is the same except for changes of color and the birds, which are bluebird at the north and blue swallow at the south. Yellow Evening Light Girl stands yellow with a white border on the tail-feather. She holds a whiteshell basket and an ear of yellow corn. On Blue Sky at the south a yellow bird and a wild canary face each other. Blue Sky Man, holding a turquoise basket, and an ear of yellow corn stands on the tail-feather.

"In the north Darkness is spread, white-bordered, its tail standing up with its twelve tail feathers in a line on top. At its eastern end the Milky Way forms a line. Next it lies Big Star and behind it the Rabbit, then Big Tail Feather (constellation), behind that Soft Feather and then the Pleiades just rising. The Sun stands first, next it is the Moon with Little Dipper lying opposite the Big Dipper."

The description of Night is quoted here because it differs slightly from the description of the Earth and Sky painting (p. 55), although the same elements are used in both. Darkness Girl with white border, and holding a whiteshell basket and an ear of yellow corn stands on the tail-feather.

Just as we have three copies of the Holy People so we have three of the Dawn painting. The one I have described is that of the Skies, each with a feather (Pl. XVIII). Mrs. Newcomb had drawn one for the collection and then Miguelito made me one because he had actually used it in my ceremony. As is usual, there are differences in detail which, to a degree, involve composition.

But it is to the differences in representation of the beings of Darkness that I now wish to call attention. The stars and constellations of the Night Sky are the ones generally used but in each picture they have a different position. Their relative position is approximately correct, and the differences are due to the fact that they are represented as they appear at the time of the year when the chant is sung. It will be seen on the paintings illustrated (Pl. XVIII, Fig. 9) that approximately the same stars are used on all, but the one made by Miguelito has a good many more than the others and it indicates a different position of the sky. In this and the paintings made by Franc Newcomb, the Sun and Moon are not portrayed.

Clouds, Rainbow, Mirage

Closely related to the Sky emblems, perhaps only another phase of them, are the Clouds, symbols much like the Dawn with tail feather, as the emblem of Pl. XVIII is described. Each of the "cloud" patterns of Pl. XIX was used as a prayer painting in the early morning of the Sun's House Chant and the Prayerstick Chant, but each had sundogs on it, a rainbow around and four sundogs below it. The black Cloud brought the Sky People; the blue, Water People; yellow, Sun People; and pink, the Summer People.

An elaborate form of these People which we do not have but which includes these, is described as a grand climax when Changing Woman in her new home gave Earth People her gifts.

"This happened in the autumn. At this time of the year Changing Woman is old and just squats and that is the way they found her. When the men entered six sat down on the south side and six at the north. The Holy People sat between them. It was dark with fog as when there is no moon. Then eight others came in and space was cleared so they sat down in the middle of the room. This was so instructions could be given.

"There was one pair each of black Sky People, of blue Water People, of yellow Sky People and of pink Summer People, male and female in each pair. So now when the picture is laid in colors the Sky People lie in the east, the male south, the female north. Each holds a black water jar and a black talking prayerstick in the left hand, and in the right, five zigzag lightnings. The jar is black with border of white, yellow, blue and red. The talking prayerstick is also black with white border. At its ankle (lower end) a white down feather is fastened on each side, and at the upper end likewise two down feathers lie, one on each side. Its eyes are blue.

"In the west the Water People lie blue, the male north. They also hold a water jar, blue, and a blue talking prayerstick in the left hand, and in the right, five straight lightnings. All of these have a yellow border.

"In the south the Sun People lie yellow bordered with blue, each holding a yellow water jar and talking prayerstick in the left hand, and in the right, five sunbeams.

"In the north Summer People lie pink, bordered with white, holding in the left hand a pink water jar and talking prayerstick, and in the right, five rainbows.

"Each male has a round face, each female a square one. The Sky People have blue eyes, all the others have black eyes. When the beautiful home was made for Changing Woman, these were made for her to do her bidding. Now she was to instruct the visitors about these People.

"Sky Man has a dark cloud in his jug, Sky Woman has dark mist, Water Man has male rain, Water Woman has vegetation. The Sun People have pollen of all vegetation lacking none and the Summer People have dew of all plants none lacking" (p. 37).

One of Roman Hubbell's paintings made by Miguelito fits this description with some exceptions due to the fact that it belongs to the Fire (or Corral) Dance Branch of the Chant. The center represents the Corral of the elaborate last night's performance. The paired figures lie with the same colors in the directions described in the myth. The long colored bodies have many dots which represent seeds. Each carries objects resembling those described but not identical with them. In the right hand each figure carries a pouch, a buffalo rattle and a feathered traveling hoop. In the left there is a talking prayerstick, a water jar and a bow. The water jars have only the contrasting stripes, not the additional ones here described. The eyes of the Sky People are not different in color from those of the others as the myth explicitly states. The faces which are all round, have the sunhouse streaks and the headdress is the chant emblem. The rectangles of Pl. XIX contain Cloud symbols like those on the heads of the Corn People (Pl. XXI). Characteristic of the Suns' House and rising above these rectangular altars are the cloud columns symbolized by yellow-blue-black-white triangles one above the other, on each of which a bird sits (Pls. XIX, XX). When the actual Sun's House was used, there were five birds winging over these cloud pillars and singing.

We have previously indicated that the majority of the pictures have a guardian which encircles three sides. This guardian is often Rainbow or Mirage. If it has feathers at the ends and corners it is simply the emblem itself. The rainbow has five eagle feathers at the southeast, five hawk feathers at the southwest, five yellowhammer feathers at the northwest and five magpie feathers at the northeast. Sometimes real feathers are used instead of the sand symbols. If the Chant emphasizes prophylaxis, red is outside and blue within; if it is given for driving off evil, blue is outside and red in. Most of the pictures have red outside but those made for Marie had the colors reversed and all the small rainbows corresponded. The Skies of Pl. XVIII are connected at the west with portions of rainbow.

The small rectangular designs are of red and blue. All colors surrounded by white are often referred to locally as "sundogs" and they represent the small portions of rainbow which appear often near the horizon during the rainy season of the Southwest. They are used in the paintings frequently indeed, and are symbols of protection.

Often, however, the garland represents the Rainbow God, in which case the feet are at the southeast, the body circles sunwise to the northeast where the upper part is depicted. The figure is treated exactly as it is for other People, except that the body is extended in a curve or with angles and the arms are shown in profile instead of *en face*.

The legs are white with red border and in some cases (Pls. III, XIV, XXI) they are fringed. This treatment represents leggings. The skirt is of the common type, with tassels varying in the same way, but some say the Rainbow should never wear fawnhoof tassels. The pouch is ornate and varied, sometimes it has a feather (Pl. XIV).

The arms are drawn white at the inside and are generally red-bordered with the red-blue wrist marks. The red line on the arms and legs of the Rainbow or Mirage circle is the life line. The necklace, if present, is shown in full on the breast. The Rainbow of Pl. XXIV has no necklace. In one region the Chanters say the Rainbow should not wear a necklace, in another, the Chanter says it symbolizes blue rain.

The head is usually square and has the yellow and white streaks as well as the other symbols of cheek painting and hair. The soft feather is usually the turkey-tail bundle (Pls. III, XIV, XVIII, XXIV).

The Rainbow of Pl. XXII carries a blue feather in each hand, has a round head with markings like the square ones described, and on its head a flint cap of three blue red-bordered points and a soft down feather. Here and there three white dots are sprinkled on the body, these represent olivella shells. It is to be noted that this picture belongs to the Female branch of the Shooting Chant.

The mirage garland is represented with varying colors and a white border, the feather bundles of five feathers each are of the same kind as those on the rainbow and similarly placed.

Mirage, when personified, is treated like Rainbow, although there is greater variation of detail. Feet and arms are sometimes red-bordered (Pl. XX), the skirt of Pl. XXXV has black triangles, and face and headdress are varied; the rainbow of Pl. XXIV has a head like most of the rainbows, but with the headdress of the Female Shooting Chant. In Pl. XXXV the face of Mirage has the sunhouse streaks and a simple soft feather.

Thunders and Water Monsters

Thunders have certain attributes of birds, but they are very elaborate figures. The body is broad with legs widespread and turned in opposite directions to show it as sitting, and it has wings instead of arms. As usual, a red-blue mark designates the joint.

The feet are inverted cloud symbols on each of which a small rainbow lies. There is one also on the calf of the leg, one on the thigh, one on the upper wing, and there are four on the trunk.

The tail is a lozenge-shaped affair of brown (Pls. XXIX, XXX, XXXI, and Fig. 3) or black (Pl. XXXIII) in the center of which is a rain design in two or four of the sunhouse colors. It may be bordered in rainbow colors (Pls. XXIX, XXX, XXXI) or in sunhouse stripes and red. At the bottom of the tail a featherlike motive curves at each side in colors which differ slightly on the various paintings. The tail carries rain and the curves on the bottom represent the reverberation of Thunder. The Chanter alternates the black and brown of the tail for different times he sings.

The wing-tips are in a color contrasting with the color of the body – Black Thunder has blue tips with yellow, Blue Thunder has black wing-tips with white border and markings, Yellow Thunder has pink tips with white, and Pink Thunder has yellow tips with blue. Each of these color combinations is that of the headpoint of the figure opposite, so that each Thunder has not only his own power but also that of his partner. Across the entire wingspread a rainbow border extends and arrowpoints belong to its tips and joint. Sometimes these lie just above the wing-tip, not attached to it, but they may be carried much nearer to the center as they are in Fig. 3.

Each Thunder has an arrow head ornament of the same color as its forewings, some with lightning marks (Pls. XXIX, XXX; Fig. 3) others without (Pl. XXXI).

From the wings female white lightnings and objects which resemble the turkey-tail medicine bundle hang. They represent the water which always spouts up like a fountain from the place where thunder sits. Altogether there are nine of each; on the right side, five lightnings and four bundles; on the left, five bundles and four lightnings. The myth mentions twelve lightnings. Only one painting gives necklaces to the Thunders (Pl. XXIX), the others having in contrast a rainbow symbol on the upper part of the wing.

Neck and face are consistent as for People. In Pls. XXIX, XXX, XXXI, Fig. 3, the yellow and white face streaks are used and in Pl. XXXIII there are sunhouse streaks.

There are two kinds of water monsters which I shall designate as Water Ox and Water Horse. Water Ox resembles a person and to a degree Thunder, and this is because he is "the adulterous child of Thunder". The body is similar to that of Thunder although it is longer and narrower. Small rainbows have the same position on feet, legs, and body as they have on Thunder. Tails are similar, as are cloud-symbol feet.

Water Ox has arms like the other People and in some paintings a pair of strings with feathers hangs from wrist and elbow (Pls. XXIX, XXXII) and from others (Pl. XXXIII) they are missing. In the right hand are five arrows: straight lightning shafts with blue-yellow points, rainbow shafts with serrate points, zigzag lightning shafts with male barbs, and yellow-white sunbeam shafts with yellow-blue male points. In the left hand Water Ox carries a jar of the same color as himself, fastened to a string of sunray.

Necks and faces are like those generally used for People and, to correspond with the other figures of Pl. XXXIII, the face of Water Ox has sunhouse streaks.

At the top of the head of the Water Oxen of Pl. XXXII horns with soft feathers at the ends extend. Each is colored like the wings of Thunder, i. e., the portion near the head has the colors of the body of the figure and the tips are in contrast, the blue-yellow figure has black-white ends, the pink-white has yellow-blue tips and each combination is reversed for the other figures.

The horns of the Water Oxen of Pl. XXXIII are made up of entirely different color combinations and they are placed at the sides of the face rather than on the head. The black figure has pink horns with black tips, the yellow has black horns, blue tipped; the blue figure, yellow horns black-tipped; and the pink, blue horns with black tips. The horns have their position so as to accommodate an arrow headdress from which the various lightnings flash as they do in Pl. XXXII where the arrow-point is not used.

The Water Horse is a four-footed image with feet of cloud symbols and each pair of legs bent inward like those of many animals. The pink figure of Pl. XXIX has the knee joints, but none of those in Pl. XXXIII have them. Straight lightning forms the hair of the forelegs and the mane. In Pl. XXIX it furnishes the tail also, and a portion of straight lightning is breathed out of the mouth, from which no life line extends to the heart. Rainbows make the horns of this monster in all versions, and there are four on its body.

In Pl. XXXIII the mane of straight lightning rises from the rainbow border of the upper part of the body which runs continuously to the end of the tail. There are rainbows on the upper legs as well as on the body. The red-blue cranklike arrangement sticking up from the body is a symbol of restoration. It means that the being has been rescued from death or that it has been restored after having been killed. A life line runs from the heart to the mouth which is a cloud symbol with a rainbow on it.

VIII

Symbolic Elements: Animals and Plants

Animals

A number of animals have place in the drama of the Shooting Chant and of these Buffalo and Snakes occupy a major position. Others, like the Water Ox and Water Horse, belong in a class of mythological beings and have some animal characteristics. Animals are portrayed in stylized form which tends to realism. Others like Big Fly, Cornbug Girl, Pollen Boy and Dragon seem purely mythological and fanciful. Most of these perform the more minor functions in the Chant although these may to the Navajo mind be just as important as the major characters.

Buffalo : The group of so-called "Buffalo paintings" is one of the most interesting in the entire set, both from a symbolic and from an artistic point of view. We have eight paintings of this group, of which six are illustrated (Pls. XXIII–XXVIII).

A buffalo is represented with a long body consisting of two rounded parts with marked constriction at the center where there is a symbol of restoration. There are four legs, each pair bent toward the center at the knee, which, as usual, is shown by small red and blue lines. The legs are hairy. The tail, which is highly conventionalized, is represented by a continuous line to the center of the spine in the color of the animal's border color.

On the forward curve of the spine the mane is shown in the outline color, as are the horns. All of the buffalo of the Male Chant have a black outline at the top of the body and yellow borders of the lower parts, whereas those on the painting of the Female Chant have the usual contrasting color as border, white has black border, blue has yellow, yellow has blue, and black has white, all around the figure. The yellow border of the Male Chant indicates that the buffalo have roamed through vegetation from which they have rubbed off pollen which they carry to other fields in order to bring about fertilization.

The nose is blunt and a red-blue lifeline runs from the heart through the mouth and somewhat beyond. This line ends in two small cross lines. Above it two small eyes are dotted.

Details are slightly different on the buffalo of the Female painting (Pl. XXIV). I have mentioned the difference in color of the bordering lines. Each animal has two symbols of restoration. The life line runs only from the heart to the neck which is represented by four vertical red lines. The eyes are further forward, and instead of being placed one behind the other as was necessary in the narrow space set off by the life line, one is placed above the other in a diagonal line. From the mouths of the buffalo depicted in female colors (white and yellow), zigzag lightnings run to red-blue crosslines, and from those of the male-colored buffalo (blue and black) straight lightnings run in the same way.

These buffalo have whiskers and their horns are black, tipped with white whereas those on the male paintings differ in various paintings.

Pl. XXVII and another not illustrated, are variants of encounters between the Holy People and the buffalo. The buffalo are like those already described for the Male Chant but each has an arrow or a cane sticking into its heart to show by what means it has been conquered. In spite of this, or perhaps because of it, the symbol of restoration is used.

In Pl. XXVIII and in one with only slight differences, the large figures represent monstrosities which were the spawn of Holy Man and Buffalo Woman. The bodies are like those I described for the Male Chant, but they stand upright on the hind feet on symbols of light. The symbols of restoration and of life are used. From the front legs, now turned away from the hind legs and thereby designating arms, the otter strings dangle, and from the left hand of each a string of lightning runs with a feathered hoop at the end. This hoop, which is carried by other People as well, is magic by which they travel, and with it the Buffalo can also quiet the wind (p. 39).

The square face has the attributes necessary to the People of the Chant, among which are the sunhouse streaks, and on the head the red feather headdress. Now that we have become accustomed to the easy Navajo change from an animal or even an inanimate form to those same forms as "People", we should have no difficulty in considering these figures as Buffalo People. The myth, however, informs us that the Navajo consider them abnormalities (p. 40).

Among the "guardians" of the Sacred Twins, of the Holy People, or of the entire painting, are Mountain Sheep, Wolf and Bear. They are pictured according to the same principles as the Buffalo.

The animal on the mountain at the north, guarding the entire painting of Fig. 3 is *Mountain Sheep*. It has a blue body, white spotted horns, well-defined, and a white tail. Its head is toward the east facing south, and it has a symbol of restoration on its body, but no life line. In cases where the animal does have a life line, it extends only from neck (not from mouth) to heart (Pl. XVIII).

Wolf, depicted in white and also with the restoration symbol, guards the part of the double-painting at the south. Its feet are shown as are those of most animals. Its white body has a black line down the back, the ears and tail are tipped with black.

Bear is the guardian facing Wolf and it, too, has a "life symbol". Its body black, has a white line over the top which indicates it is a male, and the tail is white. Bear's feet look as they do because, in his haste to escape the wrath of Slayer-of-alien-gods after the gambling for Day and Night, he got his moccasins on the wrong feet (p. 31).

In the same picture, acting as personal guardian at the left side of Holy Man, is *Otter* viewed from above. She is brown with legs and arms outspread, and five-toed feet jointed with a red-blue motive. At the middle of her body are two small rainbows, the neck is like that of the People, with blue ground, four red stripes and white border. The head is almost diamond-shaped.

Usually Otter acts as guardian with *Beaver*, who is depicted in the same style but easily differentiated by the double-hatched spatula tail, the broad body and head more rounded at the sides. When the Sun gave the Twins a freezing test Beaver Man and Otter Woman came and laid their coats under them (p. 28). Because of this episode two important items of the medicine bundle belonging to the Shooting Chant are collars of Beaver and Otter, and a number of the paintings have the pair as guardians of the east (Pl. XXXIII, Fig. 3).

Fish is a water animal represented in only one picture (Fig. 3) and illustrates the episode where Secondborn was swallowed by a fish. The fish at the four sides of Holy Boy in the South are much like Otter and Beaver, as if one were looking at them from above. The legs are the same as are the neck and head. The tail is shaped like a fish tail and two points on each side of the body represent fins.

The part played by Fish in the adventures of the Holy Twins is further immortalized by using a small portion of blood taken from a live fish in the pollen ball which is given to the patient on the last day of the ceremony (p. 23). It is the reason, too, why those for whom the Shooting Chant has been sung should not eat fish (although there is a general Navajo taboo against eating fish).

After the large Evils had been destroyed by the Sacred Twins, certain Gray Evils who were carried in headbaskets (and may have been lice) held a moccasin game at which they gambled for

Day or Night. *Bat* although he represents Night, was instrumental in causing the ball to fall in favor of the Day People.

At another time Bat summoned the hero to a place where he got help to induce his mother, Changing Woman, to move to her new home.

Bat is a guardian of the east in a number of paintings (Pls. I, XX). He, like Beaver, Otter, and Fish, is represented as if we were viewing him from the top and his wings are spread. The feet and tail are black with white tips. The veins of the wings and the legs are indicated by red lines, and there is a yellow diamond in the middle of the body representing the medicine bundle he was given as a reward for quieting the Thunders. On the shoulders there are black hooks tipped with white (Pl. XX) or white tipped with black (Pl. I) which indicates Bat's means of fastening himself when he sleeps. The neck is the common one and the head is similar to that of Otter, but Bat has white whiskers.

Birds : Each of the Skies except the Night Sky (Pl. XVIII), has its heralds. At the east Yellow-headed Black-bird sits at the south and Nighthawk at the north. Both have white dots.

"On the southern corner of the tip (of Dawn) a yellow-headed blackbird sits. Its neck from the shoulder up is yellow, and the top of its head is red."

The feathers of the nighthawk at the north of the Dawn are also speckled with white.

Toward the north corner on the tip of the Yellow Evening Light in the west there is a bluebird and at the south a blue swallow. That these are facing each other can be seen from the position of the heads, turned to the side, but with both eyes showing. The chief difference between the swallow and the other birds is in the shape of the tail (Pl. XVIII).

At opposite corners of the Blue Sky at the south are Western Tanager and Yellow Warbler, also facing each other. The one is dotted with red and has dark stripes on its broad tail.

Similar to the birds described in the general pattern are the birds of Pl. XV. These paintings belong to the Female Chant and it is said that the birds represent those who aided the Twins on their way to the Sun's House. I do not have the story of the Female Branch, but it is likely that the blue birds represent the small bluejay, and the black, the crow which, according to our story, were the first harmful things overcome by the Twins on their way to the Sun (p. 26).

All these birds have certain general features in common. Their spread legs, like those of Thunder, indicate that they are sitting, the ankle and knee joints are represented consistently as they are in other figures by the small blue and red crossmarks. The head always in profile, although both eyes are shown, shows which way the bird is facing.

Ducks : Treated in entirely different fashion are the ducks of Fig. 3. They are represented with the entire body in profile, moving in line in a sunwise direction. On each little body a small rainbow is sprinkled. The white ducks at the east and the blue ones at the south have sunbeams in their mouths. Flash lightnings issue from the mouths of the yellow ducks at the west, and from the beaks of the black ducks at the north stretched rainbows run out; each of these turn back to the mouth of the duck holding it so as to make a loop. Ducks, Wolf, Bear, Yellow Thunder and Big Fly all searched in different parts of the universe for Holy Boy and Big Fly found him in the belly of the fish.

Insects, or rather mythological insects, are commonly depicted. Of these the most common is Big Fly who acts as guardian of Firstborn when he is in the power of the Thunders (Fig. 3) and a pair of Big Flies frequently guard the eastern opening of the picture (Pl. XVI, XVII). This creature is represented sitting, has a forked tail, two points on each side of its body and neck, and head and headfeather like People. Its arms are held bent with the forearm at right angles to the upper arm.

Big Fly is a monitor in many of the Navajo myths. It sits on the shoulder of the hero, warns him of danger, gives him advice and restores him if overcome.

So similar in appearance to Big Fly is *Cornbug Girl* (Pl. XXI, XXII, Fig. 10) that she is sometimes not to be differentiated. Since she usually occurs with Corn and, as her companion is often Pollen Boy, she certainly represents the pollenizing element. She appears too, on the face of the Moon (Pl. II, D). In Pl. XXII and Fig. 10, Cornbug Girl takes on all the aspects of a person with face

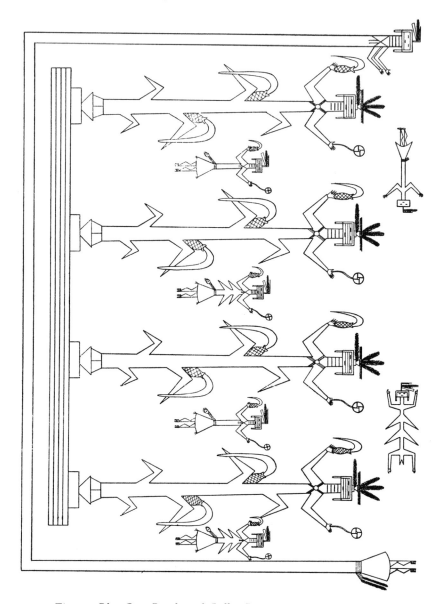

Fig. 10. Blue Corn People with Pollen Boy and Cornbug guardians.
From a painting by Miguelito

markings, soft feather and objects in hands exactly like the Corn People she guards at the right. The description of Pl. XXI says Cornbug Girl is at the north and Big Fly at the south. In the painting both look alike.

Pollen Boy, the companion of Cornbug Girl, can be classified, only mythologically or symbolically. He always has a long unornamented body but he has feet and a skirt even in the simplest portrayal (guardian of Pl. XXII, on Sun in Pl. II, B). As guardian of the Corn People at the left in

Pls. XXI, XXII and Fig. 10, he has the more elaborate features of the People and they correspond to those of Cornbug Girl. Pollen Boy is often portrayed in pollen rather than in sand.

Cornbug Girl is chosen for prayerpaintings of women patients, Pollen Boy for men.

Dragonfly, a symbol of pure water, is shown hovering over water, or water on mountains, as in Pls. XXII, XXVI, XXVIII, XXXII).

Sun's Tobacco Pouch : At the risk of apparent inappropriateness I am going to discuss the Sun's Tobacco Pouch (Pls. I, XX) here. The reason is that there is no Navajo category to which it belongs if it does not go with the guardians, the Bat in particular. It is a long gracefully-shaped red object with blue-pointed ends and elaborate fringe of fawnhoofs, and a border of points which represent porcupine quills. The central part is marked off by blue lines. On it the blue circle represents the Sun, the blue triangle is his pipe, the white at one end represents a smoke, the black speck at the narrow end a bit of tobacco root. The long blue object beside it represents the Sun's pipe cleaner. It is not always present.

One of the tests of power given by the Sun to the Twins, and oft repeated by them later to test others, is the smoking test in which the tobacco is drawn from the Pouch.

Plants

Corn : Plants are depicted extensively in the Shooting Chant, but except for Corn, there is only one case in which they become People (Pl. XXVIII). Corn however, is used frequently, as one of the corner medicines and also as a main character, in which case there are Corn People.

When described in the myth the feature stressed is the number of ears or leaves the corn plant has on each side. Of Fig. 6, which has black corn in the center, the myth dictates:

"... then (in the home of the Snakes) sand-paintings were made for him (Slayer-of-alien-gods). 'These Earth People will use in future,' he was told and the sandpaintings were rolled up. One of them was opened for him. And behold! He saw the corn extending in the center of the room with twelve ears on each side"

The blue corn of Pl. III has six ears on each side and that of the southeast corner of Pl. XXII has an ear and a leaf on the right side and an ear and two leaves on the left. These are the more common arrangements. Corn like other herbs, springs by three white roots from a cloud (Pls. III, XXI) or from a body of water (Pl. XXII) and it is often surmounted by a bird (Pl. III). Some medicine-men say it should always have a bird on its tip. There is a close connection between birds and good crops. Yellow-headed Blackbird told the People that if they saw him in large numbers the crops would be good.

Corn People have these roots instead of legs and the leaves and ears are arranged similarly along the sides of their elongated bodies (Pls. XXI, XXII; Fig. 10). In Pl. XXI the arms seem to take the place of the upper pair of leaves. Corn People carry a ripe ear in the right hand, in the left, a small circular basket containing vegetation pollen and dew.

Heads of the Corn People are exactly like those of other People but there is always a prominent corn tassel arrangement as a headdress. In Pl. XXI this is placed above a large dark cloud symbol, which is present also in Pl. XXII, but is much reduced in size.

In addition to Corn, a number of other *herbs* are represented, many of them in a general way, with three white roots, and five leafy stalks with tips (Pls. IX, XVII, XXIII, XXV, XXVIII).

"Medicines" are often combined and a few important cultivated plants, like corn, have their designating conventionalizations. The "medicines" which form the Greek cross of Pl. XXII are typical. At the southeast (east to the Navajo) there is corn; at the southwest (Navajo south) there is

bean with five stalks from each of which bean-pods hang down; at the northwest, squash with two angles on each side, from each of which projects a leaf and a fruit, and from whose end a tendril winds; at the northeast there is a medicine, which, in addition to the five stalks described for herbs in general, has white flowers along both sides of each stem, designating it as tobacco. Other paintings which have these medicines are Pls. XXXI, XXXIII, XXXV.

The only difference in the plants on the body of Earth, Fig. 5, is that the plant at the northeast (north) does not have white flowers. Tobacco may be represented without flowers, in which case it cannot be distinguished from other "medicines".

The colors of the plants differ throughout, those of each painting depending on the particular function for which it was made, i. e., the branch of the chant, the sex of the One-sung-over, and other particulars.

Except for the Corn People, there is only one example in which the "medicines" become People. In Pl. XXVIII the center stem of each plant is broadened to indicate a body and on it is painted a neck and head which meet the general requirements of these body-parts. The head feather is the turkey-tail bundle.

IX

Symbolism of Locality

Centers

I have already hinted that locality is of the greatest importance to the Navajo. Names of People, of animals, of dangers, names of arrows, of lightnings and of plants, have power when known and used properly, even so names of places are charms. Just as the modern writer or dramatist gives his work setting, so also does the Navajo myth. Whenever a protagonist meets someone who is powerful the first question he must answer is, "where do you come from?"

The Sun, after testing the boys in many ways to prove that they were his sons, and after giving them various gifts, each calculated to furnish some form of invincibility, did not yet trust their power against certain things and went with them to lend his aid. After a successful encounter with Rain Boy, Rain Girl, Hail Boy, Hail Girl, Water Boy, Water Girl, and Rainbow Boy and Rainbow Girl, he stood with them at a certain point and, as final proof of their prowess, had them name the "directions" of the earth:

"What is that my children?" he asked.
"The center of the earth."
"And what is that yonder?"
"Black male medicine."
"And that over there?"
"Yellow female medicine."
And so it went and each time the boys answered correctly because of the Wind which sat on their shoulder and prompted them. Then the medicines were like people who talk and they were placed in the center of the earth for them.
"Where did you start out from, my children?" he asked.
"From yonder where Whirling Mountain stands, that's where it was."
"And what is that there?"
"That is Pelado Peak."

And so the places were named. Not only were there places now extant in or near Navajo territory, but there were many mythological spots not known now at any rate. There were also Corn Mountain, Mountain-of-soft-goods, Mountain-of-hard-goods, Pollen Mountain, Cornbug Mountain, and Chief Speaker Mountain, places which can be only mythical (p. 29).

Nowadays there are four sacred mountains of which San Francisco Peaks are reckoned the western and Mt. Taylor the eastern, but the medicine-men do not agree about "those in between", that is, at the north and south, for they count La Plata, Huerfano and others as equally sacred. It may very well be that they do not restrict the number to four even though that is the number mentioned in the myth.

Just as deity, sky, earth, and animals are mentioned in the songs and prayers, so are place-names. In the prayer for injuries received by water:

"Changing Woman's son I am, I say it
"Changing Woman's grandchild I am, I say it
"At the place called Whirling Mountain, at the house built of white corn, at the conical hogan built
 of white corn

"From below Talking God, carrying the talking prayerstick, comes for me
"At the place called Sitting-place-of-the-white-corn-image
"From above it, Talking God, carrying the talking prayerstick, comes for me
"At the place called white-corn-with-the-image-of-footprints
"From above it, Talking God, carrying the talking prayerstick, for me comes
"Saying, 'Where is my grandchild?'
"So he comes."

The prayer of the circular prayersticks begins:

"At Sky-reaching-butte
"At House-made-of-darkness
"Black pollen with which he conceals his body
"Black Horned Rattler, young chief, your sacrifice, I have made"

And each new stanza starts with the same name.
Another prayer to the Horned Rattler begins:
"Fallen-away Mountain, at the house of mirage" and the next verse:

"Striped Mountain, at the house made of Rainbow..."

And thus with geographical words is the chant made exacting.

The tangible representation of place may be made with stage properties, as is that of the Sun's House which is a part of the bundle paraphernalia set up as a part of the altar. But even if this, or something like it is used, place may be designated also by the centers of the paintings arranged in cross-formation, and it is not a simple matter to interpret these from the completed picture, for centers, more than any part of the picture, are composite and their composition which is in layers, can be known only from the instructions given in the myth.

Sometimes the painting is made around a fire, sometimes the fire is indicated by a red cross (Pl. V). Again, a bowl may be buried in the sand at the center and filled with water, thus making the representation of water realistic. Often however, sand is sprinkled, in many layers if need be, to denote the necessary symbolism.

The center of Pl. V appears as one of the simplest centers. The rectangular yellow design represents the top and last of the Snake houses with the fire as a red cross in the center. A black layer was laid first, over it a blue, then a white, and finally the yellow one which we see. Each shows a little at the edge, and the red protection against danger is the outer line.

This center, being rectangular, represents a home. More often centers are round and the simplest are like those of Pls. XXIII and Fig. 3. The black circle generally represents a mountain, the white and yellow stripes around it may represent day streaks or sacred corn meal and pollen, and red outside may be a protection from or a warning of danger. Sometimes the different layers of color are indicated by many-colored dots. The description of the center of one of them explains how this design represents a mountain:

"First there is Mountain-fallen-away, its lower part sprinkled black to represent charcoal (of herbs burned ceremonially), over this white represents dawn; over the white, blue for blue sky; then yellow for evening light and finally over all, black to represent the mountain itself. As it stands the entire base is encircled with lines, white, yellow, blue and red, the last two composing the rainbow circle."

Slightly different but using the same elements is Sky-reaching-butte, the "center" for the southern part of the double sandpainting (Fig. 3) which actually lies in the west:

"This butte is not constructed of anything common. First, clay for pots is obtained and carefully kneaded on a flat stone so that even the finest grit is removed. At the bottom it is wide, it tapers toward the top but not to a point.

"After it has been made, the place where it is to stand is levelled off. Pollen is sprinkled in a cross and around. Then black made from burned herbs is sprinkled on to represent darkness. White sand sprinkled over this represents dawn, blue sand, blue sky, and yellow sand, yellow evening light. On the flat top it is all yellow to represent pollen and beside the yellow is a small black circle and across this a red cross to represent the fire inside.

"All around the base circle there is black, and four lines—white, yellow, blue and red. Around this standing butte four small bowls of water are set, all being within the black space. Around each rim there are four lines, white representing foam; yellow, pollen; and blue and red, the rainbow. In the bowls on the water are four rainbows in the four directions, the inner, red, the outer, blue. The lichen which is found under sagebrush is put around these bowls of water."

In Pl. XXIV the mountain is plain black, outlined in white and the four rainbows which often lie horizontally in each direction (as in Pl. XXIII), are carried out to the corners of the picture where they separate the white lines which represent the buffalo trail in each direction.

The description of Pl. XXXV is detailed about the center, but it must be remembered that all patterns which look the same, do not *mean* the same thing.

"When the painting of the Arrow People is made, a small cup of water is put down and sand is spread around it and smoothed out. Then the water is covered with herbs so it cannot be seen. Black sand is sprinkled over this to represent the sacred dark water. On top of this there are four small rainbows, one being placed in each direction, red being outside, blue inside. These are made on the surface of the water.

"On the edge of the cup a white line is made to represent foam. On this is a yellow line to indicate water pollen, then a blue line and finally a red one, making a circle of lines to represent a rainbow."

Belonging also to the center which represents water and its attributes are the four circles around it, also explained:

"In the east a blue circle with white border extends from the encircling center lines, to represent a turquoise mountain; in the west is a whiteshell mountain with blue border; in the south, an abalone mountain with red border, and at the north a redstone mountain with pinkish border."

Similarly, the circles of Pl. XXVII seem to indicate the Buffalo Mountains which the Holy People took over one by one, in this painting black at the east; white, at west; blue, south; and yellow, north.

Whole groups of paintings show a center like that of Pl. XXXV.

It will be noticed that the centers of Pls. XXV, XXVI, XXVIII are alike in form and in background colors, although slight differences exist in the outline colors. It may also be noted that the four petal-like designs which spread from the central dark circle each have a delicate tracery of decoration. These are all Buffalo paintings. The description fits them all, but there are slight variations due to different encounters with the Buffalo, different requirements, and the use or omission of other symbols in the picture.

When Slayer-of-alien-gods met the Buffalo in the shape of human beings, they told him their names and where they came from (Pl. XXVIII; p. 39):

"The one sitting nearest him is Abalone Woman who lives in the house of darkness from the center of which it is white with dawn (east). The next is called *nɑsidídiˑn*. He lives in the house of dawn the upper part of which is black with the darkness (west). The third is *ayadjil'ai*; his home is of sky blue with the upper part of yellow evening light and fourth is Small-yellow-one who lives in a house of evening light, the upper part of which is blue sky (north)."

The Buffalo People asked the hero to accompany them and they journeyed far. Finally they came in sight of the Buffalo ranges: white to the east; yellow at the west; blue at the south; and black at

the north. These colors, which differ from those given, probably do so because they represent danger and the red line around those of Pl. XXVIII represents protection from that danger. Having been admonished against trespass, Slayer-of-alien-gods started off to investigate (p. 39):

"He ascended the white mountain range at the east from the north end and saw a beautiful place where white medicine in the shape of humans lived. There were men, women and children, all very happy in their home where rain constantly sprinkled over them.

"The next day the hero went to the yellow range in the west and climbed it on the south side. Here he found Yellow Medicine People and many birds living.

"On the third day he visited the blue range where Blue Medicine People lived, and on the fourth, the black range in the north where he found Vari-colored Medicine People living.

"Because he did this the Buffalo People he was visiting were attacked. But Slayer-of-alien-gods was able to defeat the enemy Buffalo and for this reason all the medicines, sandpaintings of Medicine People, of mountain ranges and of White Buffalo were given to him."

The petal-like patterns on the pictures represent the homes of the peaceful and subdued Buffalo, and the ornamentation on them is Dragonfly, an insect which hovers over the sacred lake on the mountain-top. In Pl. XXVIII, the Medicine People are shown in the four corners.

Pl. XXXI, a painting of the Thunders, has a center exactly like those just described. The center illustrates the home of the Thunders and the symbolism is nearly the same. On top of a black mountain at the east stands a black tree on which Black Thunder sits. A Blue Thunder lives in a similar place in the west, a Yellow Thunder similarly at the south, and at the north, sitting on a pink tree on a pink mountain, a Pink Thunder lives. Here they guard rains, fogs, waters and hails.

Although the design of Pl. XXXI is the same as that described, the colors are different, representing a slightly different occasion, but the center of Pl. XXX with the same design has the colors designated.

With the same colors, but with almost triangular spaces, is the center of Pl. XXIX. More elaborate are the components of the centers of Pl. XXXIII which has the same colors as the description of Thunders' home, but in this and in Pl. XXXII the forms seem to represent clouds on which the dragonfly is shown. The colors of Pl. XXXII are changed, for this is a painting of Water Oxen and Pl. XXXIII depicts the Thunders with the Water Monsters.

A center with similar shape and indicating clouds, but in blue (gray) is that of Pl. XXII. One time as the Holy People journeyed they tried to help an old kernel of white corn which was almost dead with thirst (p. 38):

"In the south there was a range of gray hills and on it some smaller hills. Holy Man (Slayer-of-alien-gods) went to the top of this and spoke, 'White Corn Boy, White Corn Girl, Pollen Boy, Cornbug Girl, these four are dying of thirst. Upon them this day let Dark Cloud and Male Rain descend. May you, Water People, Dark Mist and Female Rain come to them. Ye, Sky People, with vegetation pollen come down upon them. Summer People, with vegetation dew come down upon them.'"

Once more the Dragonfly which leads the way as one of the Spirits of Moisture, is laid on cloud forms.

The myth explains the center of Pl. VII (p. 38):

"Then he (the hero) was told to go to Striped Mountain where the Arrowsnake People lived with the Rainbow People. There also he found the painting already made. Again the mountain is the chief object, but there are no different colors sprinkled one over another, but the whole thing is black and piled up like an anthill. From east to west a rainbow runs across it, red to the north, blue, south. Another crosses this from south to north, red toward the west, and blue toward the east. This is strung out blue toward the mountain, red outside."

This quotation being interpreted means that each part of the rainbow is left open "so there is an entrance" and for this reason there exists the charming design which revolves. The reference that there are no different colors superimposed, is to Mountain-fallen-away described on p. 70.

In a single day Slayer-of-alien-gods had visited Butte-reaching-the-sky, Mountain-fallen-away, and Striped Mountain and he had one more, Coiled Mountain, to visit before the end of the day. This mountain is illustrated in Pl. X, XIII and Fig. 3, in the last of which it is called Mountain Taylor.

"When he arrived there was only one mountain which was dark toward the east, white toward the west, blue to the south and yellow toward the north."

Continuing, the myth describes Pl. XIII particularly:

"At the west side of the mountain there is supposed to be an entrance where the tail of the Track Snake starts, and winding twelve times in a coil, its head comes exactly in line with its tail. Here the hero entered and again found the painting finished."

This Snake is one among the few paintings which has red, i. e. poisonous fangs (cp. guardians of Pls. V, VI). When the fangs are yellow they are not poisonous.

Pl. X seems to represent Whirling-Mountain, a place to which Slayer-of-alien-gods went to get help in inducing Changing Woman to move to the new home Sun had made for her (p. 33).

In Pl. XIII Coiled Snake itself is the mountain:

"In the center is one coiled twelve times with head toward the east and exactly in line with the rattle at the opposite side which points toward the west."

It seems that the center of Pl. VIII is the home of the Rattler People where they made place for Slayer-of-alien-gods when he insisted on staying. The red cross may be the fire. "The hogan had four different colors, dark at the east, sky blue at the south, yellow evening light at west and at the north, dawn. In each corresponding direction were dark, white, blue and yellow pollen."

This does not explain the extra rainbow circle around the whole. The colors are slightly different in the picture but they may represent the hogan of the Snakes after they were conquered.

Several paintings have such elaborate and unusual centers that each must be described for itself. Pl. XVII, one of the most intricate of the whole series, represents the Flint painting of Hanging Cloud:

"Exactly in the center lies the sky round and dark with a white border, then yellow, blue and red circles making four. A finger width from the center to the south is a black object with a white border and to the north, a blue one with yellow border.

"Toward the east two male zigzag lightnings of the black flint dart from the black pouch. From the front (i. e. top) of the black one four flint points project upward and from its back (i. e. bottom) five jut down. The blue pouch at the north has its head to the west where two lightnings dart from its end, and four blue flints project from its front, five from its back.

"On this black circle twelve zigzag lightning shafts lie with barbs to the east. Two lines represent each, a black at the south, white at the north. Toward the west twelve blue straight lightnings without barbs lie. These lightnings run out in two lines, red, north, the other blue.

"In the south twelve sunbeams with two angles lie, on the tip of one are yellow flint male barbs; that is, one line is yellow, the other white.

"At the north twelve rainbows are stretched straight, with unbarbed serrate (pink) points, the red line to the east, the other blue. Their borders are white and where they meet a white line is also made."

This center is consistently matched by the Flint clothes and pouches of the Flint People.

The center of Pl. XXXIV was described with the Whirling-tail-feathers carried by the Holy People (p. 34).

The elaborate center of Pl. IX has two explanations, neither of which is in our myth. Miguelito explained the large black rectangle from which Snake heads and tails project, as the home of the Snake. The blue center within, he interpreted as a metate and the rainbows on it as manos.

Galison of Newcomb, on the other hand, calls it the Black Snake House which is being transported by the Snakes which are interwoven under it. That is why a head on one side is opposite a tail. The white center, corresponding to the blue one of Red Point, is said to be the Spirit House and the People around it serve the Snakes.

Bars

The centers give the setting for those acts of the myth recorded by the paintings which are arranged in segments made by a cross or two crosses from the center, and even of those commemorating Coiled Mountain. Another common mode of arrangement is to lay figures side by side in a row, sometimes around a central unifying motive. When the first arrangement is used, there is usually some element — rainbow, arrow, feather — between the center and the deities represented in the segments set off by a motive radiating from the center. It happens also that some of the figures depicted in a row must have some protecting element upon which to stand. Arrows and rainbows have been described. There remain a few other elements which should be interpreted.

The Holy People in Pl. XXVII stand on rainbows reinforced by arrows under which lie feathers. These represent "handmade feathered arrows which belonged to White Buffalo before they were subdued."

Under the Buffalo People of Pl. XXVIII are horizontal bars made up of combinations of male and female colors (black and white, or blue and yellow). These represent the colors of the Buffalo homes on the various mountain ranges which have been quoted (p. 71); ". . . Abalone Woman lives in a house of darkness from the center of which it is white with dawn, etc."

The Crooked Snake People of Pl. IV stand on a broad black bar, white-bordered, which represents the world below the earth.

The different snakes of Fig. 6 lie over a black bar of the same kind which has white dots on it and is surmounted by a black cloud figure from which the three roots of the black corn grow. The black bar is water and the white dots represent seeds to which the Snakes take messages.

The four Corn People of Pl. XXI also sprout from the cloud symbol. The black is to represent water which was furnished to the Corn, and the white dots are foam.

A more complex bar is the one from which the Blue Corn People of Fig. 10 spring, each color of the bar represents a kind of corn.

It should be noted in this connection that the cloud from which the blue corn of Pl. III springs rests directly on the Rainbow Deity instead of on a body of water.

X

Composition

The discussion of design elements has necessarily given hints of the principles of composition. They are not many, but the variations on a single theme are surprising. The prayer paintings are simply motives used alone. They may be combined in large pictures and it is the composition of these which concerns us here. The Shooting Chant and some others use a huge fire for sweating with dry heat, whereas other chants use the sweathouse. When the fire is used, some element from a larger picture, a cloud figure from Pl. XIX, for example, may be made at the west of the hogan. The basket containing the emetic stands on this painting. Snakes or arrows of sand form small paintings near the fire at the same time.

The sweathouse is a slightly cone-shaped protuberance in sand, being mainly underground. Paintings may be drawn over this and often they represent a trail with tracks leading up to the main figure on top.

The paintings are often classified in groups by the Navajo and we have arranged them thus inasfar as possible. The group containing the most paintings is that of the Snakes. Following them are Holy People, Flint People, a group each of Skies and Sky People, Corn, Buffalo, and Thunders with which Water Monsters are classed, since they are closely related. All the principles of composition are demonstrated by each group except the Buffalo and Thunders.

A common arrangement is that in which figures, usually four, but sometimes two or multiples of four, are laid in a row. Generally these are greatly elongated, for length gives power (Pls. IV, VI, XIV, XVI, XXI). Since the paintings are on the floor, we look down on the figures and they do not seem to lie on their sides. When more than four figures are used as in Pl. III, the power is in repetition, and naturally the figures are smaller. The oftener a figure is drawn, the greater the strength of the painting is thought to be. Mrs. Newcomb once saw the painting of Pl. III with thirty-two snakes.

The same symbolism applies to the other common arrangement, where from a center four divisions of the space are made. Sometimes plants growing from the center which represents a supply of water (Pls. XVII, XXII, XXV, XXXI) form them, and again they are made by additional representations of the main figures (Pls. V, VIII). There are two arrangements of crosses, one in which the deities form a Greek cross and the plants or other figures, a St. Andrew's.

A characteristic of composition which is obvious only when the painting can be seen in large sets, is the placing of motives in arrangements which vary from the simplest to the most complicated in which all elements of a kind are present. Fig. 10 has its ultimate realization in Pl. III; Pl. IV in Pl. V; Pl. VI in Pl. VII. Fig. 10 introduces the elements, Pl. III uses them lavishly. Pl. IV shows simplicity of treatment with length, Pl. V, repetition carried far. In the last, four Crooked Snake People form the Greek cross while four crooked snakes take the place of each arm of the St. Andrew's cross.

Often a pair of figures or People occupy the position ordinarily forming the Greek cross in which case its form is obscured. This is the case in Pl. VIII, in which pairs of Big Snake People stand on rainbows in each direction. The sectors are made by Big Snakes and here is another example of the convention of repetition. One painting representing more figures, or another depicting fewer, will

be used according to the sum paid the Chanter. The paintings involving a large amount of work are used when the payment is large, the simpler ones when it is small. There is no indication that simpler and therefore cheaper ones, are less effective.

Fig. 8 and Pl. XVIII give an impression of divergence from the usual composition. Fig. 8 is merely a simple arrangement of Sun, Moon and Winds which in Pl. XVIII becomes the central theme, and because the Skies are so highly elaborated, is reduced in size. The circular designs add to the impression but they are actually arranged according to conventional rules.

Corn People (Pls. XXI, XXII) illustrate once more the general rules as do the Buffalo, although the Buffalo pictures have interesting variations. Thunders and Water Monsters, doubtless because of their form never have the elongated arrangement but always, even in the simplest painting of Pl. XXIX, are placed within one of the four sectors. The most repetitious painting, Pl. XXXIII, uses four Thunders, one in each sector and each has near it a Water Ox and a Water Horse. Thus all the overhead and underground water powers are represented at one time.

There are certain paintings in which the central motive is enlarged so as to take up nearly all the space. Pl. XV is an example of such an arrangement. The circle representing the Sun's House on which lies the elongated figure of Slayer-of-alien-gods really constitutes the picture although at each direction a rainbow, bird and bow are shown. That this is thought of as the usual composition is indicated by the encircling motive which is, in this, an exceptional case, open at the northeast instead of at the east. This is of no significance in Navajo thought for they consider the whole arc from 0^0 to 90^0 as east.

This and its companion picture, Child-of-the-water on Moon, not illustrated, as well as that of Fig. 5, the Earth and Sky painting, belong to the general chant lore. That is to say that, although they are used in the Shooting Chant, they may be used in various others as well. The Earth and Sky picture demonstrates a further variation from the usual norm. In this only two figures are shown, but they are enlarged and treated in such detail that they become the picture. In the one case the center occupies the major field, in the other, only two enlarged motives.

Generally some guardian — rainbow, mirage, lightning or arrows — device encircles three sides of the picture. Often in this Chant, but not always, there are two small guardians of the eastern opening.

Although the pictures give a general impression of versatility, they are bound quite strictly by the requirements of these few conventions. There is perhaps none to which there is no exception and in considering the composition of certain paintings these will be noted, for it is by variation in the combination of the particular elements and also by rationalizing exceptions to the rules, that some of the most striking effects are secured.

When we discussed the function of centers we showed that some were enlarged or elaborated beyond the ordinary limits. We may now look at the most outstanding of these from the point of view of composition. Pl. IX represents the Grinding Snake picture which is considered unusually effective by many observers. The effect is due to the large black center relieved in two ways, within by the white space on which two rainbows lie, and outside by the border of alternating snake heads and tails. Even without knowing that these represent the bodies of the snakes interwoven underneath their black home to make a raft to transport it, we should expect the head-tail arrangement to be impressionistic.

Because the center has been greatly extended, the plants marking the corners are somewhat reduced in size, a device which is found with other extended centers. The center having been changed in Pl. IX, the rest of the picture fulfils the rules in every detail, but necessarily the figures of

the People are not as long as usual. Frequently the figures depicted in pictures with the two cross divisions, stand on some protective device, most often a rainbow and this painting is an illustration. In this case because the center is large and because there is a pair of Crooked Snakes in each sector, the rainbow is long. The rainbow separates the figures from the center in Pls. VI, VII, IX, XV, XVIII, XX, to mention only a few. All of these are sector spacings and we have come to look for this use of the rainbow in such compositions. It is not very common on those in which figures lie in rows, but each Crooked Snake of Pl. IV stands on a rainbow, and none does in Pl. V where the more ordinary composition is found.

When something occurs or does not occur, the reason, though it may perchance be artistic in reality, is nevertheless likely to be couched in symbolic terms. The Snakes of Pl. V need no protection because they are standing in their home represented by the rectangular yellow center. It is likely that the Snakes of Pl. IV require rainbow protection because they do not have it in the encircling guardian (Mirage) whereas those of Pl. III do not need it because the guardian, Rainbow, furnishes it. Sun, Moon, Black and Yellow Winds seem to require rainbow protection except when they are represented by the baskets in which they are carried. In the prayer paintings of Pl. II, A, B, D, each figure has a rainbow in four directions, in that of Pl. II, C and Fig. 8, both of which are protected by the basket feathers, there are no rainbows. In considering other compositions we shall return to the use of the rainbow.

Other motives in the same position between center and figures are arrows on which the Arrow People of Pl. XXXV, and the Holy People of Pl. XXVII stand, and in Pl. XXVII, both arrows and rainbows occupy this space. Symbolically the bars on which the Buffalo People of Pl. XXVIII stand belong with the description of centers since they indicate locality; artistically, they belong here for they occupy the same space as the rainbows and arrows. It should be noted too that plants spring directly from cloud symbols attached to some water-giving element (Pls. XXI, XXII), no matter which composition is used.

The digression on rainbow "platforms" has served us well and will continue to do so since it is a fundamental characteristic of composition. Each of the figures of Pl. XV stands on a whole bundle of arrows of its particular kind. These are symbolical of the exaggeration which exists consistently in this painting from center to the unusually armored clubs held by the Flint People. The black center which is not larger than usual is extended by the arrows which shoot out from it in every direction making a kind of wheel figure. The clubs with zigzag lightnings on their surface are also quite consistent with the "flinting" motive. Because of the extension of the center and the emphasis on the flint clothing of the figures, the plants which divide the sectors are somewhat reduced in size. The arrow-bundles on which the figures stand, as well as their clothing and weapons, represent a perfect orgy of flint and lightning. There is probably no other picture in the entire collection in which repetition is carried as far as it is in this, and in none is it more consistent.

Comparable with the center of Pl. XVII in the manner of its extension, is the center of Pl. XXXIV, although the total effect of this is not so far-reaching. This center has been described as the Whirling-tail-feather which was overcome by Holy Man (p. 34). The white face reminds us of the Moon but the twelve tail feathers of white, black, blue and red furnish the balance and tone for the entire picture. They are brought out more emphatically by the device of repetition used in Pl. XVII in that a simplified variant of the central figure in different colors swings off from the bow of each figure forming a swastika design of the whole.

The centers just described indicate the unusual possibilities inherent in the development of one element of design. The extension of the center of Pl. XV was shown to be almost the making of the

picture, but in it other elements are also felt to be necessary even though they are reduced. The center of Pl. XII, as that of Pls. XVII, XXI, likewise sets the theme. The huge black coiled snake represents Coiled Mountain and it is surrounded by four smaller coiled snakes, the whole protected by a black Snake circle.

In my opinion we have hardly as effective a pattern as this unless it be that of Pl. XIII or of Pl. X. All three are astonishing in their simplicity, and to that and the originality of arrangement is their effect due. The White Snake of Pl. XIII coils out from the same mountain center as the Whirling Snakes of Pl. X, and with its coiled body extends the center so that it practically becomes the picture.

This picture is remarkable in that it has been discarded as being too powerful for the knowledge of the medicine-men near Newcomb since everyone for whom it was used died. The reason for this is again in symbolic detail. The other coiled and whirling snakes have their heads and tails in opposite directions, this has both turned to the east. They have yellow fangs showing them to be harmless. This one has red fangs, symbolic of danger. The Mountain from which the Whirling Snakes derive is surrounded by red, signifying destruction overcome, the White Coiled Snake *is* danger. And last but not least, the large white snake is surrounded by an unbroken circle of crooked snakes signifying power so great that even the convention of the open circle may be disregarded.

Of different significance are the closed-in pictures, one of which shows Holy Man in the power of the Thunders (Fig. 3, north picture) and the other, not illustrated shows Holy Man and Holy Boy in the Sun's House. These pictures, unlike that of coiled White Snake, show how the protagonists got into the power of those about them and got out again, armed with the very powers which overcame them. The thing the Navajo at Newcomb have lost is the restoration power of the Coiled White Snake which they once had. No painting was originally wholly evil.

The series of Buffalo paintings, Pls. XXIII–XXVI, XXVIII, demonstrates different combinations of the principles which have been explained. In Pl. XXIII, the rainbows are on the mountain represented by the black center from which the plants spring. These, in contrast to those of Pl. XXIX, are carried out to the very edge of the circle. In Pl. XXIV, which lacks the herbs, the rainbows are not on the water-element, nor do the Buffalo stand on them, but they form the sector lines, being placed aslant at the four corners. In Pl. XXV they occupy their wonted position between the center and the Buffalo. The Holy People of Pl. XXVII, need not only a rainbow, but also a male and female arrow between them and the center mountain homes of their Buffalo enemies.

The arrangement of the white zigzag Buffalo trails is interesting in this series. In Pls. XXIII and XXIV one of these trails leads from the forefoot of each Buffalo to the source of pure water known to be on a mountain. In Pl. XXIII the usual four-sector division is made by the plants, in Pl. XXIV it is only simulated, but the rainbows across the corners make it quite clear nevertheless. In Pl. XXIV the Buffalo are the main figures, everything about the picture is conventional except that the trail twists around the rainbow to the water source of the center. In another, the Buffalo and their trails form the sector lines, and the Holy People form the cross as the main figures, whereas in Pl. XXVII Buffalo without trails and facing away from the center, form the sector-lines with the Holy People as the chief actors.

Pl. XXVIII is to be especially noted as the only painting seen by Mrs. Newcomb in which herbs ("medicines," i. e., plants not corn) are People.

I have already suggested how the use of conventionalized elements like Sun, Moon and Winds, influences the composition. This influence is the more noticeable when figures representing such elements as clouds or skies are used. There are three compositions involving the skies in the

collection and they become increasingly elaborate. In one Dawn, Blue Sky, Yellow Evening Light and Darkness are represented by trapezoidal elements of their respective colors on the edge of which twelve feathers are set, and on the body of which birds or heavenly bodies are drawn. On another the "Sky" is drawn out in a "long feather" in the shape of, but not as long as, those of Pl. XVIII, and from behind the rectangular portions the little heads of the Sky People project, in the same fashion as those of Pl. XIX. Finally, the composition of Pl. XVIII is the most elaborate of them all, for in this the Sky's long feather is so elongated that the person representing that particular Sky can be placed upon it. In all of these the Sun, Moon and Winds picture really forms the center.

Pl. XX which is called "Cloud Houses" is perhaps the most inclusive of the pictures. As in the pictures of the Skies, the Sun, Moon and Winds form the center. Between the center and the rectangular cloud homes at each direction are rainbows as might be expected. Each cloud house has an ear of corn at each corner and on each side of the natural element at the center above it — Sun, Moon, Black or Yellow Wind according to color — there is a cloud bank arrangement surmounted by a bird such as is used on the Sun's House (cp. Pl. XIX). In spite of the fact that these figures nearly fill the space, in some respects in an awkward manner, bent rainbows, each edged with five feathers are placed at the corners. These feathers do not match the baskets in which Sun, Moon and Winds were carried nor do they correspond to those of the rainbow garland, for in neither of these cases do we have yellow. If they match the "houses" as they well might, I cannot explain the red feathers at the southwest. As if this picture were not already crowded with elements and therefore "power" as well as design, it has the Mirage garland and Sun's Tobacco Pouch with Bat as guardians. This picture is a rare one belonging to the Corral Dance Branch of the Chant and for this we do not have the myth explaining the combination of the elements, all of which are quite apparent.

The design of Pl. XI, one of a pair also rarely used, is nevertheless explained. This painting represents Pollen Boy on the face of the Sun, the blue center somewhat, but not unduly, enlarged. As in Pl. II, B rain rays extend to small rainbows in each direction, but unlike Pl. II, B, the feathers of Sun's basket are represented here, two at each corner. The rain rays preserve the Greek cross formation and the feathers the St. Andrew's cross, even though the design is a unit closely connected with the center. The Sun needs all his power on the occasions when this picture is used, after eclipses, and besides, all the elements of the center figure, an arrow of precious stone, one of the trumpets which guards Sun's house, and the magic featherhoop on which he travels through the air, are placed at each cardinal direction. Two snakes, one of each sex, must guard this picture and they are placed head-to-tails.

This picture of a male element, Sun, on which Pollen Boy, another male element stands, is painted for a male patient, and the white snake guardian being female, gives female protection. The companion picture of a white Moon with Cornbug girl, is painted for a female patient, and secures male power from the black snake guardian placed outside the white. These compositions, which are very striking, are secured once more by a ritualistic requirement which demands that power of both sexes or even of opposites should be present. The male picture demands female protection which it gets by arrangement of the guardian and the reverse is true of the companion picture.

The Thunders and Water Monsters demonstrate the same requirement which was discussed under the symbolism of these gods, but in general it influences the composition. In Pl. XXXIII, e. g., Black Thunder at the east has male (zigzag) rain in his tail, his opposite, Blue Thunder at the west has female (straight) rain in *his* tail. Black Thunder has the advantage of blue wing tips, with straight lightning and blue headdress, and Blue Thunder has them black with zigzag lightning.

XI

Artistic Devices

Every convention must compromise with the medium in which it is depicted. The most outstanding feature of this compromise in Navajo art — myth, song, prayer, and sandpainting — is the rationalization in the use of the numbers four and five. Either the Navajo originally had four as a ritual number, picked it up on their way to the Southwest, or completely absorbed it after arrival. But from somewhere, either as an original number as a rhythmic unit taken on from other tribes of the north or of the south, they also got five. At the present time, if there were no visual art, we should have to consider four and five of equal ritualistic importance. At the moment it matters not whether either belonged to them originally, or whether they adopted it, both are used almost equally, and the use of five is often rationalized.

Even a casual glance at the paintings shows that four dominates in the composition. Ceremonially there are six directions, east, south, west, north, up and down, of which four are shown in the paintings. Up and down are included in prayer with pollen and meal sprinkling, but are not often referred to in describing the sandpaintings. So far neither Mrs. Newcomb nor I have seen a painting with an arrangement of five similar figures. With the question in mind I was somewhat startled one day to hear tł'ăh say "The painting has five figures," but before I had sufficiently recovered to inquire he went on, "Two of these figures south, then Corn, then two more," at which my mind once more settled comfortably into the groove of four. The remark illuminates a way of thinking: the counting need not be according to figures all of which are alike, and the unit of repetition is as likely to be five as four. Whether the composition is of rows or of a circular space, the number of main figures is four or a multiple of four. In some cases, there are only two but they are treated the same way.

In the long prayers there is accumulation of words, powers, acts, and results verbally expressed which is quite comparable to the climactic combination of ideas like that in the paintings of Pls. V, XVII, XX, XXXIII, and in these as well as in the paintings (except compositional devices which may be rationalized), five as a unit of repetition is often introduced. An example of such a prayer is a long one, too long to give in full here, for "people hurt in the water." The prayer starts with couplets mentioning places from which Talking God who is addressed, is said to come. From five parts of my house he then "comes to me." There follow lines describing the direction, way by which, and place from which, Talking God "comes to me."

He then "comes to me" after going through eight kinds of rooms each of which in its turn is described by mentioning five items. There are four rooms of each of the following: dark water, blue, yellow, and white water; dark, blue, yellow and white moss, and the description of each runs:

> Going through the first room of dark water,
> Going through the second room of dark water,
> Going through the third room of dark water,
> Going through the fourth room of dark water,
> Going forth from the dark water,

the last sentence being a kind of summary which regularly forms the fifth line in these stanzas.

Talking God now helps me with the talking prayerstick and takes me home with him. From five parts of the home of Water Ox, the same as the five to which he came in my house, he leads me away, and again through these points in each of the forty rooms through which he came to me. We arrive at the home of various Holy Ones and he leads me home again. Four is the dominant unit of repetition in these parts, but it is not the only one, two and six being used also. And finally a unit of five, followed by one of four, illustrates the point delightfully:

> The beauty in front of White Corn Boy shall be the beauty before me.
> The beauty at the back of Yellow Corn Girl shall be the beauty behind me.
> The beauty below Pollen Boy shall be the beauty under me.
> The beauty on top of Cornbugy Girl shall be the beauty above me.
> All beauty surrounding Rainray Boy shall be the beauty surrounding me.
>> All is restored again
>> All is restored again
>> All is restored again
>> All is restored again.

This is only one of many illustrations in which the literary form, which is free to use rhythmic units of any number of elements, utilizes each almost equally.

In accordance with the compositional devices used, the major figures of the paintings never number five. The most outstanding examples are those of Pl. XVI and Fig. 4. Each contains four figures although the myth says that in the attack on Changing Woman, five gods were involved. In both pictures all five are depicted, Slayer-of-alien-gods, Child-of-the-water, Changing Grandchild, Reared-within-the-earth and a powerful Shooting God. Since there are eight figures, three are repeated, but not more than one picture is used at a particular performance of a chant so that only four of the five are indicated on any one occasion.

The unit with five elements is common however, but it is subservient to the major elements. At this point I wish to emphasize only its use in the Shooting Chant, for it seems that in other chants, other units of repetition, three or six, for example, predominate in the representation of minor elements. Slayer-of-alien-gods and his twin, Child-of-the-water, often carry five lightnings in their hands and wear five flints as headdress (although there may be only three). From their clubs, five flint points project, as they do also from the clubs of Pl. XVII. Water Ox carries five weapons in the right hand and is protected by five of the same kind on his head (Pls. XXXII, XXXIII). Holy Boy (Child-of-the-water) at the south of the double painting (Fig. 3) has five points around his neck (shown under his right arm), five medicines in his left hand, and five around his neck (drawn under his left arm). Plants represented by more than one stem (such as corn and squash) invariably have five stalks. The bean at the southwestern corner of the south painting of Fig. 3, and the tobacco at the northeast, demonstrate this use of five.

It is well to note in this connection, that plants spring from three, not from five roots. This difference in number may be an artistic device, for certainly a five-division spread on a three-unit base, or a unit stalk on a three-unit base are more interesting and better balanced than they would be if top and base were the same.

All Thunders are represented with five waterspouts and four lightnings dangling from the right wing and four waterspouts and five lightnings from the left, although the myth specifies twelve of each altogether. I wonder if this arrangement is not an artistic and perhaps symbolic rationalization of five and four. Whether it is or not, it is perfectly adjusted.

Five points indicate flint armor on the front and back of each of the Twins (Pl. XV), and each

has five points to his club, as do the flint-armored deities of Fig. 4, but those of Pl. XVI, although having five points on their clubs, nevertheless have five flint points at the back and only four in front, as do those of Pl. XVII. Each figure of Pl. XVII stands on a bundle of four powerful weapons, carries five in the left hand, has five on the head, and five dart from each side of the club which has five points on one side and four on the other. Five weapons run out in each direction from the moon to the rainbows of Pl. II, D.

The feathers of the encircling garlands, Rainbow and Mirage, are in bunches of five. When the otter strings dangling from the arms of People are decorated, the tendency is to use five pairs of feathers. Although all do not stand at the same angle, there are five feathers on the heads of the Snake People of Pls. III, IV, V, VI, VII, VIII, IX, three standing upright, one leaning a little, and the other pairing with the turkey-tail bundle at a right angle to the head.

Another rationalization which is merely for artistic effect is that of the description of contrasts. Figures are said to have "white feet black-bordered" or "black feet, white-bordered" (Pl. XIV), actually all are alike. This is because it does not matter. A white figure should have black feet with a black border and a black, the reverse, but, since the contrast is there, the differentiation has ceased to exist. The description of a yellow figure bordered or touched with yellow pollen or yellow meaning pollen, is executed in yellow background with the usual contrasting blue border which, in this case, is thought of as yellow by those who know its significance (Buffalo of Pls. XXIII—XXVIII). It is customary to show white cornmeal on the forehead and yellow pollen on the chin. If the face depicted is that of Moon, or that of Yellow Wind, either the white or the yellow does not show. Both are thought of as being there, however, and in the case of the sandpainting, are actually there since there are two layers of the same color.

The description of symbolism has indicated the dogmatic uses of color. Black and blue are male colors in all chants, white and yellow, female. The combination yellow-blue-black-white forms the sunhouse colors which in this order dominate the Shooting Chant.

These colors or some of them may, according to the rules of chance, sometimes occur in this combination and have entirely different meanings. For example, a black mountain (or lake) may have contrasting outlines of white, yellow, blue and red. Although they may seem to be sunhouse colors with a red line of destruction overcome, the white signifies cornmeal or water foam; the yellow, pollen; blue and red taken together, a rainbow border.

Most commonly white is the color of the east; blue, of the south, yellow, of the west, and black of the north, but these colors may be interchanged or varied for cause. One explanation of changes may be that the reading is: east, west, south, north, instead of in a sunwise direction, for the one is as common a ceremonial requirement as the other. Other reasons for varying the position of the colors are the sex of the patient and the question as to whether the painting is made for driving out evil or for enticing good. Even these causes do not explain every use of color and once more I may intrude my theory about five. Pink adds a fifth color for large spaces. This must be justified then, even as is the use of four figures when five are prescribed, and it seems to be in the paintings of Pl. XVI and Fig. 4.

The placing of color will be discussed in treating the subject of balance, but here a word about color notions is in order. There has been much discussion about distinctions in color made by primitives which has led to formal psychological tests as well as careful observations on the part of ethnologists. The results so far available indicate that many primitives note the difference between shades of a color, and hues, e. g. blue and green, but do not have names for them. Their categories, even if they do have names, do not correspond exactly with ours. The Navajo distinguish between

blue and green, the latter being more closely related to yellow, whereas sky and turquoise are the purest blue in their minds.

As far as I know, white has no general symbolism. As a dawn color it vies with cornmeal ceremonially, white cornmeal of course being meant. Nevertheless, its extensive use in the paintings is noticeable at a glance. It is often an outline color being used much as some of our artists use black, to unify and bring out a design. It is interesting too I think, that the Navajo use pink to indicate sparkle, for that is what pink means. Iridescence is indicated by "all the colors," as in the center of a painting and on the bodies of Big Snakes used for prayer paintings and not illustrated here, and in the body (curve) of the Mirage symbol (Pl. XXXV). Pink really means then, "motion without color" and iridescence "motion with all colors."

We do not understand the reasons for all the uses of color in major portions of the surface, but in the cases where pink fills one it seems to displace white. In Pl. XVI, the series from south to north is black, blue, yellow, pink. This arrangement corresponds to the east-west, south-north arrangement of Pl. XVII and Fig. 3, and in each case white is missing. In Pl. XXXII the male colors at east and west are reversed, blue being east and black west, and in this case, the only one we have, pink, is at the south, yellow, at the north. A remark about the prayersticks illuminates the matter a bit: "Pink is used on Thunder and Water Ox prayersticks when illness is due to snakebite or lightning; white, when the blessing side of the chant is sung." However, it is said that Thunder paintings are always the same.

These are clues which may help establish rules of color position for the chant, but it is likely we shall have to have much comparative material from other chants before we can determine them. Another interesting note in this connection is the use of a variegated figure instead of a white one in Fig. 4. Perhaps all of these colors are used because there seem to be no White Flints, Thunders or Water Oxen. The pink of Pl. XIX represents Summer People and the color may distinguish them from the Dawn People who are white.

The only picture in the entire collection in which red is used to fill a large space is Pl. XXXV. The Arrow People in this are made of the precious stones, consequently red represents redstone, and variegated stands for the iridescence of abalone. In Pl. XI, the trumpet and arrow which protected Sun's House and were given as powers to the Twins, are painted in brown to represent abalone. Both Pl. XXXV and Pl. XI are unusual paintings and unfortunately we do not know enough about either of them.

Various references have been made incidentally to the use of contrasting borders on figures of various colors, black, a male color, bordered with its corresponding female color, white and the reverse; and similarly blue with yellow and its opposites. Outlining, although it has ritual significance, is also an artistic device, the most important perhaps of all those used. Not only are patterns made with outlines of their contrasting colors, but they often have outlines of as many as four or even five colors. Outlines around centers, around the tails of Thunders and Water Monsters, and a succession of colored lines at the joints of Snakes are examples of these. It is interesting and amusing to note that, since the Arrowsnakes of Pl. III have no joints, these outlines are carried out to the sides of the body.

Since one sand color is laid beside or even on another, it is not surprising that numerous outlines should be made, once one realizes the careful attention paid to detail. However, the fact that outlining, even with two, three, or four colors has carried over to weaving, shows how necessary and satisfactory it is to a Navajo artist, for in weaving it creates a great deal of additional effort since the thread which makes each color must be picked up and dropped for every stitch in every row.

Comparable with the outlining device but lending even more subtle effects, is the use of contrasts on points and tips. Rarely is a feather finished in its base color, a white has at least a black tip, but further, the black tip has just a dotting or slight streaking of white, in other words a contrast to a contrast. Similarly, red feathers have black tips, each with a final touch of white. These are illustrated by the feathers of Rainbow and Mirage garlands, and by the "vibrations" of the tail of Thunders and Water Monsters. Some herbs which form the St. Andrew's cross of many paintings are tipped with contrasting colors (Pls. XVII, XXIII, XXV [all white tips], XXVIII). The bean, which is represented in fruit, also has a flower which lends the contrast to the leaf color, and the dots on the beans which are of different color combinations, illustrate again the same device. Holy Boy in Fig. 3, holds five medicines in his left hand which correspond to those under the left arm and the colors from inside out are black with white tip, white with black tip, blue with yellow tip, yellow with blue tip, and pink with white tip. Corn tassels and ears, skirt tassels, pouch fringes, and medicine bundles all are decorated with the contrasting touches. Snake fangs, generally yellow in this chant, but red in Pls. VI, XIII, have a black tip. Although all patterns on the body are more thoroughly schematized than they are in the sandpaintings, the Chanter always indicates the black tips of the fangs which come at the under side of the first joint of the big toe. This circumstance, as well as the use of the contrast in weaving, shows how fundamental it is felt to be even in those media which require unusual efforts.

As we view the art of primitive people in general, it frequently appears that interest in shades is not specific, but that it centers rather in the relative position of darks and lights. This is a marked tendency but there are not enough detailed studies to make it of general application. Navajo art demonstrates it and adds another example to the steadily growing list. Where the color demands are fixed by dogma, a nice balance is kept between light and dark, indeed, the pairing of colors in sex definition may be a compromise to artistic principle. We do not know and perhaps never shall determine which came first, artistic or religious considerations. The relative and balanced position of light and dark colors is even more noticeable in those designs where the artist, allowed to cast dogma aside, gives scope to his artistic feeling, e. g., in representing the variegated bodies of Holy Woman and Holy Girl (Pl. XIV) and that of Shooting God of Fig. 4 and again in the pouches of any of the deities (Pl. I).

In sketching the work of the painter (p. 20) we have already referred to them, but the devices of superimposition of sand, of sculpturing with attendant superimposition, and of use of realistic objects as a part of the composition, should be noted in connection with the achievement of the particular results we see. Where green is present in the reproductions, (Pl. XIX, e. g.) it represents live green boughs which stand up in the sand of the painting, a realistic object not previously mentioned.

The question of proportion is always an interesting one. The reproductions of the paintings are made to scale with slight distortion at the center where there is a little more crowding than in the originals in order to accommodate all the elements in the reduced space. That the Chanters are conscious of special problems is evidenced by details in the descriptions of the paintings, but more generally they are unconscious of the proportions used because of their feeling for them and the fact that they are accustomed to these above all others.

Of the painting of Pl. VII it is decreed:

"The bounding guardian is a narrowing black arrowsnake with a tapering end and a head like a rattlesnake. Although the distance is long there are only four marks with deer tracks one after another. Two fingerwidths from the head a black bow is placed so that the tongue of the snake touches the bowstring. It means that the dark bow lies at

the tip of its speech. Two fingerwidths from the rattle end is a tail-feathered arrow to which a mark extends from the rattle. In the song of this the dark bow moves along in front of it and the tail-feathered arrow follows."

The painting of Pl. XXXV has the following specification for spacing:

"At the tips of the roots a blue cornstalk rises with five leaves. The tassel is even with the headfeather of the figure."

The double-painting of Fig. 3, is very complicated and certain exact details of relationship are ordained in the myth:

"After the corn is finished Holy Boy is laid down, his head in line with that of Holy Man, the feet of both stepping in line"

"On the south side in line with the tip of the cornstalk Mt. Taylor is placed about the size and shape of an anthill."

Although these are only a few of the verbal expressions of special relationships, there is no doubt that the Chanters have them constantly in mind and direct the painters explicitly. When a Chanter relates the myth he usually indicates the painting by a sketch and then does not feel it necessary to include every detail in the verbal description. He takes it for granted that the listener understands and feels the proportions as he does.

It does not require much concentration to see that the Navajo do not use perspective. Certain symbols represent particular ideas, they may be placed as near the position they actually occupy as possible, but if something else essential has that same position, the first element may just as well be placed elsewhere. Snakes are commonly drawn with three-cornered heads with fangs projecting from the middle point, the mouth.

When, however, they are represented in an upright position facing the audience and have clothes, the headdress may leave no place for the fangs. In such case they may be omitted, as they are in Pls. IV, V, VII—IX, or they may be folded over the forehead as they are in (Pl. VI).

Most of the Holy Ones which are represented as People have red cheeks to indicate the red face color of the last day's painting. This color is a red line at the side of the circle or square which represents the face. Many of the pictures have short white lines crossing the red lines at two or all four corners. These represent the strings by which the red headdress is fastened. Other examples in which essential parts of the head are somewhat out of position when other necessary lines interfere are the eyes of the Buffalo. When a life line runs from mouth to heart (Pl. XXIII), the one eye lies behind the other although the animal is represented in profile. When the life line extends only from neck to heart, one eye is under the other, the same view of the Buffalo being given. And, even as both eyes are shown, so also are both horns.

The disregard of perspective is evidenced by certain original conceptions of representation which are not merely naïve, but also pleasing. The whole composition of Pl. XXXV demonstrates this. Arrows have become People. They stand upright, feet and legs in profile, body and face in full face. The nock of the arrow forms the shoulders of the person, and, to show how closely arrow is related to bow, the spread arms of the arrow form the bow. The small white lines of the bow which are commonly depicted at the bends are shown on the arms too. Further, even though these People *are* bows and arrows, they also *carry* bows and arrows, thus furnishing a natural and consistent means of exploiting repetition.

The bows and arrows of this plate, as well as those of numerous others, demonstrate, too, by their size which is disproportionate to the figures holding them, the lack of perspective.

Still another example in which the use of different elements furnishes the impression, is the center of Pl. IX where only the heads and tails of the Snakes stand for the entire figure, the alternation signifying that the bodies are crossed under the burden they hold up like a raft.

Much has been said about flint armor and Flint People, but they both demonstrate well the device substituted for perspective. Points up on one side indicate armor at the front; points down on the other side, armor at the back; points on the shoulder represent armor at the sides, small points on limbs, armor on those parts. The club is of such a form that it might well be thought of as a quiver, but it too is made and protected by flint as may be seen by the points on both sides.

Parts of the body other than the face demonstrate further representation of design without perspective. The necklace is commonly depicted on People but if the artist wishes to indicate the body painting as well, both are shown although both occupy almost exactly the same position on the torso. When Holy Boy is shown carrying his five weapons and five medicines "around his neck", the weapons are depicted under his right arm, the medicines under his left. Bandoliers (Fig. 4) cross the body from left shoulder to directly under the right arm.

There is no hesitancy in placing objects in the hands of People, whether they are shown *en face* or in profile. In front position, the most common, the object is simply drawn near the hand, or it dangles from it. Usually this object is disproportionately large in relation to the whole figure. The same attitude persists with regard to figures in profile, the objects they carry are either in the hands, as the feathers of Pl. XXIV, or they are depicted beside them. Even the strings dangle from the arms shown at the side of the body (Pl. XXVIII).

Animals with long legs, buffalo, mountain sheep, wolf and bear, are shown with the knees bending outward, giving them a tottering look. Animals with short legs which seem dominated by the body, like beaver, otter, and bat, are depicted in top view and are differentiated with a few simple strokes. Heads of these animals, like those of snakes, are three-cornered. Fish has feet, even as they have, the characterizing elements being fins and tails.

The substitution of symbolism for perspective shows disproportion in ideology as well as in size. The Tobacco Pouch, so often used as guardian of the east, belongs to Sun. Nevertheless the small circle on it is Sun, and he is no larger than his pipe or pipe-cleaner which lie beside him. The reason for the marks on jointed snakes seems as inconsistent. It is not obvious why they should carry the symbol of their home or of deer track on the body, or why rain and moon phases should be a part of the same decorations.

Not much need be said regarding the question of symmetry and rhythm. Regular repetition with careful observation of balance are the keynotes rather than symmetry. The use of opposites, contrasting colors, the need for male and female powers on the same figure, and the power a figure in one direction borrows from that of the opposite direction (Pls. XXXI—XXXIII), or from the one in the succeeding space, serves an artistic purpose which can hardly be calculated, for it makes for variety and at the same time preserves balance. This device is equally symbolic and consequently ritualistic, and artistic at the same time.

In discussing color, attention has been called to the use of light and dark shades at strategic points. It should be noted here that this feeling for color is the most important element in maintaining the balance which a carefully calculating regard of any picture will demonstrate. That it is a purely artistic manifestation is shown by its presence in those places where complete freedom is allowable, in variegated bodies composed of triangles which may be arranged in any manner the artist likes (Pls. XIV, XVI), and in the pouches which hang at the belt of People (Pl. I, B).

One more major notion is striking in this art which, according to definition, seems so stereotyped, and that is, that the paintings are generally not static. The literary convention prescribes motion and the pictorial devices carry it out. People "follow one another" or "face," animals seem to move,

indeed whole compositions, such as some of the Snakes, all of the Buffalo, and the Whirling-tail-feather, actually circulate in the space they occupy.

Features which determine the back of a person and give him motion are his calves on the same side as his pouch and head feather. The direction of the points — up in front, down in back — together with the angle of the calf and the head feather show the motion of those outfitted in flint. All other parts of these figures are represented *en face*.

Figures may be static too. In such case they are shown in front view with legs spread and both calf angles at the inside! Thunders "sit" thus on top of their mountains. Birds "sit" in the same way but their faces are shown in profile for both eyes and beaks are represented in outline.

The paintings with the greatest motion of the whole collection, are the Whirling Snakes of Pl. X, and the Coiled Snakes of Pls. XII and XIII. The very significance of that which they designate is sufficient to send them whirling and coiling. Nevertheless they do not seem to me to put the on-looker into an illusion of unpleasant motion with them. As the Whirling Snakes writhe from their mountains, they are held within the territory assigned them, I believe, by the restful smoothness of the snake which forms the guardian circle.

When one looks at the coiled snakes of Pl. XII and XIII, one coils with them, but instead of con-tinuing motion in an unpleasant coil as he continues to look at them, he finds them building up a coil in three dimensions. I think this illusion is created by the fact that the spaces are made discontinuous by the use of the snake markings in contrasting colors, furthermore, the smooth guardian of Pl. XII holds the composition within bounds. The White Snake of Pl. XIII is to all intents and purposes coiling to the east, and the rapidly moving line of crooked snakes of the surrounding cricle moving sunwise corrects the illusion so that once more, this mighty picture, though it moves sinuously from the center and rapidly, even gaily, from the edge, nevertheless keeps its place. It should be noted too that, according to Navajo convention both portions move according to ritualistic requirements, i. e., sunwise. It must be remembered that the Coiled Snakes' direction is reckoned from the tail.

The motion of the picture of the Whirling-tail-feather (Pl. XXXIV) is developed along different lines. The central figure which sets the theme moves very little, if at all, because of the variation of the colors which compose it and perhaps because of the points at the end of each feather. The arrows around it, however, start the motion which is taken up by the figures and exaggerated by the Whirl-ing-tail-feather at the end of each horizontally held bow. The whole composition becomes a swastika turning on the wheel-like center.

It is then with a relatively small assortment of artistic devices, with subtle and balanced use of color; with outline and contrast; with conventionalized and largely inarticulate proportions; with symbolism as a substitute for perspective; with keen sensitivity to the questions of symmetry, rhythm and motion, these based upon the ritualism of the number four and as a subsidiary variant, five; that the Navajo attain effects which have the permanent charm of unity, variety, and with few stereotyped exceptions, consistency. The secret of the effect is the originality in the choice of device, the subtlety in its use, the imagination with which the simplest devices are combined, the surprise which is constantly created, in short, a demonstration of naïveté and great knowingness combined with the most extreme simplicity.

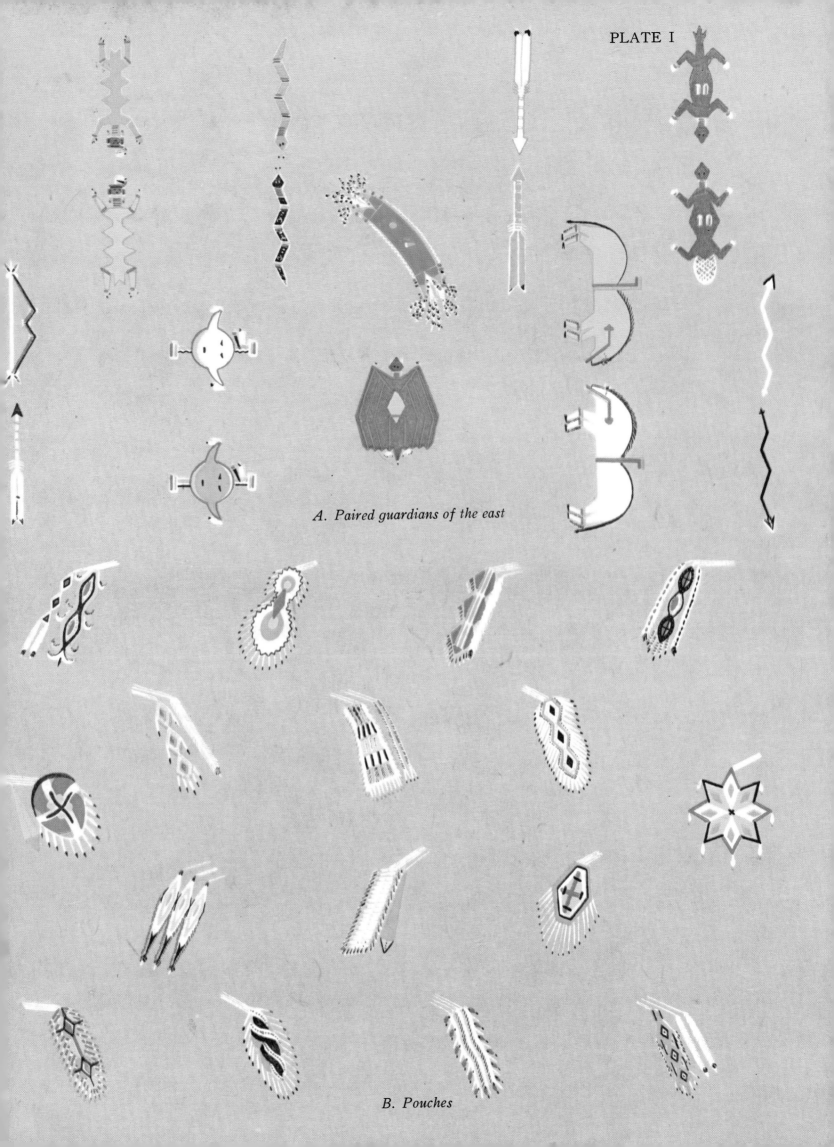

PLATE I

A. Paired guardians of the east

B. Pouches

PLATE II

C. *Basket in which Black Wind is carried*

A. *Female Snakes crossed on Yellow Wind*

D. *Cornbug on Moon, used for woman patient*

B. *Pollen Boy on Sun, used for man patient*

PLATE III

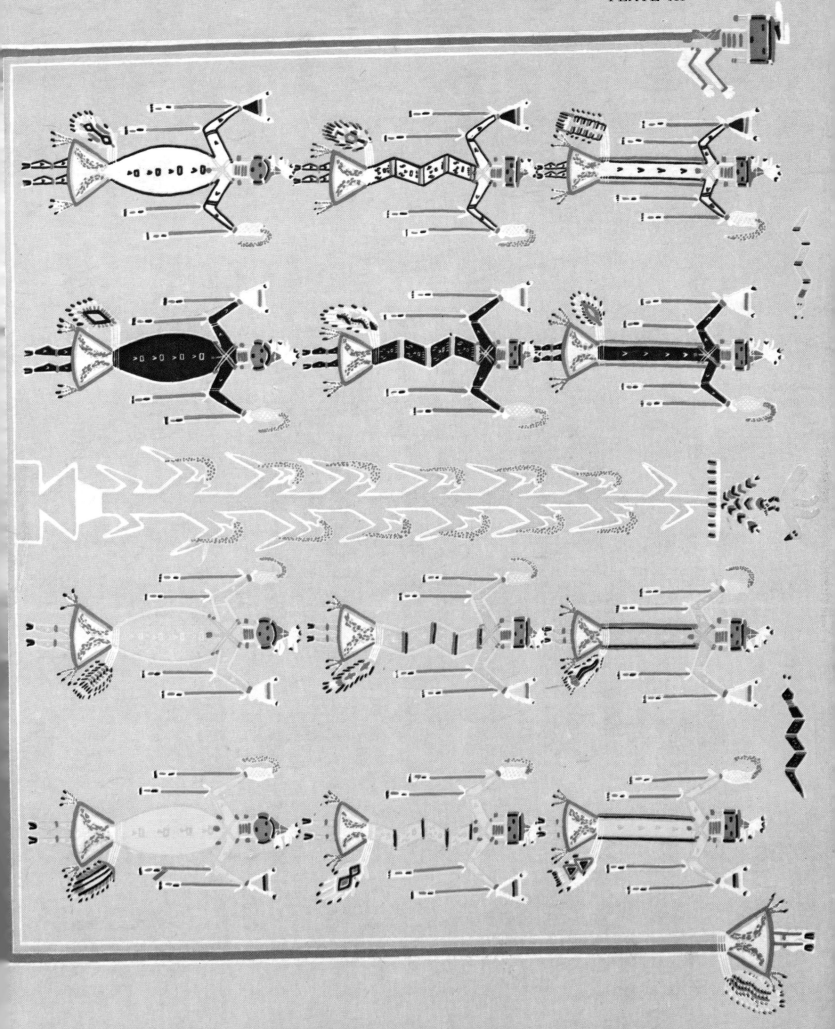

Blue Corn with all kinds of snakes. Arrangement shows power of repetition (p. 67)

PLATE IV

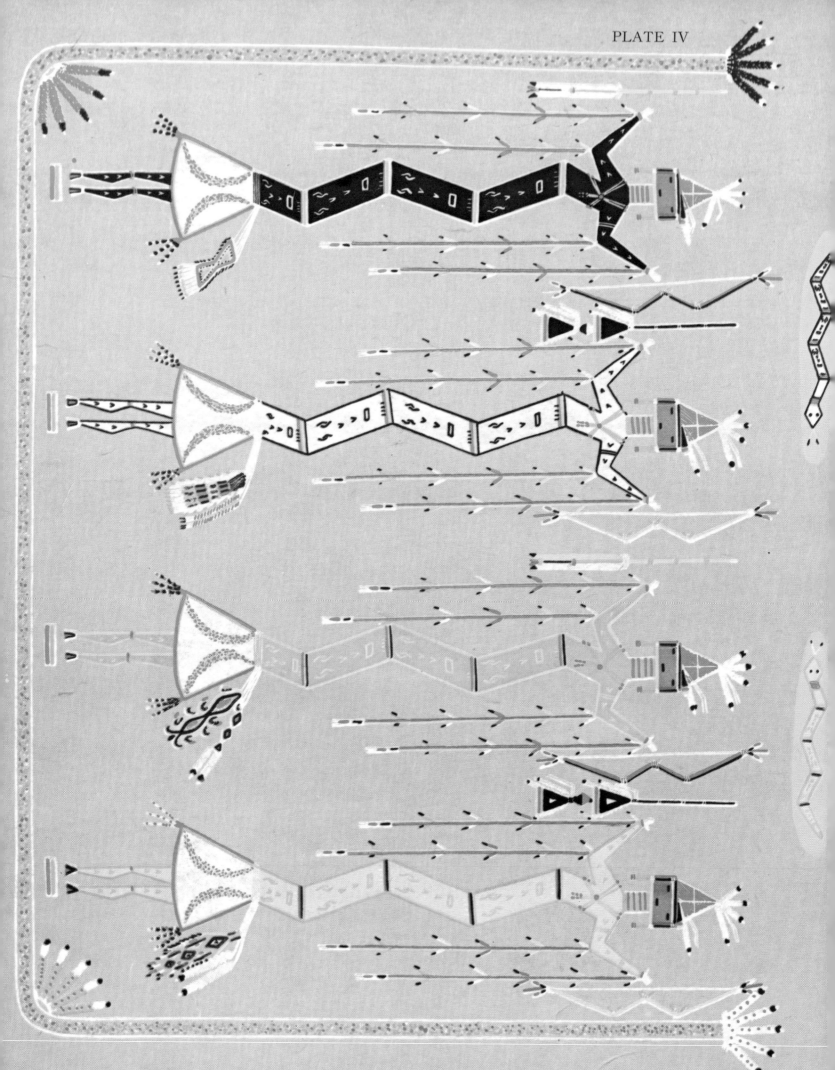

Crooked Snakes showing power of length (p. 54)

PLATE V

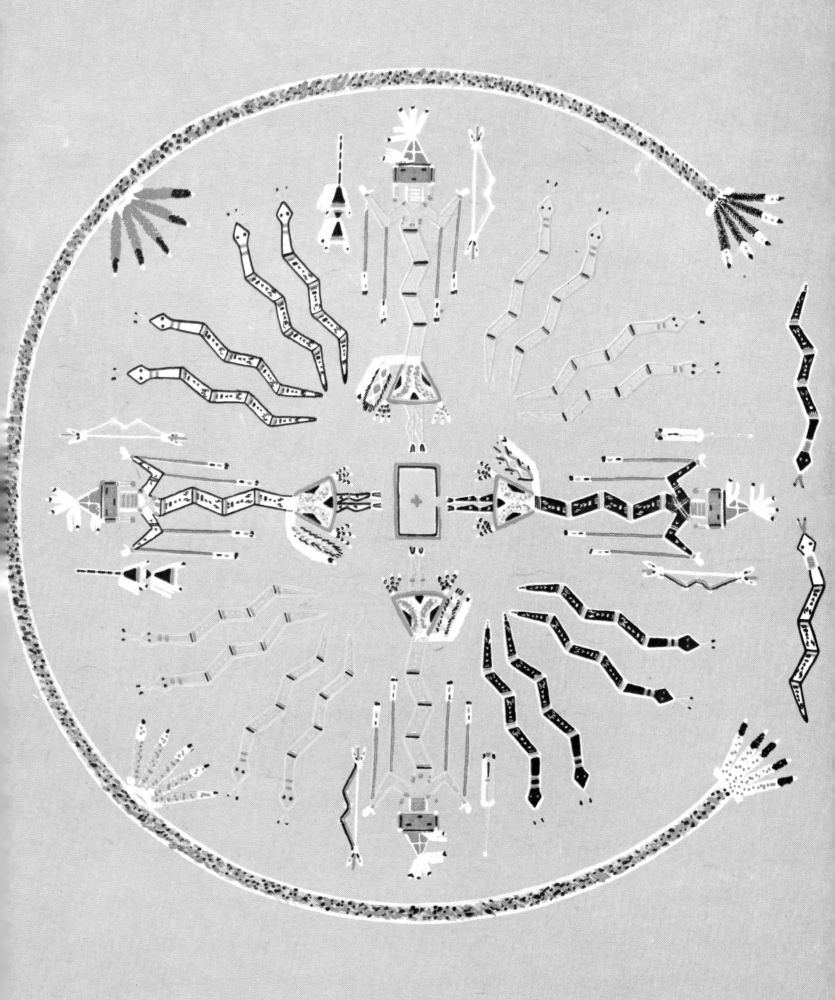

Crooked Snakes showing power of repetition (p. 54). Center shows home with fire

PLATE VI

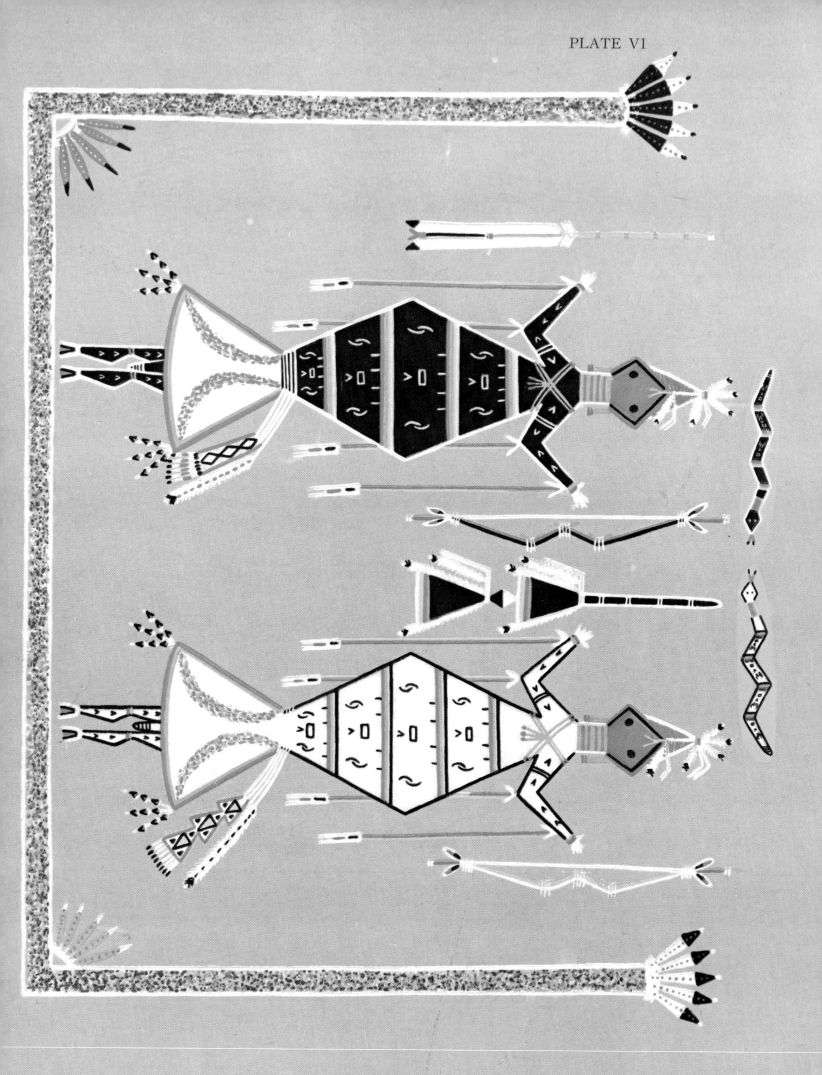

Two Big Snake People. Fangs on forehead. Mirage encircling garland (pp. 54, 85)

PLATE VII

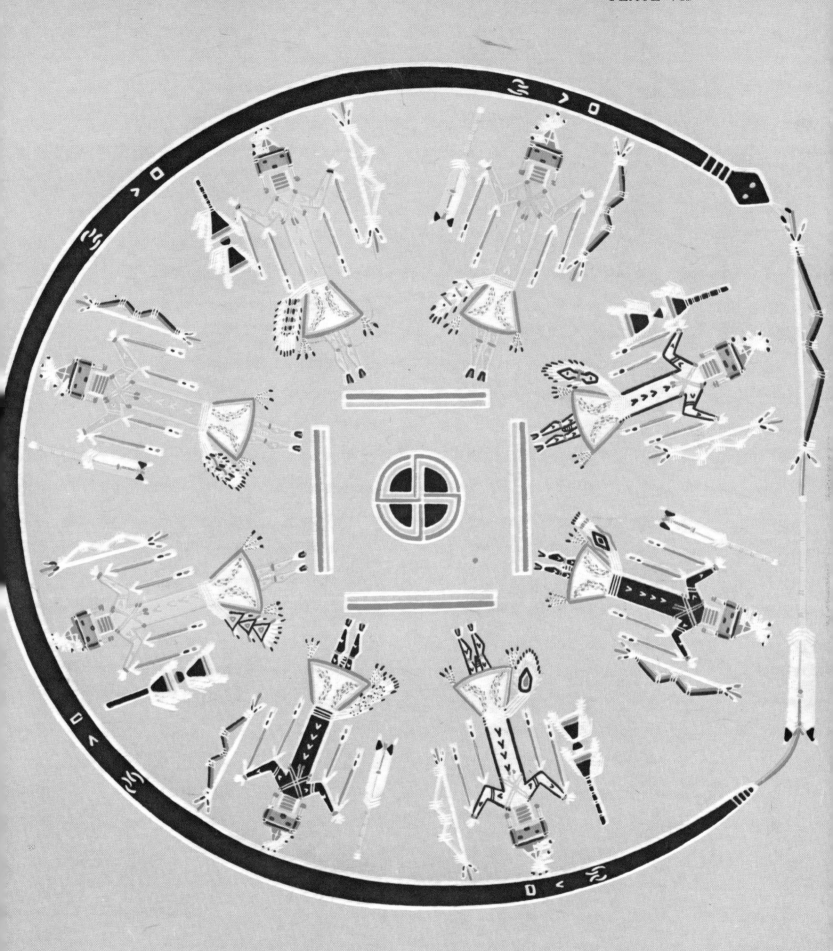

Arrowsnake People at Rainbow House on Striped Mt. (p. 72)

PLATE VIII

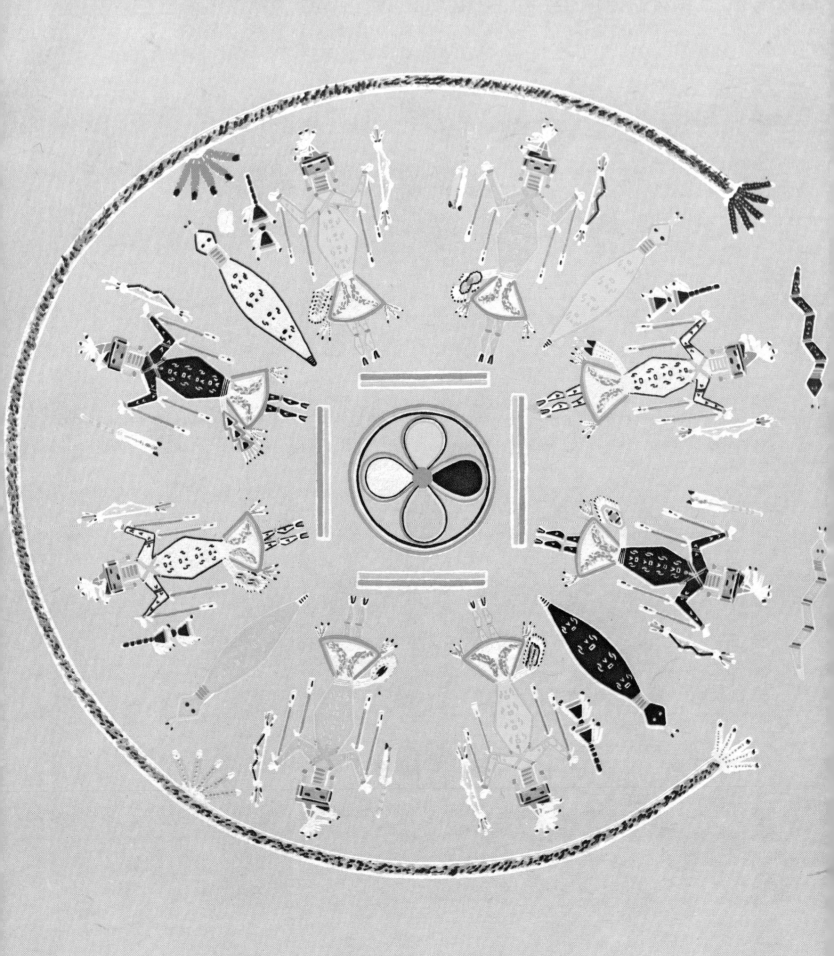

Big Snake People. Power of repetition. Mirage garland (p. 54)

PLATE IX

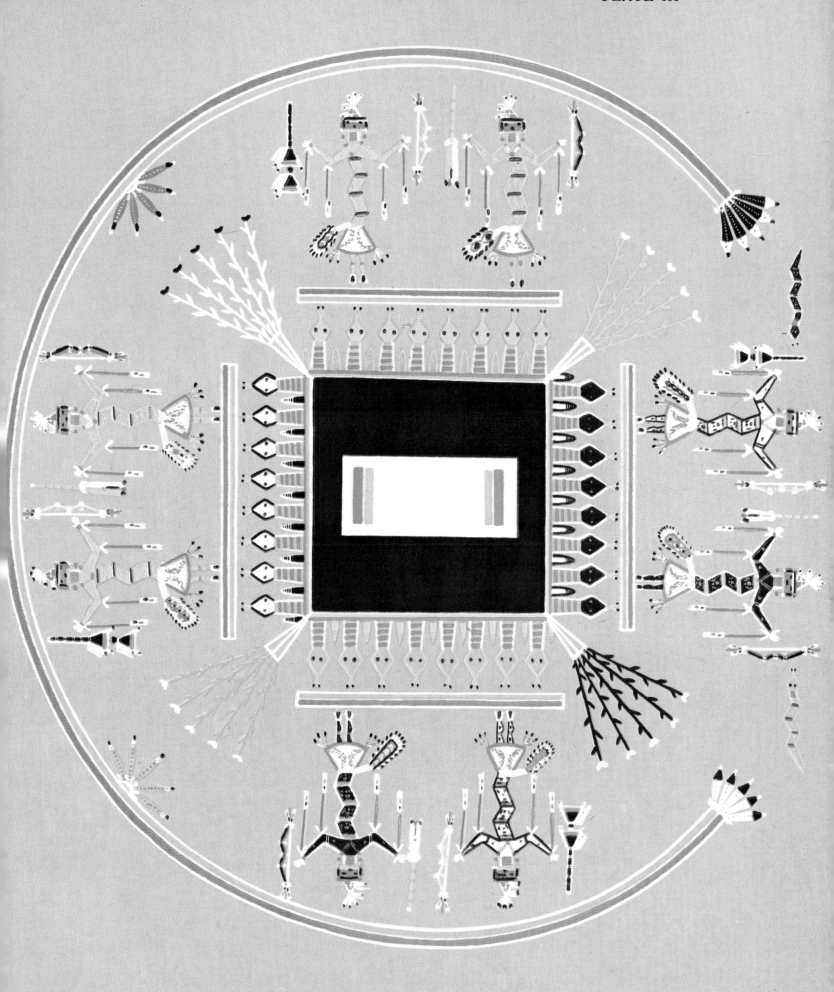

Grinding Snakes or Crooked Snakes move their home. Snake bodies interlocked under home so as to form raft (p. 54)

PLATE X

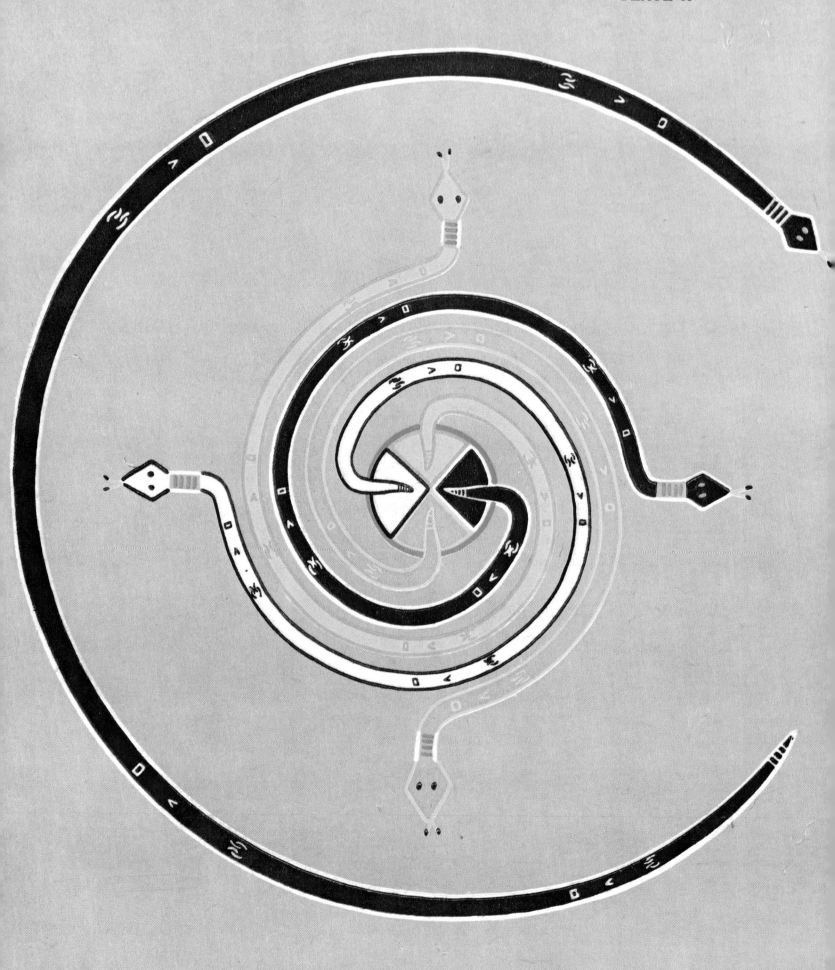

Whirling Snakes or Whirling Mt. (p. 53)

PLATE XI

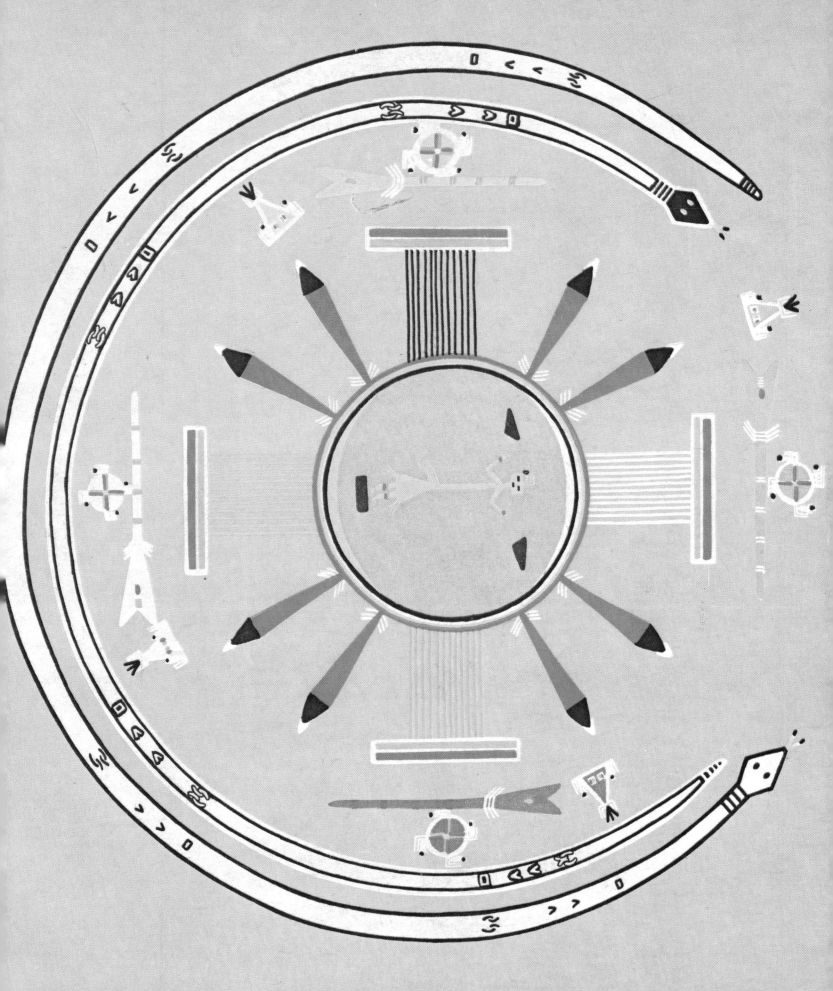

Pollen Boy on Sun. At each side sun's rattle, trumpet, and arrow of precious stone. Used for male patient only after eclipse of Sun. White Snake guardian outside furnishes female protection (p. 56)

PLATE XII

East

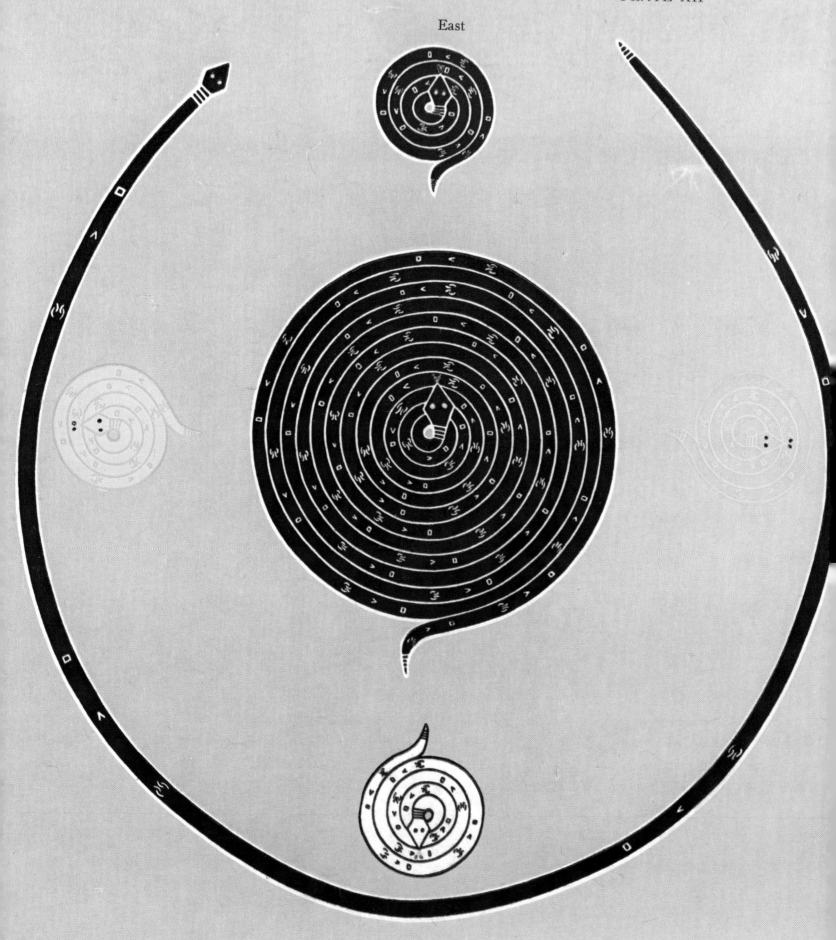

East

Coiled Mt. (p. 53). Corral Branch of Male Shooting Chant

PLATE XIII

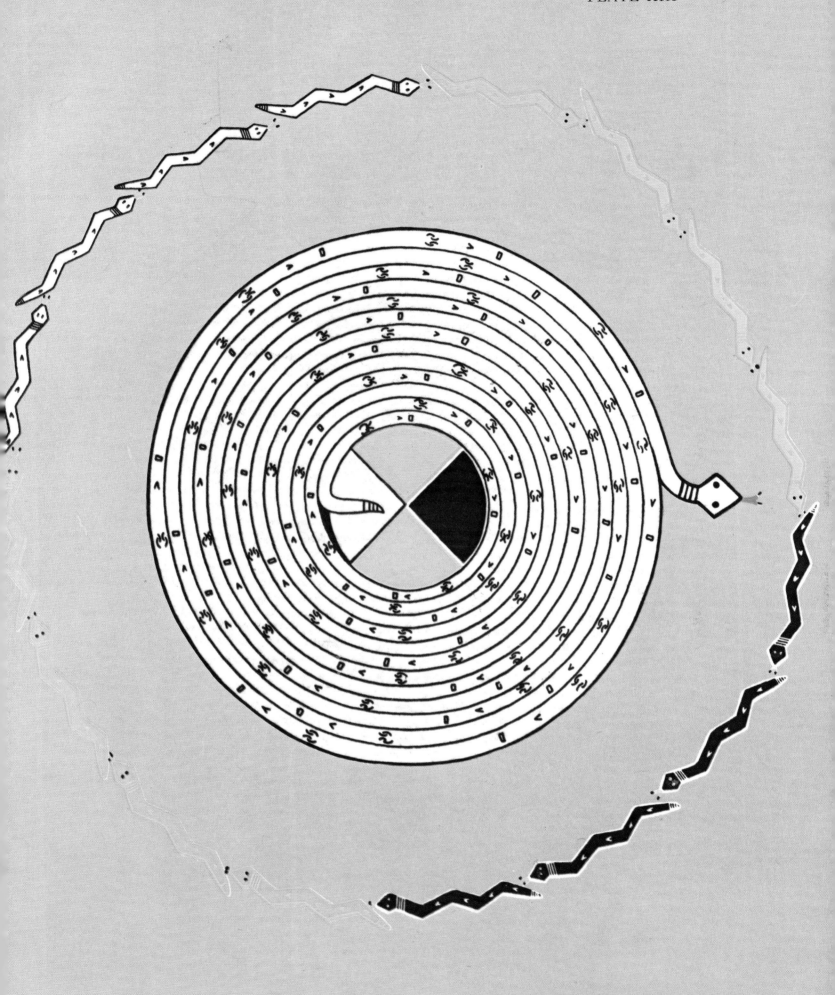

White Coiled Mt. with guardian circle of sidewinders. This painting is no longer used near Newcomb because it is "too dangerous for Chanters to handle". This was the painting Mrs. Newcomb saw being painted at night when she visited the "reversed" Chant (pp. 13, 78)

PLATE XIV

Holy Man, Holy Man, Holy Boy, Holy Girl (p. 45)

PLATE XV

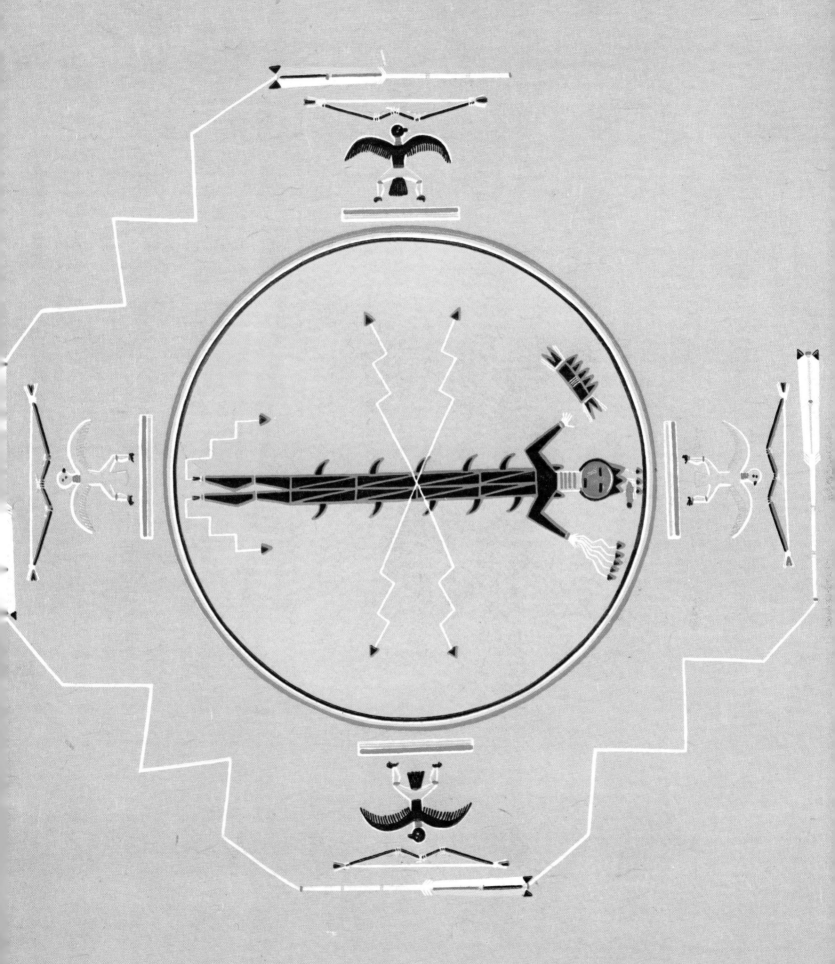

Slayer-of-alien-gods visits his father, the Sun. Female Shooting Chant (p. 47)

PLATE XVI

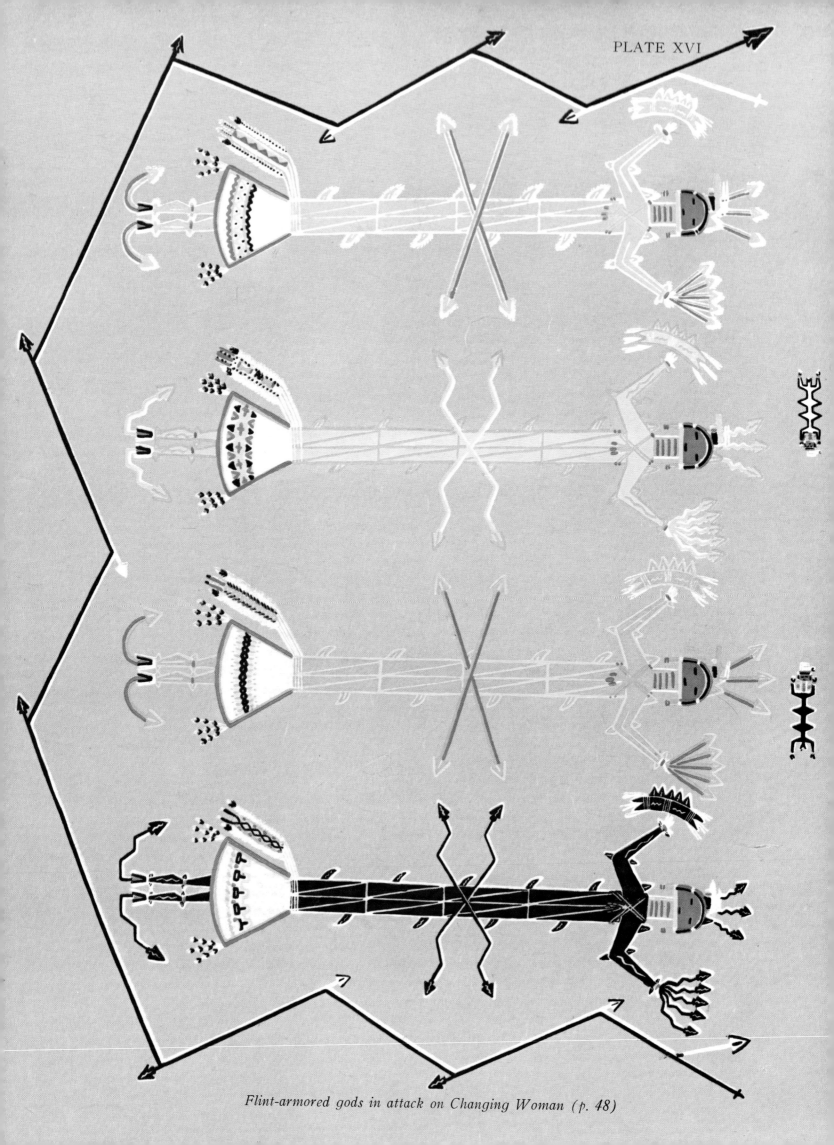

Flint-armored gods in attack on Changing Woman (p. 48)

PLATE XVII

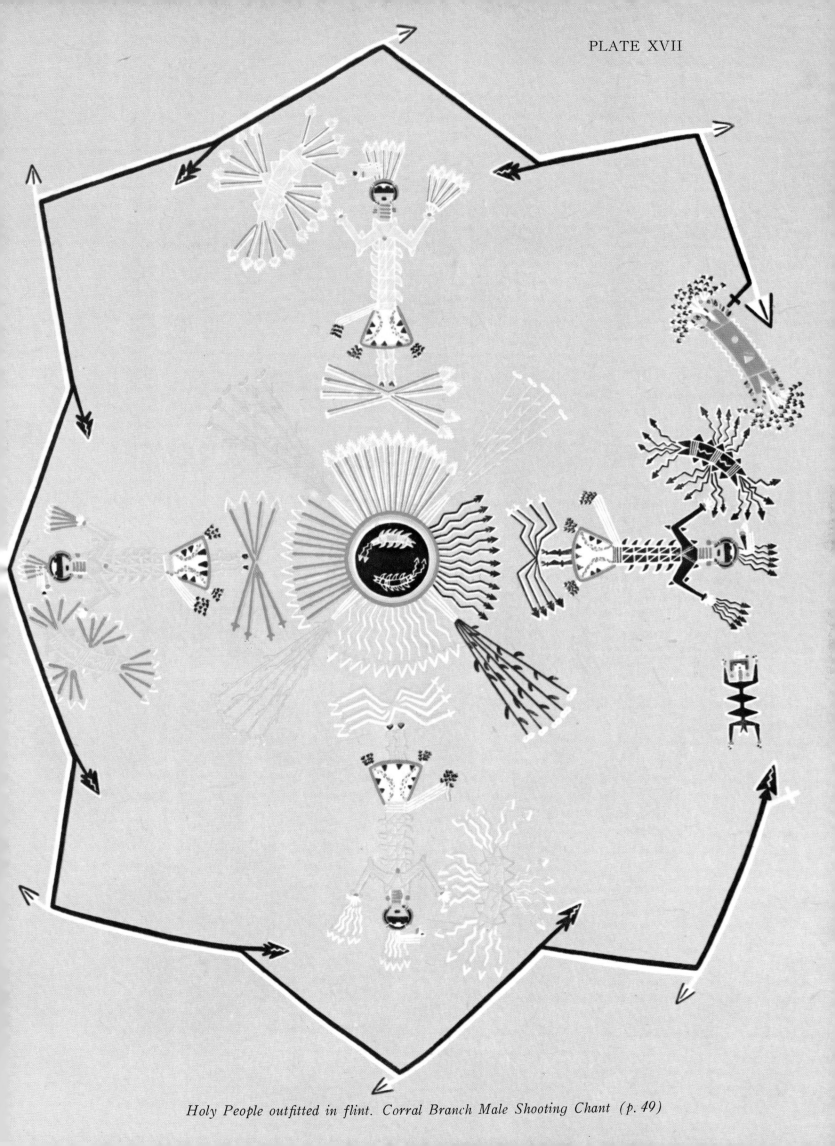

Holy People outfitted in flint. Corral Branch Male Shooting Chant (p. 49)

PLATE XVIII

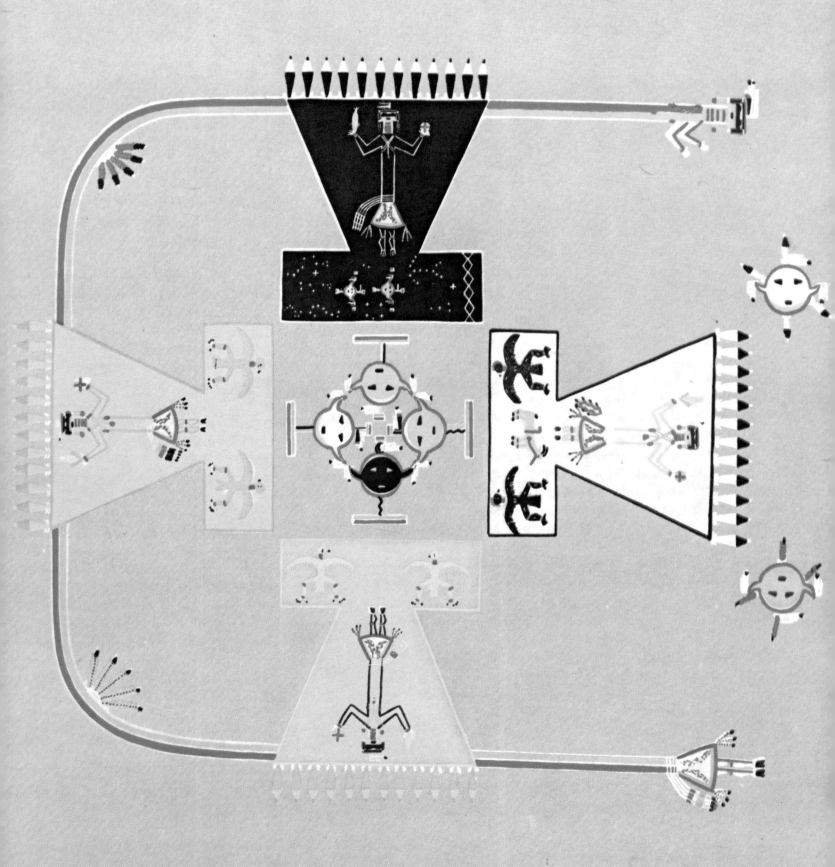

Sky People: Dawn, Blue Sky, Yellow Evening Light, Darkness (p. 58)

PLATE XIX

East

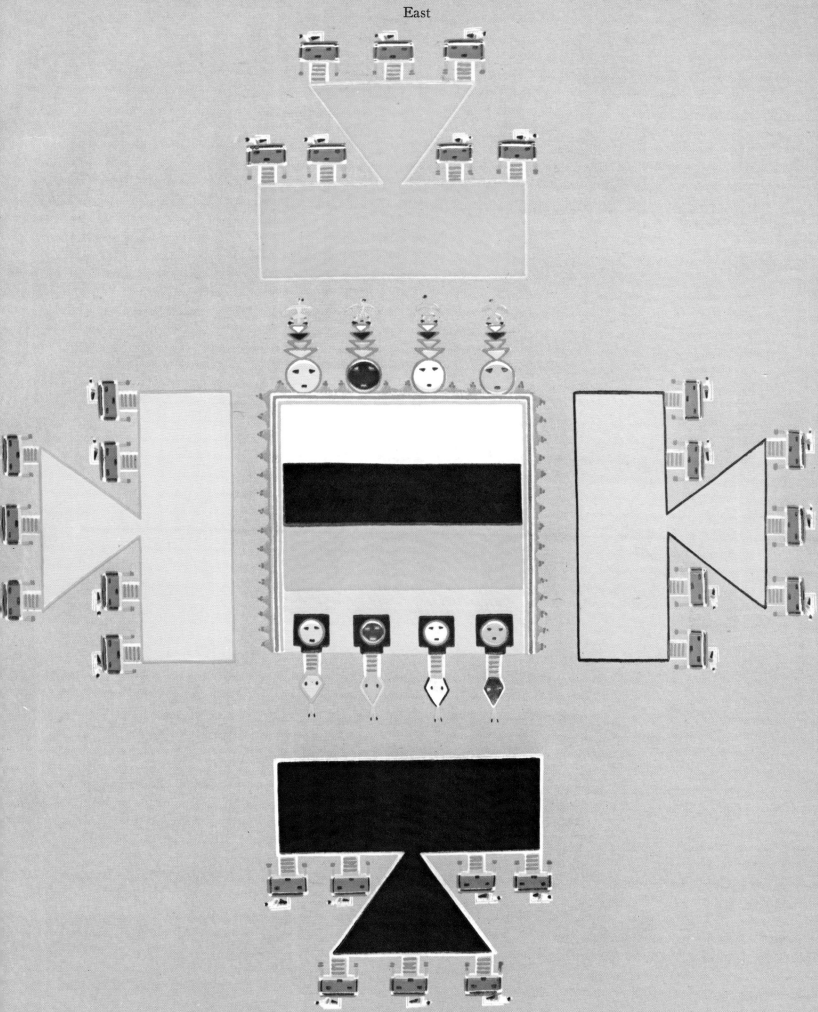

Sun's House surrounded by Sky, Water, Sun, and Water People (p. 59)

PLATE XX

East

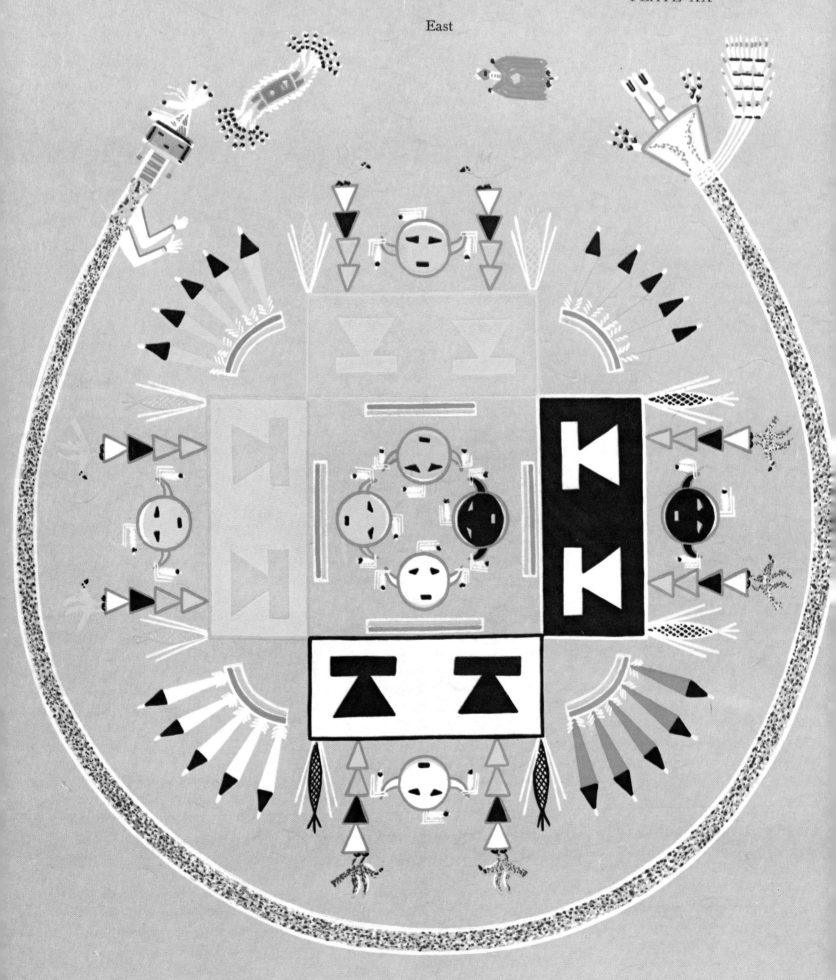

Cloud Houses. Corral Branch Male Shooting Chant (p. 60)

PLATE XXI

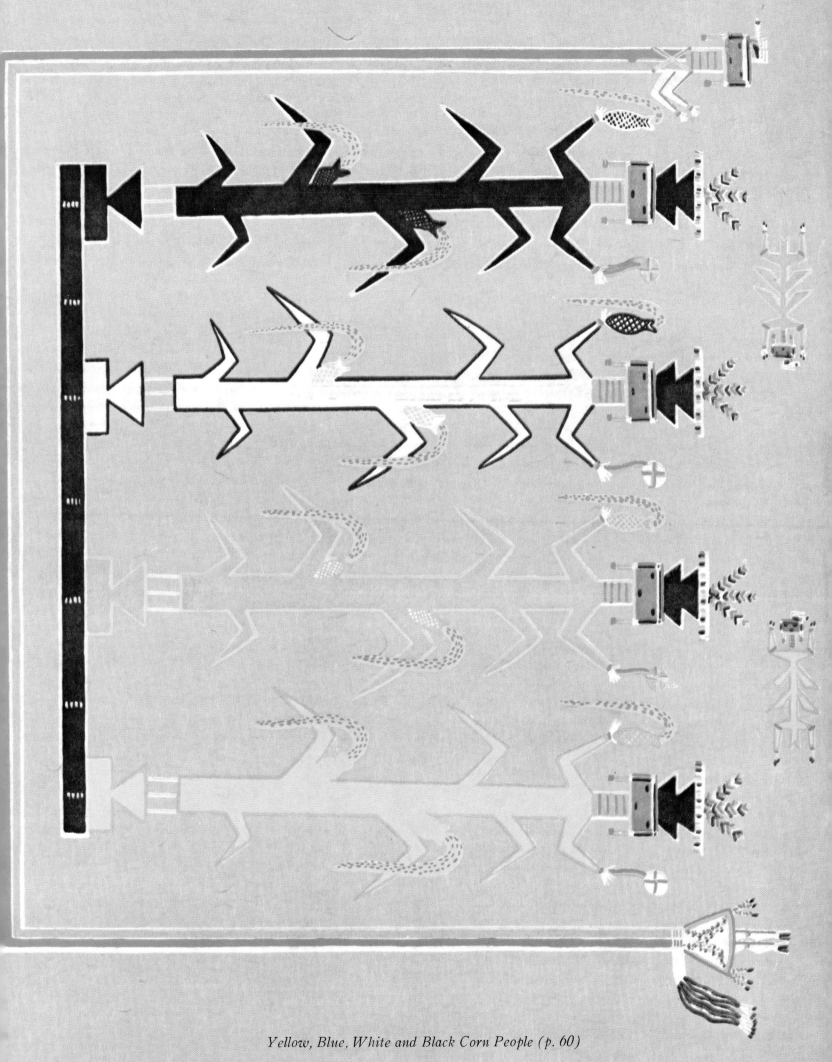

Yellow, Blue, White and Black Corn People (p. 60)

PLATE XXII

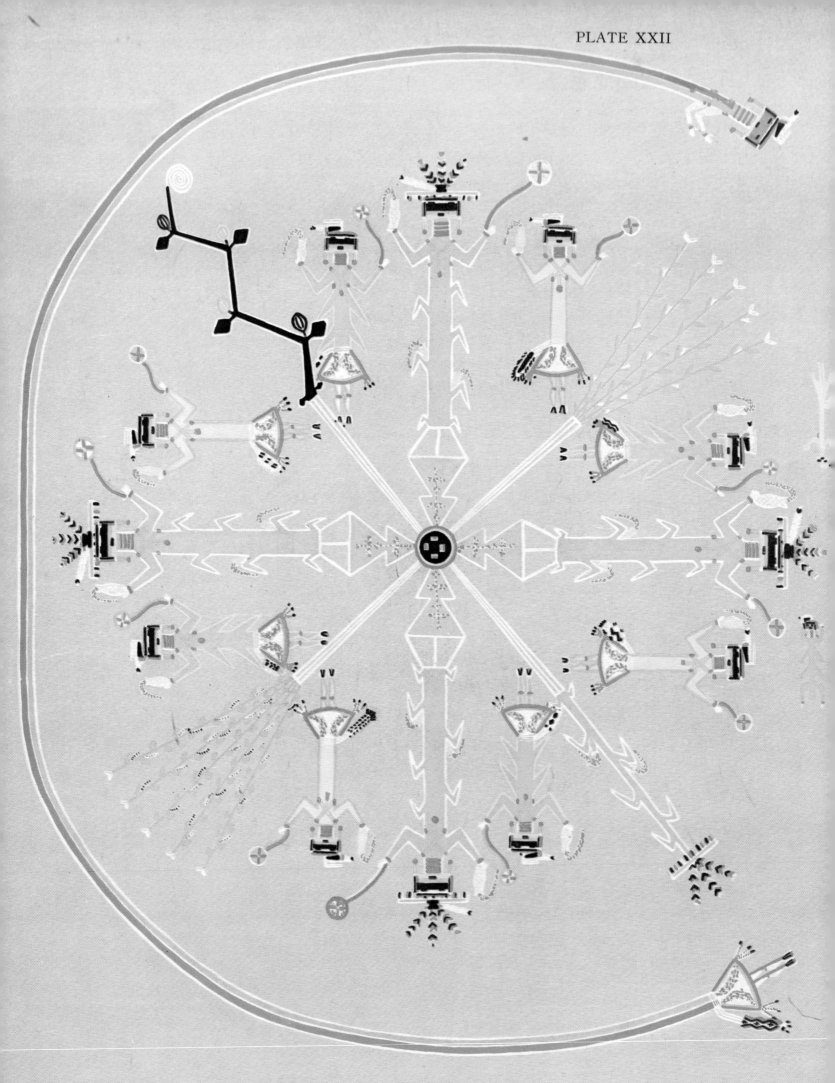

Blue Corn People guarded by Pollen Boy and Cornbug Girl (p. 67)

PLATE XXIII

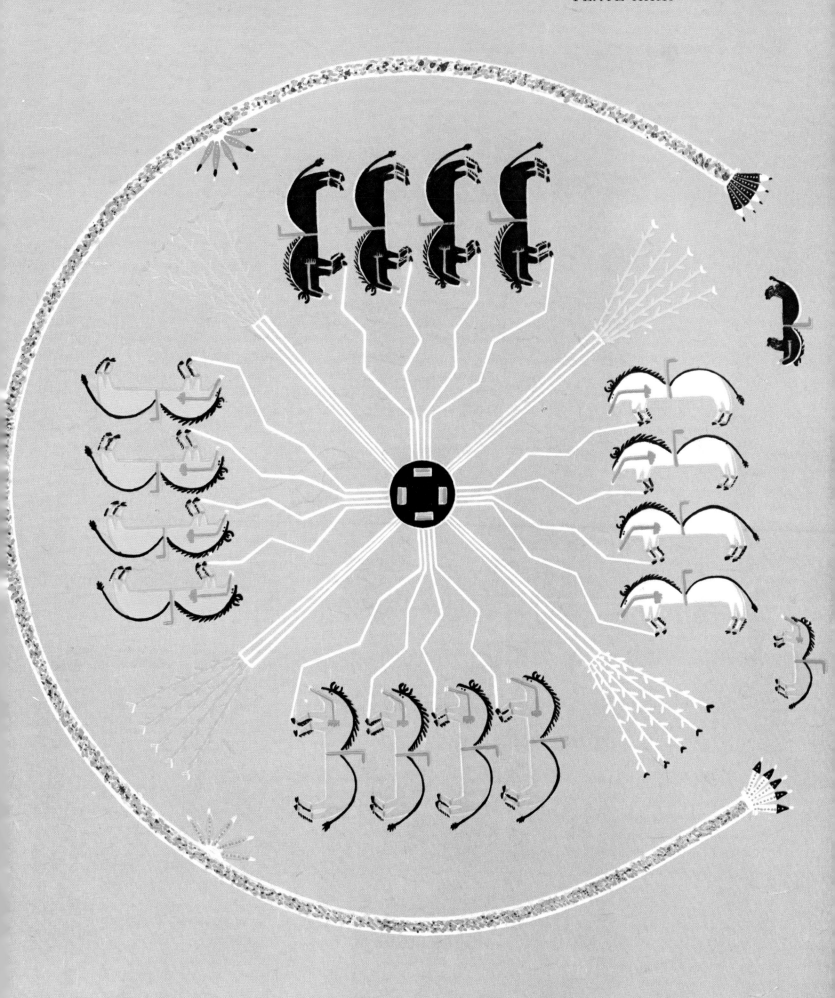

Buffalo and trails to water on mountain (p. 63)

PLATE XXIV

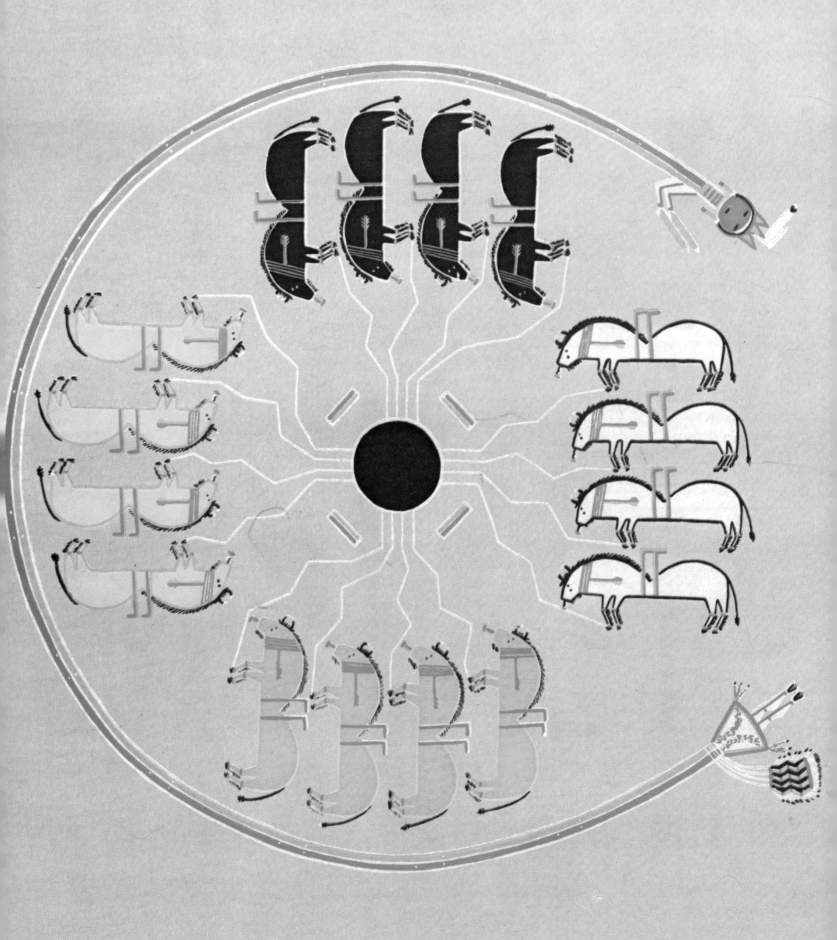

Buffalo and trails to water on mountain (p. 63). Female Shooting Chant

PLATE XXV

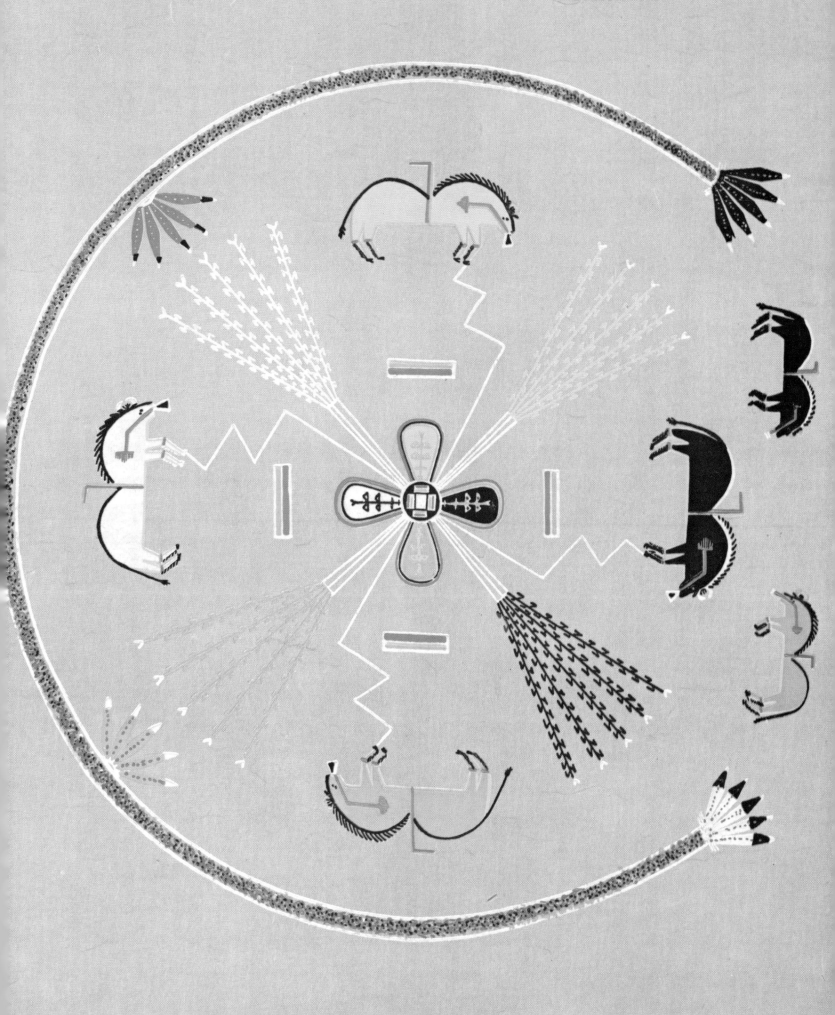

Buffalo in each sector formed by "medicines" (p. 63)

PLATE XXVI

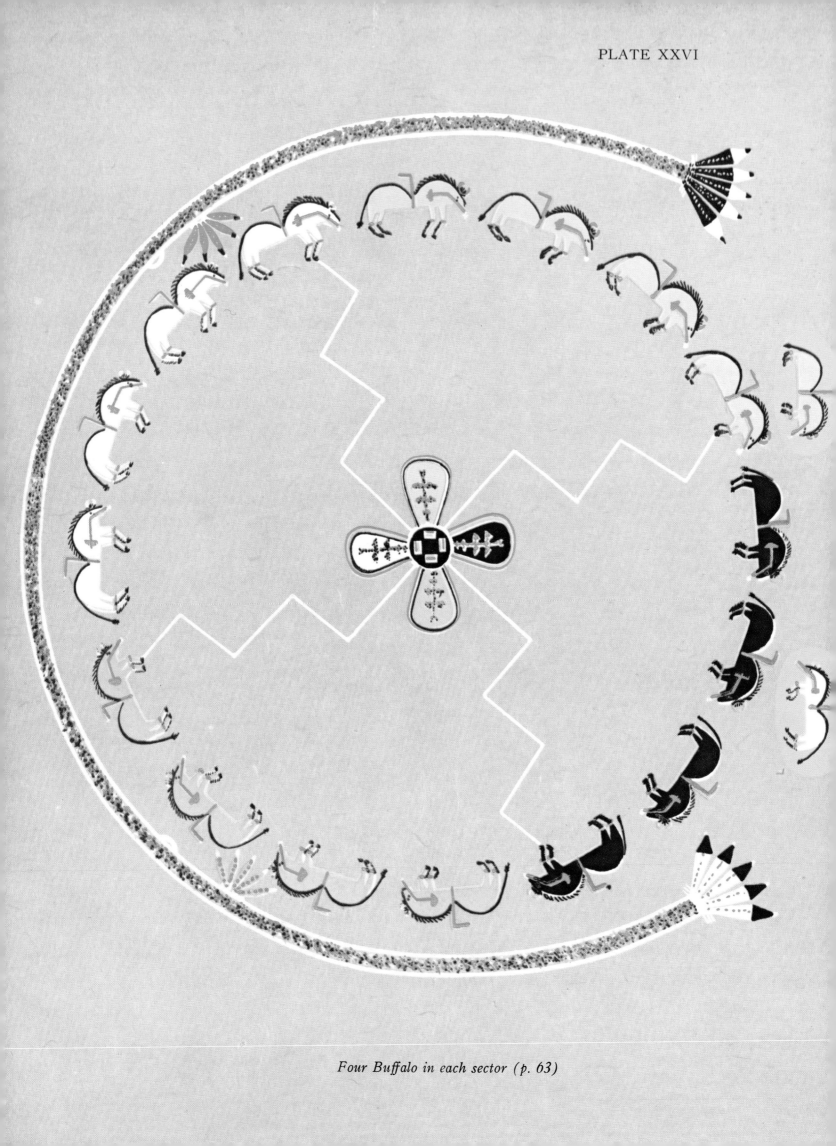

Four Buffalo in each sector (p. 63)

PLATE XXVII

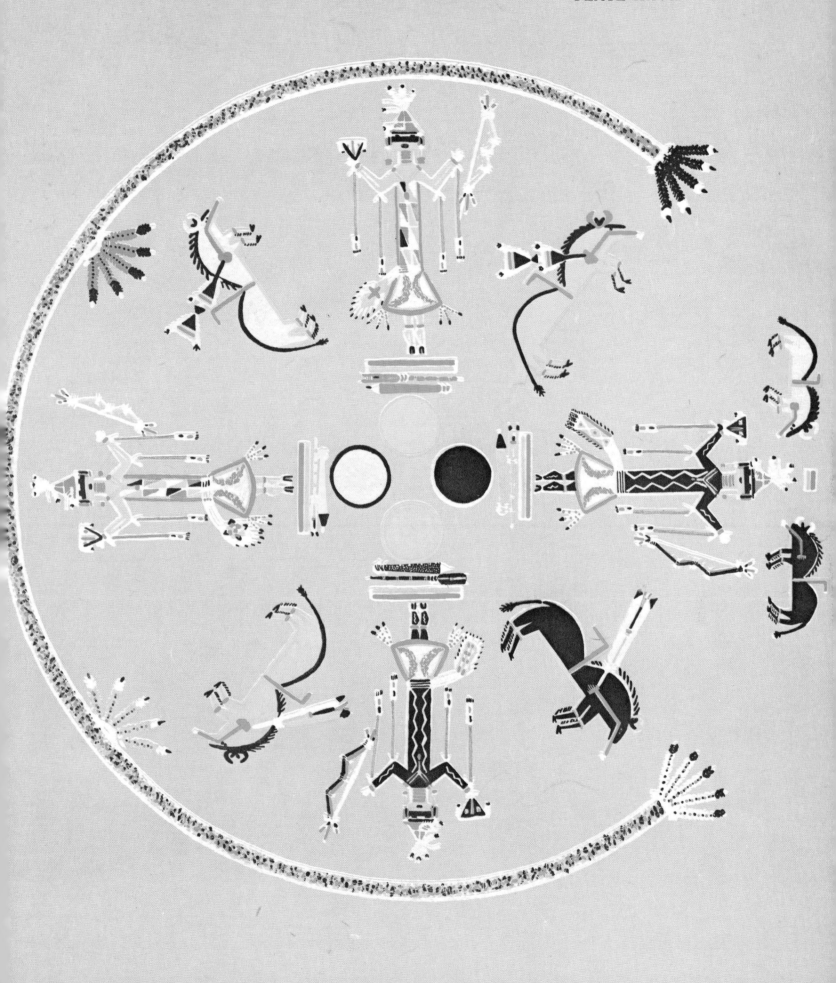

Holy People overcome Buffalo (pp. 47, 63)

PLATE XXVIII

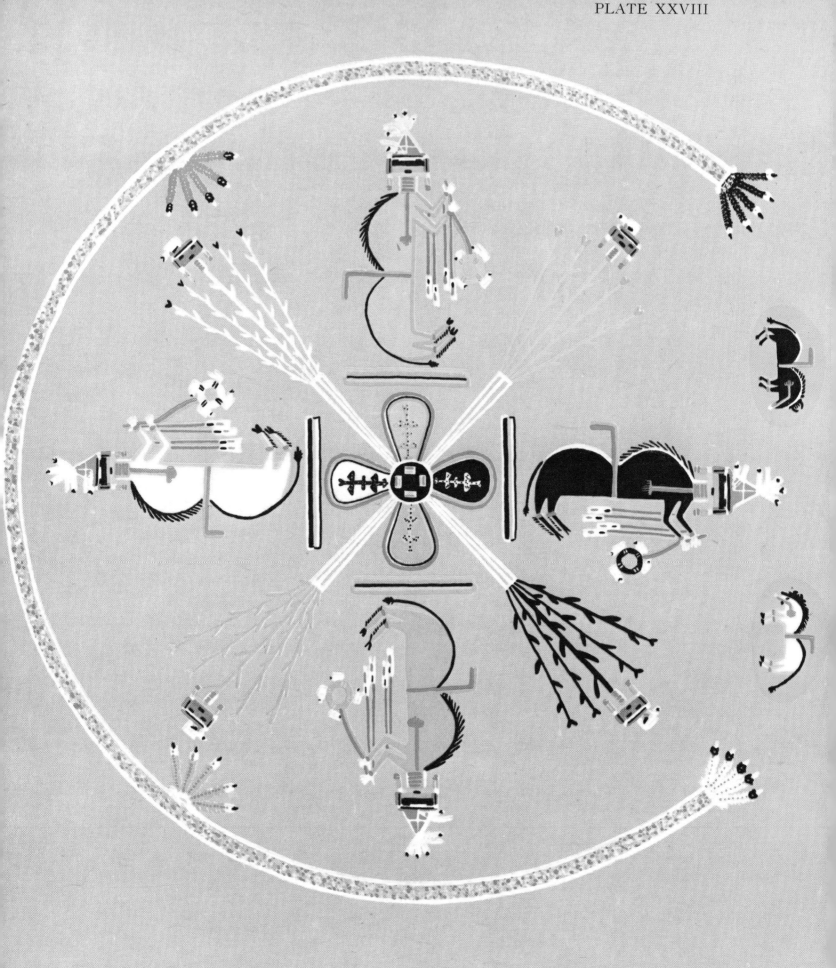

Buffalo and Medicine People (p. 63)

PLATE XXIX

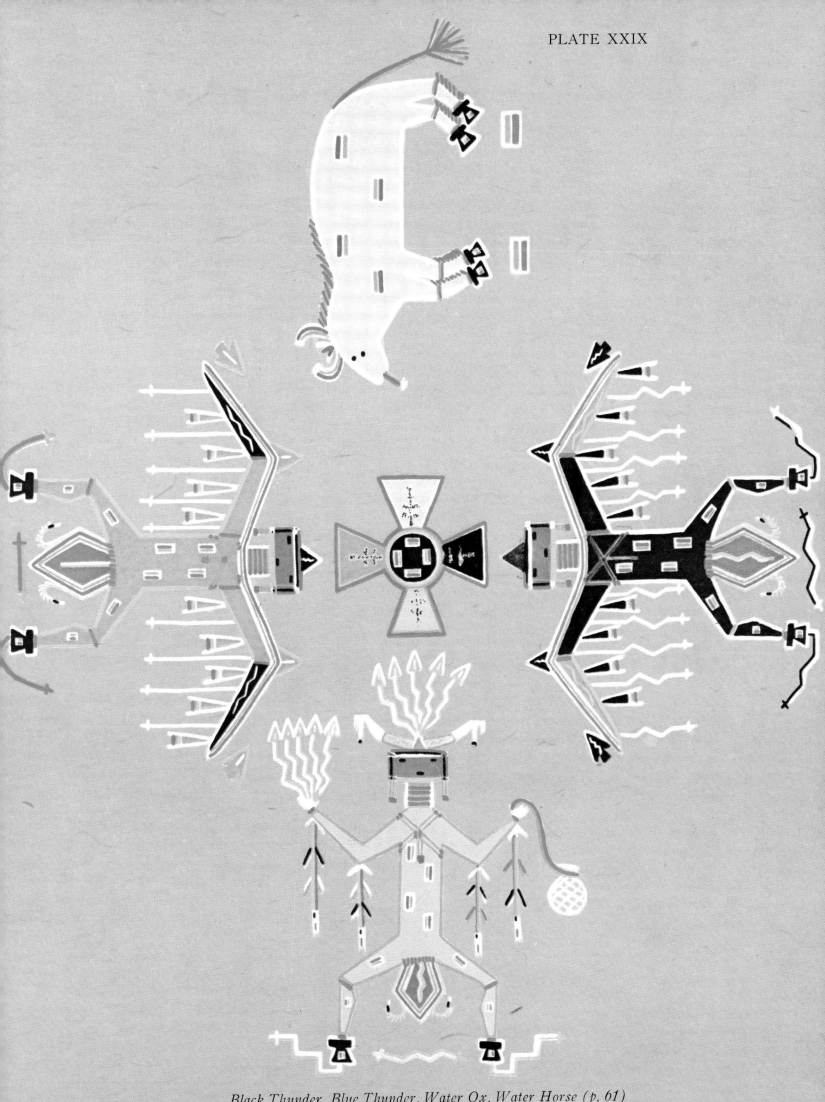

Black Thunder, Blue Thunder, Water Ox, Water Horse (p. 61)

PLATE XXX

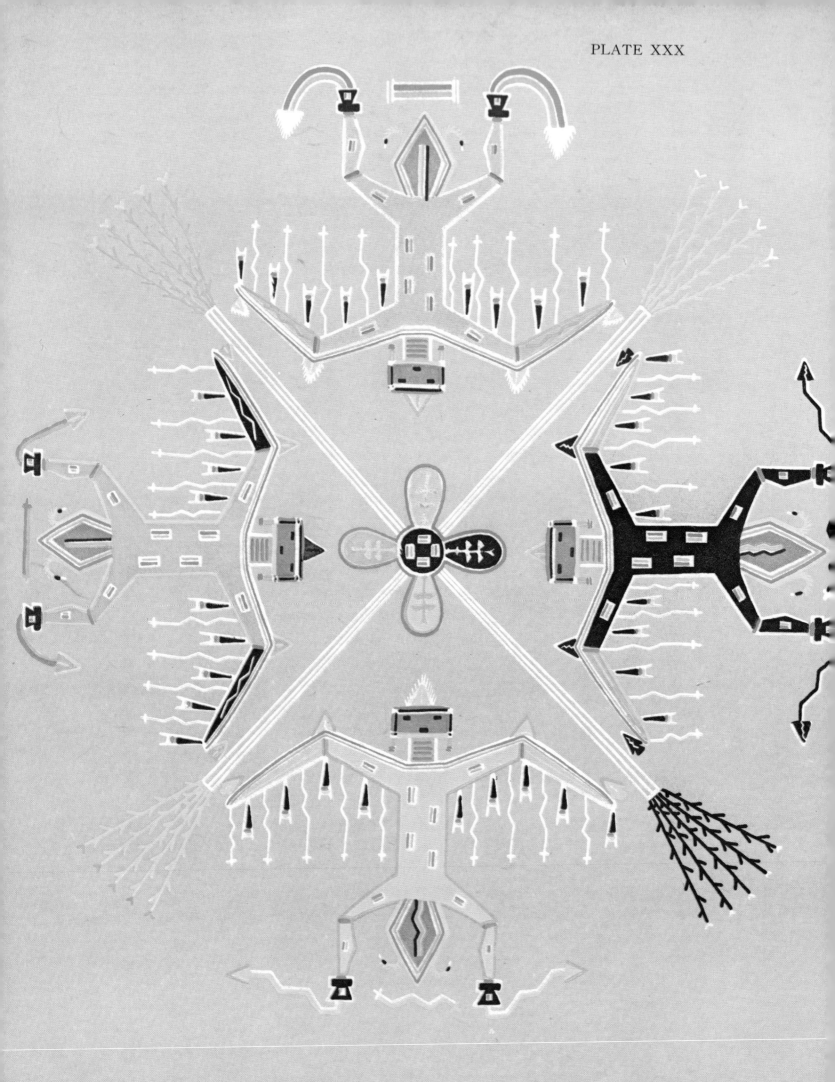

Thunders in sectors between "medicines", no encircling guardian (p. 61)

PLATE XXXI

Thunders in sectors betwen herbs with encircling guardian (p. 61)

PLATE XXXII

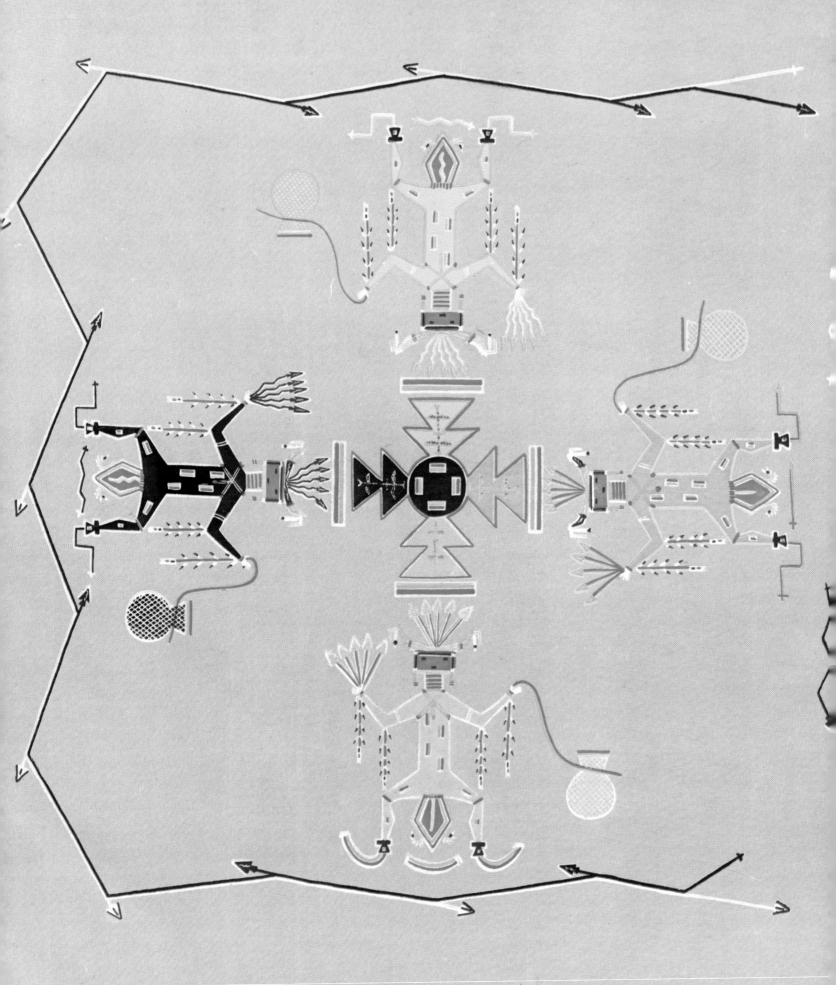

Four Water Oxen. Water Ox has many attributes of Thunder because it is the "adulterous
child of Thunder". This painting used after too much rain (p. 62)

PLATE XXXIII

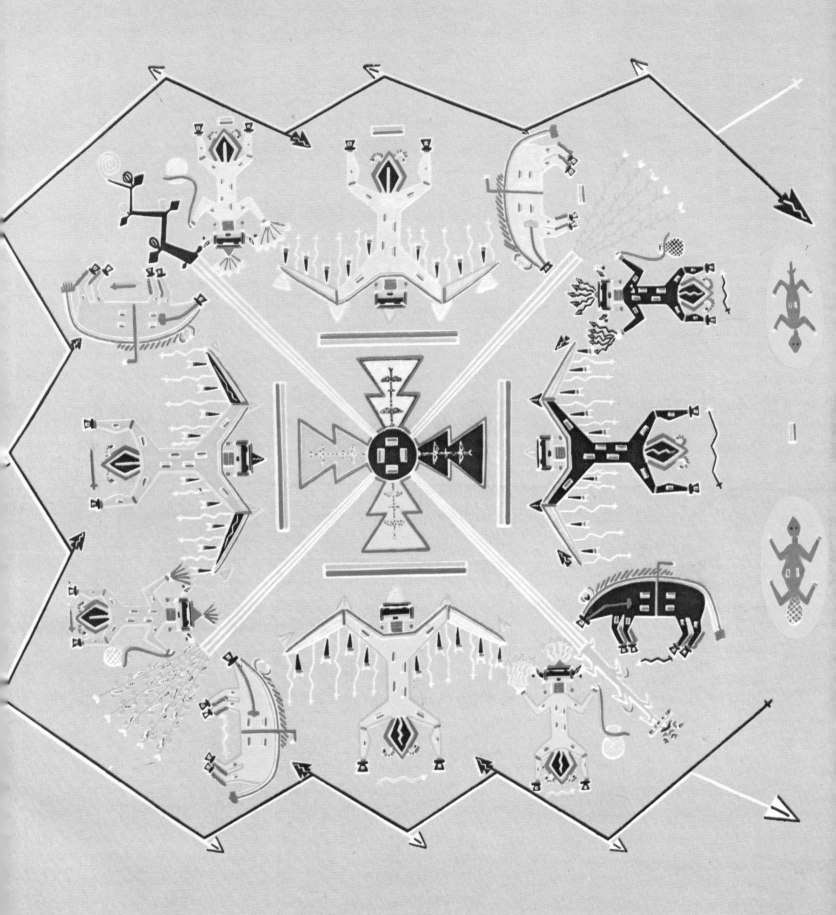

Thunder protected by Water Ox and Water Horse in each sector (p. 62)

PLATE XXXIV

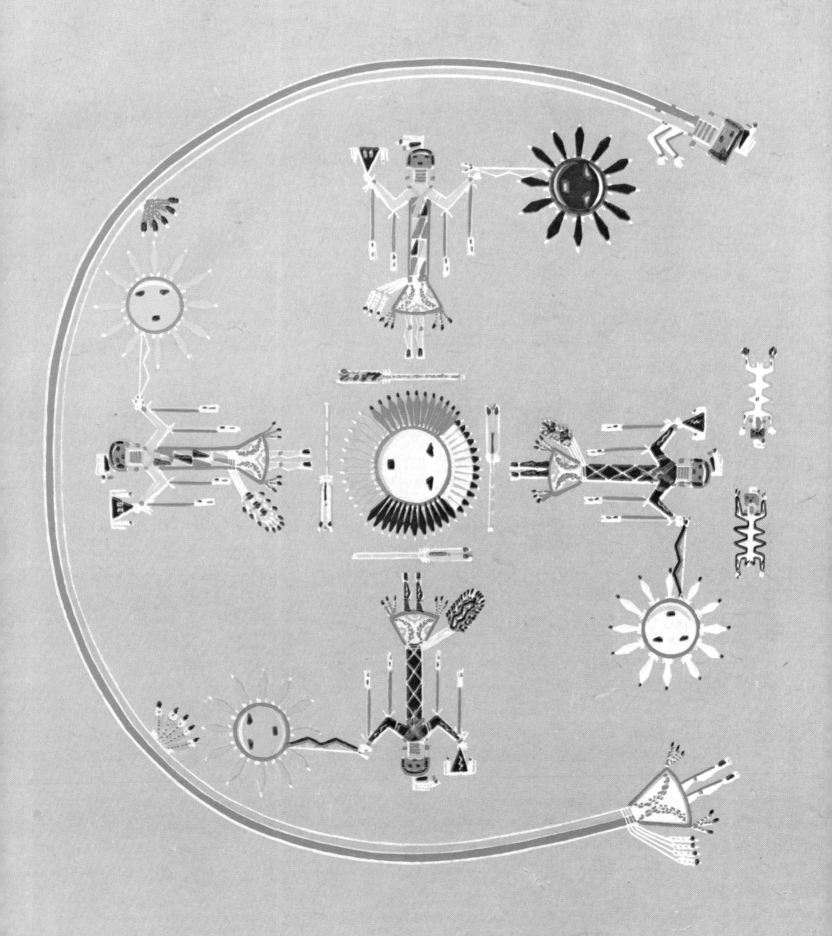

Holy People overcome Whirling-tail-feather. Corral Branch Male Shooting Chant (pp. 34, 87)

PLATE XXXV

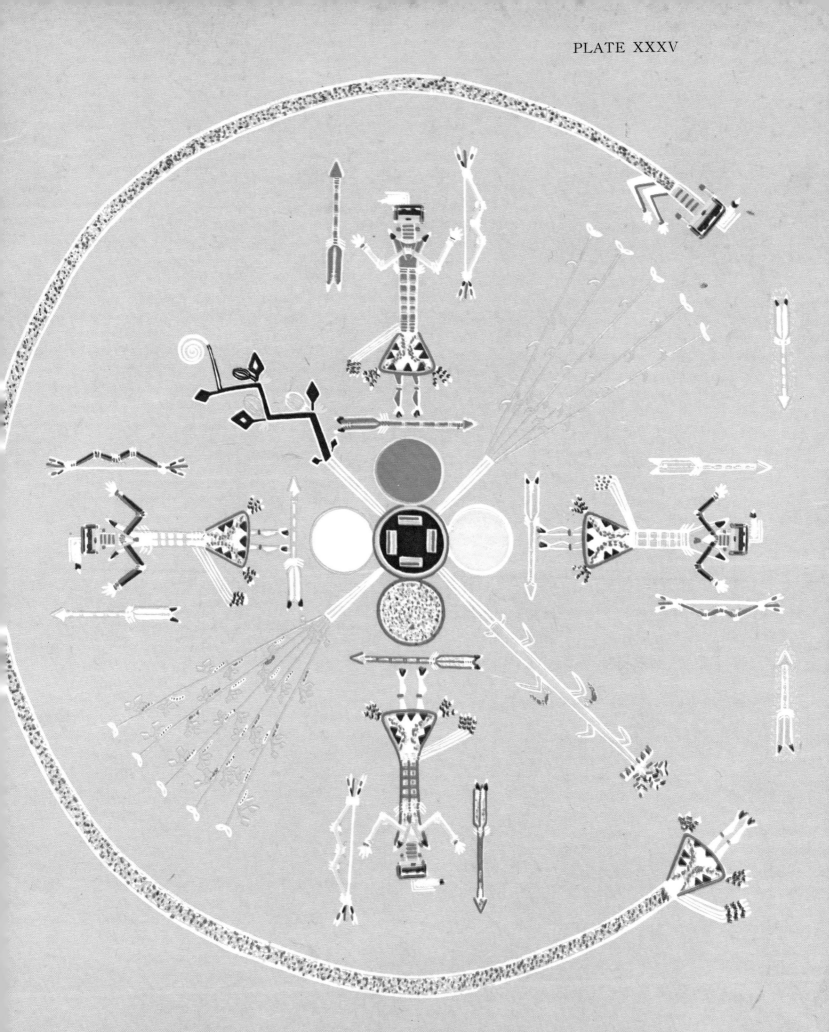

Arrow People. The body is the arrow, the arms form the bow. Arrows are made of, and live at, mountains made of precious stones (p. 50)